Boerenverdriet

**Violence between
Peasants and Soldiers in
Early Modern Netherlands Art**

Studies in the Fine Arts: Iconography, No. 5

Linda Seidel, Series Editor

Associate Professor of Art History
University of Chicago

Other Titles in This Series

Boerenverdriet
Violence between
Peasants and Soldiers in
Early Modern Netherlands Art

by
Jane Susannah Fishman

UMI RESEARCH PRESS
Ann Arbor, Michigan

Copyright © 1979, 1982
Jane Susannah Fishman
All rights reserved

Produced and distributed by
UMI Research Press
an imprint of
University Microfilms International
Ann Arbor, Michigan 48106

Library of Congress Cataloging in Publication Data

Fishman, Jane Susannah.
 Boerenverdriet—violence between peasants and
soldiers in early modern Netherlands art.

 (Studies in fine arts. Iconography ; no. 5)
 Revision of the author's thesis—University of California,
Berkeley, 1979.
 Bibliography: p.
 Includes index.
 1. Art, Dutch. 2. Art, Flemish. 3. Netherlands—History
—Wars of Independence, 1556-1648—Pictorial works. 4. War
in art. 5. Peasants in art. I. Title. II. Series.
N6935.F5 1982 758'.9949203 81-19655
ISBN 0-8357-1275-3 AACR2

Contents

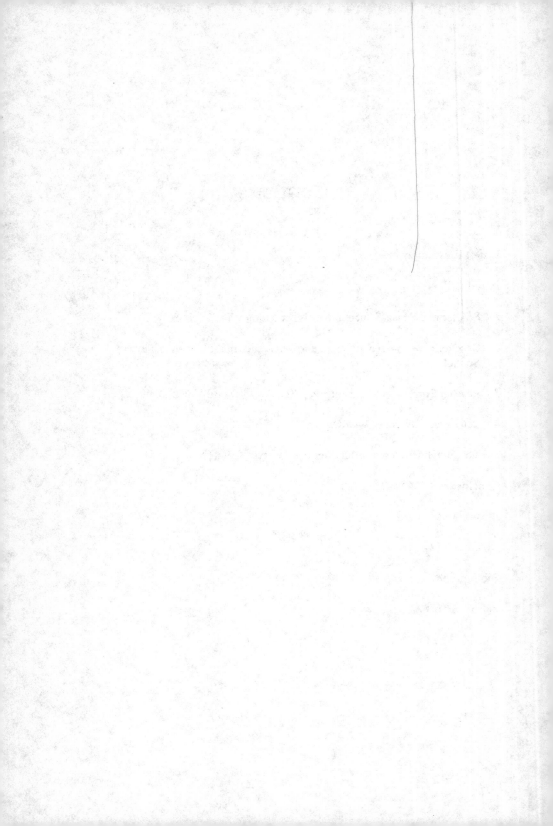

List of Illustrations

Introduction

Picasso's *Guernica*, painted as a response to the destruction in 1937 of a Basque town by German fighter planes, is now perhaps the best-known "protest" painting of the twentieth century. Although the work was occasioned by a specific historical event, it has long been viewed as signifying far more than an outcry against a local tragedy, and since its creation has served to shape the response to later events like Hiroshima and My Lai.[1] In spite of *Guernica*'s deliberately modernist style, critics and art historians have seen the work as continuing an honored tradition in European art.[2] Goya's *Disasters of War* is constantly invoked as an antecedent; anterior to Goya's print series is, again, what has been seen as a tradition of moral outrage extending from Callot's *Misères de la Guerre* back to Bruegel's *Massacre of the Innocents*, and even to the scenes of carnage which are enacted by the Children of Mars in the late medieval Children of the Planets series. This invocation of the past has served to lend legitimacy to Picasso's work. Its location squarely in the Disasters of War tradition appears to redeem it from the charge that Picasso's abstract modernist style has emptied the painting of any protest against war's inhumanity.

Whether or not *Guernica* is an adequate symbol of the horrors of twentieth-century warfare is a question beyond the scope of this study. But the retrospective effect of this famous work—how it conditions a twentieth-century viewer to see and interpret earlier art (as well as *not* see and *mis*interpret) is relevant to the visual traditions I shall examine. There is no question that Picasso's painting does not simply record the events at Guernica (in fact, as has been said, the concrete detail which would enable us to recognize either the town itself or precisely what is going on there are completely absent from the composition) but invokes more abstract and universal themes of human violence and innocent suffering.[3] It is a mistake, however, to assume because of iconographical or thematic similarities artists as different as Goya, Callot or Bruegel shared the same concerns. In fact, recent research has shown that Callot's *Misères*, far from being a global indictment of war itself, is rather a more limited catalog of what was considered unjust or excessive in seventeenth-century war practice.[4]

In the chapters which follow, I shall examine one strand of the European

tradition which *Guernica* supposedly culminates: that of the Boerenverdriet or Peasant Sorrow theme in the art of the sixteenth- and seventeenth-century Netherlands. I hope to show that rather than being undifferentiated outcries against the inhumanity of war, works like Pieter Bruegel's *Massacre of the Innocents*, David Vinckboons' *Boerenverdriet* and *Boerenvreugd* and Rubens' *Carousing Landsknechts* differ fundamentally in their interpretations of violence between peasant and soldier and display a wide range of historically specific meanings and functions.

The Peasant Sorrow theme disrupts certain standard assumptions about the art of the Netherlands. Eugène Fromentin, the nineteenth-century French critic, certainly did not have the peasant/soldier frays of David Vinckboons and Jan Steen in mind when he wrote that

> In thinking of the events contained in the history of the seventeenth century in Holland, the gravity of the military deeds, the energy of this people of soldiers and sailors in their fights, and what they must have suffered—in imagining the spectacle that the country must have offered in those terrible times, one is filled with surprise to see their painting thus indifferent to what was the very life of the people. It was domestic habits, private, rustic or urban that they undertook to paint in spite of everything, through everything, to the exclusion of everything that caused the emotion, anguish, patriotic effort, and grandeur of their country. Not a trouble, not an anxiety existed in this world so strangely sheltered, that this might be taken for the Golden Age of Holland, if history did not inform us to the contrary.[5]

For most Dutch art, Fromentin's generalization is valid enough. Most frequently, we meet the peasant as he is engaged in the yearly round of festivity—at weddings and saints'days—or, in the northern provinces after Calvinism had made these popular celebrations illegitimate, we see peasants drinking, dicing and carousing in taverns and inns. This image of rural life as carefree, uninhibited and bounteous has a long history, going back to literary sources in antiquity. But while the pastoral mode can suggest timelessness, and imply that certain aspects of peasant life are unchanging, the theme of Peasant Sorrow interrupts this idealized picture of rural existence to reveal, albeit in a form mediated by its own conventions, realities of suffering and disruption.

The role of peasants and other civilians in warfare was a vital issue in the seventeenth century. Historians view this period as the setting of military modernization, when, with centralization of state power, warfare and armies reached a scale and technical efficiency never before experienced. The early years of the Netherlands' revolt against Spain, as well as the course of the Thirty Years War in Germany, demonstrated the increased vulnerability of civilians to the new mass warfare, and were understood by contemporary Europeans to represent new and qualitatively different levels of violence and disruption.

Explanations of war and violence were also in flux in the late sixteenth and seventeenth centuries.[6] On the whole, war was accepted as a fixed social institution—only minority groups in the tradition of Christian pacifism maintained that

war could or should be done away with altogether. Out of the older, Christian view which held war to be punishment for sin, cyclically recurring and out of human control, there emerged more secular and psychological forms of explanation. In the opinion of legal writers like Grotius and others, war, when initiated by a legitimate sovereign for good cause, was the continuation of state policy by other means. Other writers, in the humanist tradition of Erasmus and Vives, traced the cause of war and other forms of interpersonal violence back to human nature; psychological theories like those of the "Humors" and "Temperaments" implied that individuals might be predisposed to violence because of imbalances in their physical makeup. Only when conflicts dragged on and on, with increasing desolation, did the older, nonsecular explanations for warfare, with their denial of human agency, reappear.

While the theme of Peasant Sorrow existed in European art before the sixteenth century (in the late medieval Children of the Planet series, for example) the historical developments of the early modern period partly account for, and are ingredients in, the energetic variations on the subject which appear in Flemish and Dutch paintings and prints. In Chapter 1, I discuss the social and military character of the Eighty Years War with particular reference to its effect upon the rural populations of the Spanish Netherlands and the United Provinces. The types of abuses to which the peasantry was subject at different stages of the conflict (forced garrisoning, extortion, physical violence) as well as the range of peasant response to such abuse (flight, resistance, revolt) help to illuminate the theme of Peasant Sorrow as it is treated in the art and popular literature of the period.

In Chapter 2, I compare the cyclical view of violence embodied in the Children of the Planets series to the first large-scale, painted version of the Peasant Sorrow theme in Flemish art: Pieter Bruegel I's *Massacre of the Innocents*. Bruegel, rather than assuming, as the earlier tradition does, that violence against the innocent is astrologically determined, uses the Biblical account of Herod's crime to critique the unjust use of political authority in his own time. Further, the violence perpetrated against the inhabitants of the Flemish village in Bruegel's picture is fundamentally social: we see an entire rural community spread out before us, including the authority who gives the order to kill and the soldiers who carry it out. The Flemish landscapists who follow and in some cases imitate Bruegel (Vrancx, P. Snayers, and others) abandon his totalizing picture of events, with its structured allocation of responsibility, in favor of a more secular, episodic version of the Peasant Sorrow theme.

Chapter 3 investigates David Vinckboons' serial conception of Peasant Sorrow. In four narrative episodes which portray the oppression and revenge of one peasant household, Vinckboons, in contrast to Bruegel, uses a comic, intimate representation of peasant/soldier conflict to focus our attention on human nature, rather than social organization, as the source of violence. Moreover, Vinckboons' version of Peasant Sorrow, while formally independent of the Children of the

Planets series, recalls the earlier tradition in its implication that violence is cyclical, an ever-present human potentiality.

In Chapter 4, I discuss Rubens' *Carousing Landsknechts*, a variation on Peasant Sorrow which unlike the works of Bruegel and Vinckboons dates from the later years of the Netherlands' conflict with Spain. While Bruegel uses the Boerenverdriet to unmask the injustice of a tyrannical ruler, and Vinckboons focuses on violence as one of the fundamental and endemic human passions, Rubens embodies in his marauding mercenaries all that is most illegitimate and unpredictable in warfare, creating a counterpoint to his celebration of martial heroism in his numerous portrayals of Hapsburg military feats.

Chapter 5 deals with the survival of the Peasant Sorrow theme after the Treaty of Munster. Vinckboons' comic, intimate portrayal of the theme is transformed in the works of some Dutch genre painters into a glamorized vision of banditry. Only Jan Steen's *Sauvegarde van den Duyvel* retains the energy and popular imagery of Vinckboons' works. Elsewhere, in the art of Esaias van de Velde, J. C. Droochsloot, Philips Wouwerman and others, the Boerenverdriet theme continues in the tradition of the Flemish landscape school. These paintings are local and partisan, many of them portraying conflict between Catholic peasants and Protestant troops. Other works by Wouwerman are similar to decorations in the illustrated military handbooks of the seventeenth century: Peasant Sorrow becomes a colorful anecdote from an older, more disorderly period of warfare which enlivens the instruction intended for increasingly regimented and disciplined troops.

1

Soldier and Peasant During the Eighty Years War

Although the devastation of rural Flanders and Brabant during the early years of the Eighty Years War is well-known, less has been said about parallel experiences in the northern provinces during the same time period. A long tradition of historiography has represented the United Provinces as one of the few areas of early modern Europe which was not severely disrupted by war.[1] The primarily urban triumphs of Holland's "Golden Age"—the flourishing of Dutch commerce and culture in the seventeenth century—are often partly ascribed to this relative immunity from war-related disasters. It is true that the Twelve Years Truce (1609–1621) meant the end of land warfare in the provinces of Holland and Zeeland. After hostilities resumed in 1621, fighting was confined to incidents along the border between north and south and to seasonal campaigns in the outlying provinces. The two wars fought with England in the second half of the century were sea conflicts, leaving the civilian population untouched. When France invaded the United Provinces in 1672, she entered a country totally unprepared for war, which surrendered to her armies with a rapidity that seems astounding when compared to the fierce local resistance of Haarlem, Leyden and Alkmaar in the early years of the conflict with Spain.

The early years of the Netherlands' revolt (1567–1609) are generally agreed to be qualitatively different from the half-century of warfare which followed. Insofar as the Peasant Sorrow theme—although mediated through artistic convention—answers to the lived experience of warfare, it is to this early time period that we must look. In the last decades of the sixteenth century and opening years of the seventeenth, the effects of combat upon the rural populations of north and south were quite similar. In this chapter, we shall see how changing methods of warfare meant the disruption of rural life on a wide scale, and, at the same time, brought the role and treatment of civilians during wartime increasingly to the attention of military and legal thinkers. We shall also examine how the experiences of the northern and southern provinces parted ways after the Twelve Years Truce, and what the cultural consequences of this split may have been with particular regard to the theme of Peasant Sorrow.

Historians view "modern war," characterized by mass armies, strict discipline, state control and the submergence of individual initiative, as a product of the sixteenth century.[2] In the Netherlands' conflict with Spain, this modern, rationalized style of warfare gradually emerged from a less organized, more erratic and spontaneous "guerilla" war.[3] The watershed which separates the two styles of combat is, roughly, the period of the Twelve Years Truce.

In both phases of war, Spain and the United Provinces followed standard practice by employing professional hireling soldiers.[4] What was new, however, about both the Army of Flanders (the Spanish force) and the States' Army was their sheer size. The phenomenal increase in army size which took place in the sixteenth century inevitably affected civilian populations. Because there was no systematic provisioning system during the early years of the Revolt, troops were lodged with civilian residents of both town and country.[5] Further, in addition to regular troops, before 1600 virtually no area of the Netherlands was free from *vrijbuiters*, raiders who seemed to be under the control of no government whatsoever. These marauders, sometimes commanded by leaders who seemed to be waging private wars of their own, roamed the countryside in small bands, burning and looting, killing, and amassing prisoners and booty for ransom.[6]

After 1600, the nature of the war changed. Spain was diverted from its conflict with the rebel provinces by other military adventures. The United Provinces, with Prince Maurits as an exceptionally able commander, succeeded in routing all the Spanish outposts north of the major rivers and consolidated this victory by erecting its own chain of defensive fortification. With this stabilization of the frontier, the amount of irregular, spontaneous action was greatly reduced. Ransoming of prisoners became regulated so that it was more difficult for individuals to profit by it; plundering raids across the borders on the initiative of individual garrisons gave way to a formal system of protection payments and *sauvegardes*.[7]

The second half of the Eighty Years War was characterized by an upsurge in confrontations involving the main armies of the war parties. While this increase in formal confrontation continued to require large numbers of troops, the size of individual companies decreased and they became more disciplined and manageable. The United Provinces took the lead in developing the new, efficient style of warfare, with Maurits' reform of the military code, Simon Stevin's scientific program of siegeworks and Johan of Nassau's *Exercise of Armes*, a musketry practice manual illustrated by Jacob de Gheyn.[8] With the expense entailed by the muster, maintenance and drill of large armies and the building of siegeworks, warfare in the latter part of the Netherlands' Revolt became largely a matter of economics. To put it simply, the party with the most cash won the battle.

Where did the peasantry of the north and south Netherlands stand in this conflict between Europe's greatest imperial power and its upstart provinces? One historian of the Eighty Years War has aptly characterized the rural populace as a third party, buffeted by both States' and Spanish troops alike:

Om den Tachtigjarige Oorlog op de juiste wijze to beoordelen moeten wij eigenlijk drie partijen onderscheiden; de beide oorlog voerende en het platteland. De eerste hadden in elk geval het voordeel, dat de slagen slechts van een kant kwamen; de derde was het hoofd van Jut, dat er van beide zijden van langs kreeg.[9]

[In order to accurately comprehend the Eighty Years War we must actually differentiate between three parties: the two war parties and the countryside. The first two had at least the advantage that the blows came only from one side; the strength of the third was tried by blows coming from both sides at once.]

The peasantry of the Netherlands was not alienated from the interests of the two central antagonists for military reasons alone, however. Ideological factors were also important. Most of the rural population of both north and south was staunchly Catholic, so that resisting religious repression, the strongest motive for revolt on the part of Protestant artisans and other city dwellers, was not in its interest.[10] Those peasants who were Catholic but not sympathetic to Spain were in an even more conflicted situation, particularly after the death of William of Orange ended the hope of Calvinist/Catholic unity.

The suffering of the countryside followed in part from the nature of war as it was fought in the late sixteenth and seventeenth centuries. Siege warfare automatically left unfortified villages and farms more vulnerable. Lack of a rationalized system of supply meant that the soldiers had, at least some of the time, to live off the peasants—"Teeren op den Boer" is a phrase repeated in many popular songs of the period.[11] Finally, the fact that most soldiers were foreign mercenaries meant that both friendly and enemy troops alike could act like invaders, with little regard for the inhabitants of the land they presumably were engaged to protect.

The experience of the peasantry during the years before the Twelve Years Truce differs from that which followed the resumption of hostilities in 1621. During the early years of the war the countryfolk were more vulnerable to certain kinds of abuses, notably billeting troops without payment, mistreatment by mutineers and *vrijbuiters* and forced labor. In the States' army before Maurits' reforms, the practice of extorting food and lodging from the peasantry of friendly and contested areas was frowned upon but so widespread that officers, as well as regular soldiers and mutineers, were guilty of it. A *plakkat* issued several times during the 1580s by the States General reads

Alsoo aen ons dagelijcks groote klachten komen . . . dat de Krijghsluyden soo te voet als te paard in haere Majesteyts, onsen, ende's Landts dienst ends besoldinge wesende, vergetende alle discipline Militaire, loopen herwaerts ende derwaerts achter hande, levende ende teerende sonder eenige discretie, ja bedwingen, rooven, stelen. . . . Ende alsoo men dagelijcks verneem dat Gouverneurs, Colonellen en Capiteynen, vergetende alle behoorlijcke Krijghsdiscipline, sich gelusten uyt hare eygen autoriteyt, de Dorpen ande Huysluyden te dreygen ende uytterlijck te bedwingen met afteeringe, beschadinge in haere goederen, ende met tormenten aen haer lyven. . . . [12]

[Since we daily receive complaints . . . that both cavalry and foot soldiers in his Excellency's, ours, and the country's service, forgetting all military discipline, rove here and there, exploiting and plundering without restraint, even robbing and stealing. . . . And as we daily understand that governors, colonels and captains, forgetting all proper discipline, on their own initiative threaten the villages and countryfolk with extortion, damage their goods, and torment their persons. . . .]

Nor was lodging supplied by the state in the Army of Flanders. Forced billeting of soldiers upon country people and other civilians continued up until 1600, when the Archduke Albert, responding to complaints, commuted the requirement to lodge soldiers to a cash payment. Even when some barracks were finally built, they were inadequate to the demand, and troops continued to be quartered upon the local people.[13]

Although lodging soldiers was only one (and not the worst) of the injuries which war inflicted upon the rural populace, it is a theme which is treated more frequently than any other in both the contemporary histories and popular song and literature of the period. Van Reyd, in his *Historie der Nederlandscher Oorlogen*, relates how the peasants of Overijssel were abused by the States' troops:

Die Soldaten krygen weynich gheldts en leefden op den armen huysman. Niet te vreden wesende met ghemene cost ende dranck maer dwinghende den selven om uytte naeste Stadt te halen wijn, dicke bieren ende anderes wat op Dorpen niet te krygen was, ende daer en boven noch gheldt afpersende, Koeyen ende Peerden wechdryvende. . . .[14]

[The troops received little wages and lived on the poor peasants. Unsatisfied with ordinary food and drink, they forced their hosts to go to the nearest town for wine, heavy beer and whatever else was unobtainable in the village, and furthermore they extorted money, and drove away the peasants' livestock. . . .

The popular ballads of both north and south also play off the greed of the unwelcome military guests against the simpler habits of the peasants, who are content with coarse bread and beer:

Boer, loopt om wijn of men slaet u met vuysten
Maer het ware van noode dat zy aten,
Boven maten, leckerlick in alle saysoenen,
Wittebroot, weervleesch, niet om verdelicaten
Maer baroenen, die noch wel moght zijn Hooghe verheven
Om vechten voor dlandt en durft ghy niet vercoenen.[15]

[Peasant, fetch wine or we beat you. / Perhaps it's from need that the soldiers eat / so much and so richly. Foods out of season, / white bread, meats, the finest sides of beef, / and who dares to deny anything / to these noble protectors of the land?]

Mutiny, at least during the early years of the war, was at least as disruptive of peasant life as the garrisoning of regular soldiers. Between 1572 and 1607 there were over forty-five mutinies in the Army of Flanders, some lasting over a year.[16]

The mutineers, whose wages were sometimes as much as twelve years in arrears, were genuinely desperate men. Their standard procedure was to choose a leader, attempt to capture a fortified town to serve as a base and, if this succeeded, to formulate their grievances and find ways of securing an income. Most historians have focused on the effect of the largest mutinies upon the cities (for example, the "Spanish Fury" at Antwerp in 1585).[17] However, the villages and farms surrounding a town captured by mutineers usually suffered most, since until settlement of the strike and payment of wage arrears, the mutineers were forced to survive by taking supplies from the rural population. Though in this sense they may not have been perceived as any different from regular soldiers, in fact their outlaw status made them more aggressive and crueller in their extortions. Furthermore, some mutineers were among Spain's most experienced veterans, so that their fighting skills were formidable. Attempts at local resistance were not often effective, although there was some effort to muster and train makeshift militias.[18]

Mutineers from the States' army never plagued the countryside to the extent that those from the Spanish forces did. However, Prince Maurits' reform of the military code in 1590 was in large part a response to the disorders of the eighties, among them mutiny.[19] Under the foreign governor-generalship of Leicester, troops mutinied in the provinces of Overijssel and Holland to the extent that the government empowered the local peasants to defend themselves against the striking soldiers.[20] After 1590, in spite of Maurits' efforts to end mutiny by initiating stricter sanctions against it and effecting a more rational pay system, unrest continued. In 1593 unpaid States' troops in the eastern provinces had to survive by plundering raids in the countryside and even into neutral German territories.[21] In 1599, new German mercenaries boycotted the army of the United Provinces because of irregular payment practices.[22] The situation continued to worsen before 1609 as the size of the army grew. The cavalry of the States' force was especially disorderly because of irregular payment. In 1585, it was totally dependent on forced contributions from the peasantry, and this continued to be the case up to the time of the Truce.[23]

In their methods of operation, *vrijbuiters* had much in common with mutineers—they too used force and intimidation to secure supplies and money from the rural population. However, *vrijbuiters* were mainly independent adventurers bent on using the war for their personal gain, rather than troops withholding their labor power for better pay and work conditions. Occasionally *vrijbuiters'* numbers would be strengthened by deserters or mutineers.[24] A special characteristic of *vrijbuiterij* is that it originated behind the States' lines and was carried out mainly in the southern provinces—only this favoritism toward the rebel provinces distinguished it from ordinary banditry.[25]

Villagers sometimes organized local militias to deal with the extortions of *vrijbuiters* and mutineers but often would come to some agreement with them rather than fight. Like regular soldiers and mutineers, a central concern of the *vrijbuiter* was extortion of money from the peasantry in the form of contributions

and ransoms. A letter from a peasant who was captured by *vrijbuiters* recounts how he was held for twenty pounds of grain and one guilder per day ransom—his wife had to sell their horses and wagon to pay.[26] Occasionally villages would pay protection money to States' troops against *vrijbuiters*, which makes it clear the *vrijbuiters* were not part of the regular army. In other cases there were apparent instances of collaboration between peasants and raiders, but whether these occurred because of active sympathy or out of fear of reprisal is unknown. With the establishment of a definite frontier in the late 1590s, *vrijbuiterij* ceased to plague the peasantry of the southern provinces.

Under the older, less organized style of warfare, peasants were sometimes pressed into service as diggers of siegeworks. A sixteenth-century *rederijker* portrays such an incident in his dramatization of the siege of Leyden. When two peasants who have worked for the Spanish timidly ask for payment, one of the soldiers answers:

> Wat soud' ghy hebben doch? Neemt eenen voet int gat, ghy schelm, dorst ghy een mond noch kicken oft noch roeren.[27]

> [What would you have then? Shut up, you rascal, and let's have no more of your running off at the mouth.]

And a peasant lament from the *Geuzenliedboek* of the same period runs:

> Wij moeten oock arbeyen
> Aen schanssen ende Wal
> Het sij in wat contreyen
> Men roept ons in ghetal:
> Tis hier een twintich dertich man,
> Wij sijnder al wat qualick an.[28]

> [We must also work / on fort and wall, / be it where it may, / we are always brought into call: / It's "Here we need twenty, thirty men"— / we've already had enough of them.]

Until Maurits' reforms of the nineties, the States' troops also used peasant labor for siegeworks. Later, Maurits and Simon Stevin developed more scientific siegeworks which required professionals.[29]

Forced piercing of dykes to provide defensive inundation was another way in which peasant labor was exploited during the early years of the conflict with Spain. Van Reyd, for example, relates how the peasants of Friesland were forced to flood the best part of their lands during Taxis' invasion of the province in 1585.[30] There was no recompense for their labor or for the damaged land, except in the form of a tax credit for the acreage during the time it was rendered useless. It is not surprising that occasionally peasants would sabotage inundation projects, secretly tapping off the water at night, or bribing the soldiers sent to execute the mission with food, beer or money.[31]

Around the turn of the century, the high command of both the States' army and the army of Flanders attempted to institute reforms which would protect civilian populations, and particularly the rural populace of friendly and contested areas, from the kinds of abuses which characterized the early part of the war. Reasoning on this issue was pragmatic and political rather than humanitarian: clearly, a peasantry abused by supposedly friendly troops could transfer its loyalties to the other war party; making enemies of the rural population in disputed territory might have the same effect.

The efficacy of the reforms, which to some degree may have normalized relations between military and countryfolk, is difficult to assess. Sometimes old abuses were simply given new names, and proceeded just as they had done before. To take an example from the Spanish side: during the early years of the war there were no regular provincial taxes in comparison with which the amount of contributions to the military could be set, and at first the troops were allowed to raise as much as they could, using threats or main force. Later, this "system" was replaced by a quota to be levied from each rural community, in return for which the populace was guaranteed exemption from further payment. But around 1600, it was clear that the newer system was in fact the old method of extortion made legal. A special investigator sent to report on it wrote:

> I was unable to find anyone who could tell me for certain the method or manner by which the officer raised the contributions, but it is generally believed that as Superintendant of the said contributions he fixes their amount on his own, according to his pleasure, in every village.[32]

Maurits' military code also attempted to replace *vrijbuiterij*, extortion, spoilage of property or livestock and personal injury with a rational system of monetary exchange regulated by the high command. Peasants in the seven provinces and in areas controlled by the States were to be promptly reimbursed for any goods or services, under penalty of punishment:

> Niemand en sal . . . den inwoonderen der geunieerde provincien, heur toestanders of bondgenoten verdrukken of beroven, of eenige eetwaren, geld of anderszins afpersen, sonder de eetbare waren of andere behoorlijk te betalen, noch ook ter nederwerpen of bederven eenige watermolens of waterwerken, of dezelve of andere huizen . . . alles op lifjstraffe.[33]

> [No one shall . . . force the inhabitants of the United Provinces or any of her allies to give up money or foodstuffs without appropriate recompense, nor should any mills, waterworks or houses be destroyed . . . under penalty of corporal punishment.]

The basic forms of the system of protection monies and certificates of safeguard employed by both Spain and the States were *brandschat* and *sauvegarde*.

Brandschat literally means a fire-tax. It was paid by an individual or community to enemy troops for renunciation of burning and plunder of property. The property thus protected automatically acquired a safeguard or *sauvegarde*. De-

struction of an area protected by *sauvegarde* was strictly forbidden; protection was enforced by stationing soldiers near the appropriate area or by making out a certificate which could be shown when persons or property were endangered. Such a system was open to a particular form of abuse—occasionally a very expensive *brandschat/sauvegarde* was forced upon a community which would have preferred to take its chances. This amounted to a refined form of plunder.[34]

Since *brandschat* could be both an important source of income and a form of collaboration with the enemy, it was in the interest of each of the warring parties to hinder payment to the other side. This could be accomplished either through offering protection against enemy attack, or by reprisal against villages known to have paid contributions. In many cases, however, it is significant that communities preferred to continue to contribute rather than have their own troops come to their aid.[35] To sum up, *brandschat*, when it proceeded in an orderly fashion, was not the worst curse of contemporary warfare. However, the incentives to use the system for private gain remained strong as long as the payment of military wages continued to be inefficient.

Brandschat, though important, was not the only systematic means used to extort money from peasants and other civilians in seventeenth-century warfare. Capture of individuals for ransom was also widely practiced, not only by *vrijbuiters*, but by the regular armies.[36] It is among the war ills portrayed by David Rijckaert the Younger in his Antwerp and Vienna versions of the Boerenverdriet theme (Figs. 25–27). The contemporary historians of the Eighty Years War also note that farm animals were held for ransom, sometimes repeatedly:

> Die Soldaten leefden op den armen huysman . . . gheldt afpersende Koeyen en Peerden Wechdryvende/ die eenen Huysman vier of vijf mael van verscheyde Soldaten rantzoenere moeste.[37]

> [The Soldiers lived on the poor peasants . . . extorting money, driving away livestock that certain peasants had to ransom back four and five times over.]

As early as 1586, attempts were made to curtail free-lance capture and ransom. In a *plakkat* from that year, individuals are strictly forbidden to perform such acts on their own initiative, although ransom is not outlawed *per se*. Maurits' military code does not distinguish between civilian and military prisoners; it simply states that no prisoner may be executed, ransomed or released without word from the central authority.[38]

As we have seen, in spite of the apparent advance on free-lance raids and plunder which *brandschat*, *sauvegarde* and ransom represent, the rural population continued to be vulnerable to abuse under the new style of warfare. In addition to the examples cited above, a string of legal ordinances issued by the States General of the United Provinces after 1590 and resuming after the end of the Twelve Years Truce suggest that disorder and violence between peasant and soldier continued to trouble the States' army, particularly in the Generality lands, in the eastern prov-

inces and in neutral principalities.[39] In fact, some *plakkaten* refer to disorders occurring after the Treaty of Munster:

> Niet tegenstande de jegenwoordige Vrede, die een yegelijck volckomen behoort te genieten, ende dienvolgens gherust ten plattenlande onder onsen Staetghehoorende, ende daerbij ende omtrent gelegen, te blijven sitten en ongemolesteerd te wonen, de Ingesetenen in de voorsz plattelanden nochtans dagelijcks noch met verscheyden onbehoorlijcken exactien, uyterringen ende foulen worden gequelt.[40]

> [In spite of the recently concluded Peace, which guarantees the right of our countryfolk and their neighbors to be left unmolested, the inhabitants of the aforementioned countryside are daily plagued with unlawful extortion and plunder.]

In this case, the soldiers were probably discharged men with some or all of their pay in arrears, who in fact had no choice but to live off the land as they made their way homewards.[41]

Certainly, the publication of the *plakkaten* demonstrates the States General's concern to enforce the principles of Maurits' reformed military code. But in fact, as the repetition of these ordinances emphasizes, it was long before increased state control actually had an effect upon peasant/soldier relations. The size of armies and the enormous problems of supply which they posed continued to mitigate strongly against a style of warfare which effectively protected the rights of civilians.

Failing the consistent intervention of the state, then, what were the possible responses of the rural population of the Netherlands to the wartime ills discussed above? Broadly, the peasants had three options: flight, payment of contribution, or resistance.

Flight to the nearest fortified city or town was a frequent choice of the countryfolk. Here, those among them unlucky enough to have lost all their means of livelihood rapidly joined the ranks of the urban poor.[42] Occasionally, peasants would leave their farms and flee to the woods for temporary shelter—to celebrate Frederick Henry's successful siege of Grol, Vondel portrayed the joyful return of the local peasants from their woodland hiding places:

> Keer Melcker, dien de schrick gejaeght heeft in de bossen Besoeck uwe oude Buurt: vermaet met vet uwe ossen. . . . [43]

> [Return, Herdsman whom fear chased into the wilderness, to your own neighborhood; return to fatten your herd. . . .]

Brandschat or contribution payment, if effectively transacted, was another way for the peasantry to avoid violent encounters with the military. But a number of factors could inhibit payment. In some cases the sums required were simply too great—this was especially true in the border areas subject to repeated waves of troops. There were also legal attempts to prohibit contribution to the enemy. Occa-

sionally, discoveries of *brandschat* payment were punished by death or torture; in one case, the Duke of Alva had all the elders of a village executed.[44] Payment of contribution could also serve as an excuse for "friendly" troops to harass the peasantry, as a late sixteenth-century ballad proclaims:

> Wacht liever eenen boer, wilt dien bewieghen
> Zeght dat hij den vijant heeft gesustineert,
> Met goet en ghelt, al zoudy daeromme lieghen,
> Hangt hem met de duymen dat hij wert ghepersequeert. . . . [45]

[Take a peasant—if you want him to behave, / say that he has aided the enemy / with goods and money, and if he denies it, / hang him up by the thumbs until he confesses. . . .]

Payment of *brandschat*, then, while it might buy protection from one of the war parties, often made a community vulnerable to reprisal from the other. In such a desperate situation, a peasant village might resort to resistance. One form of resistance was purely defensive: peasants would build siegeworks to defend a village or a church used as a temporary shelter, or dig trenches along roads where *vrijbuiters* or mutineers molested travelers.[46] A more active form of resistance was the peasant militia. A number of "Akkermans" or "Huisliedengilde" existed in small villages, forming a rural counterpart to the shooting companies in the larger cities of the Netherlands. The charter of one of these rural shooting guilds, decorated with a motif of a peasant at work, defines its function as "Die moetwillighen inde ongehoorsamen te straffen ende bruecken." During mutinies or plundering raids, these local militias would be mobilized.[47] Sometimes, however, peasants waited until a mutiny was over to take revenge. The strike leaders, fearing official vengeance, would frequently head homeward as soon as they had collected their arrears. Bands of peasants would waylay and attack them, pocketing their pay in the process.[48] In at least one instance, the government itself urged peasants to take up arms in an organized fashion—against its own troops! The *plakkat*, from 1638, suggests

> Dat de Ingesetenen . . . alle ende iedere Soldaten van deser zijde hun dragende onbehoorlijk tegens het ordre van het Landt, ende bysondere sulcke Soldaten, de welcke van het eene Dorp tot het andre loopen grasseren . . . met gewapener hand mogen behulpen om alsucke aen te grijpen.[49]

[That the inhabitants . . . take up arms in order to help apprehend each and every soldier in the States' service who conducts himself in an unlawful manner . . . such as those who go from village to village pillaging.]

During the course of the Eighty Years War there was one large-scale, organized peasant revolt, motivated in part by abuses suffered at the hands of both war parties. The revolt took place in Overijssel in 1580, and was directed against the States' troops. Several thousand strong, under a banner with a broken eggshell and

a sword, the peasants succeeded in driving the States' cavalry to the borders of the province. (Their slogan was based on a proverb, "Beter een half ei dan een lege dop"—hence the emblem on their flag).[50] The regular troops soon returned, however, and succeeded in crushing the peasants.

The Overijssel revolt received an unsympathetic press. Bor, in his *Neder-landsche Oorlogen*, believed the uprising was the result of conspiracy between a Spanish-sympathizing officer and discontented peasants. He approved the States' massacre of six or seven hundred peasants, saying "Dit maektense zeer bevreest/ soo datse niet meer soo stout waren als te voren."[51] Van Reyd calls the peasants "arme veleyde Boeren," but says nothing explicitly condoning their revolt.[52] P. C. Hooft, basing his 1642 history on the earlier accounts, produced an even more aristocratic view of the uprising. Although his version follows hard on an admission that the countryside of Overijssel had long suffered from unpaid troops, he sees the peasants' action as a "verloor van geduld" and condemns it as "erg quaad." Hooft's sympathy for the peasant is evoked only by incidents of individual bravery, as, for example, his favorable account of a wealthy farmer's revenge on a soldier for the rape of the farmer's daughter.[53]

Bor, van Reyd and Hooft all display an attitude toward organized peasant revolt that is not so different from Martin Luther's during the German peasant war over half a century earlier.[54] Like Luther, they seem to believe that the disobedient peasant "mob" deserves whatever punishment it gets. Such a view may help to explain why, when peasant resistance to oppression by soldiers is portrayed in art and literature, it almost never deals with the issue of mass, armed resistance. When we see groups of peasants driving soldiers from their villages (as in the paintings of Vrancx and Snayers), usually the only weapons they use are flails, rakes, pitchforks or, if they are women, kitchen tools. Yet the peasant militias were *shooting* companies, equipped with bows and firearms.

Another way in which the issue of mass resistance could be evaded was to focus on individual acts of retaliation. In David Vinckboons' *Boerenverdriet* series, members of a peasant family are shown driving armed soldiers out of their house—again with farm implements—a scene which, in its quarrelsome intimacy, has far more the character of a spontaneous outburst of rage than a planned attack. The same is true of Constantijn Huygens' literary portrait of the Dutch peasant. He is portrayed as long-suffering, willing to put up with the abusive soldiers until he suddenly erupts into violence:

> Elck vlegel wordt een Roer, en elcke pols een Pijck
> De wraeck sit in sijn hert, de Wanhoop in sijn handen
> En elck' in ijder oogh; hij wenschten in sijn tanden
> Noch Room, noch Schapenkaes voor menschen vleesch en bloed.[55]

> [Each flail becomes a musket, and each pole a pike.
> Wrath sits in his heart, and desperation in his hands,

And each in either eye; he wishes in his mouth
Not cream nor cheese but human flesh and blood.]

The peasant is depicted with an epic amount of courage, fighting off armed men with farm tools. But this image overlooks the sometimes unacceptable ways in which resistance occasionally did occur. In reality, flails and poles are not adequate substitutes for guns and pikes, though it may have been a convention less threatening to the social order to depict them as such.

Up to this point, we have examined generally the types of abuses to which the peasantry was subject under the two styles of warfare, as well as the possible range of peasant response. While it is true that until the turn of the century the experience of the peasantry of both the northern and southern provinces was similar in kind, it differed in scale. In the following section, we will compare the effect of warfare in the different provinces of both north and south, before and after the Twelve Years Truce.

The Walloon or French-speaking provinces of the Spanish Netherlands were never major areas of military operations during the war and thus their agriculture was spared the misery endured by Brabant and Flanders. The countryside of these two provinces was reduced to a kind of wasteland by the time of the Truce. The historical sources of the period present a uniform catalog of rural devastation: depopulation of farms and villages, ruins and burned dwellings, arable land overgrown and infested with wild animals, roads unsafe to travel because of bandits and *vrijbuiters*.[56] The troubles of the Brabant and Flemish peasants really began in the 1570s. Troops mutinied on a large scale, and even soldiers who had been paid off roved the countryside terrorizing the local population. Flight into the cities was not always the best solution for the peasantry: towns already overcrowded with refugees became vulnerable to famine and disease. Burial lists from some churches in the cities of Brabant and Flanders for the late sixteenth century are filled with the names of displaced countryfolk.[57]

The 1580s marked Spain's attempt to regain Brabant. This major war effort, coupled with mutinying English soldiers in the States' service, totally devastated a farming area in Brabant known as the Kempen. If a ballad from the period accurately reflects the desperation of the peasantry, the scale and duration of the devastation were experienced as something qualitatively different from what had gone before:

Ons ouders weerden eer in hares weeldes dagen,
Ook somtijds gekastijd met's oorlogs strenge roên,
Maar hebben nooit zoo lang's krijgs overlast gedragen
Nooit zooveel kwaads geleên, als wij, och arme, doen.[58]

[Our fathers were in their time / Also chastized by war's strong rod, / But never endured its punishment for so long a time, / Nor suffered so much ill as we unfortunates do.]

Nor were things any better in Flanders during the eighties. The rural weaving industry collapsed, and in the area around Ghent only a tenth of the arable land was under cultivation. In the region of Courtrai, only one percent of the rural population remained on the land at the peak of the crisis.[59] The fall of Antwerp to the Spanish in 1585 did not by any means lead to stabilization. A poor harvest in the summer of that year, coupled with an embargo on Baltic grain, led to another crisis. A number of peasants were reduced to extreme poverty, "having no provision to make money, many lived on herbs and roots, begging everywhere."[60]

In sum, rural Flanders and Brabant presented a sad spectacle in the years before the Truce. The country population had been drastically reduced—by flight to the cities, to the United Provinces, by death from disease or at the hands of both war parties. In most of the villages of Brabant, the population was only twenty-five to fifty percent of what it had been before 1575, and in Flanders and Hainaut the decline was about the same.[61] When in 1597 the central government at Brussels asked Brabant for a large tax increase for war purposes, the provincial authorities replied that the request was hopeless: the province lay in ruin, "een groot deel van den lande geheel ende vogelweyde liggende ende dandere dwelck noch eenichsints soude moghen bewoont ende gelabeurt worden, wordt ongenaedelyck belast."[62]

Before the Twelve Years Truce, the worst war injuries in the north, as far as the peasantry is concerned, were suffered by the provinces of Gelderland, Utrecht, Friesland and Overijssel.[63] The peasants of Holland and Zeeland, however, were by no means immune to war-related disasters. During the sieges of Haarlem, Leyden and Alkmaar they got the worst of things from both sides. When Leyden was besieged in 1574, the countryside was plundered by the enemy while at the same time it was expected to contribute to the States' troops. The peasants were also at the mercy of inundations, which were engineered to defend the cities at the expense of the rural population. Although the States of Holland agreed to recompense the peasants for the spoilage of their land caused by flooding, this "insurance" amounted to a tax credit which would only benefit the farmers once they were back on their land. When farmers resisted inundation either by sabotage or refusal to leave their land, they were threatened by edicts which declared that all their livestock and possessions would be confiscated as lawful booty.[64]

The countryside of Holland also endured abuse from supposedly friendly troops. A special instance of this was the tyranny of the States' officer Diederich Sonoy over the Catholic population of North Holland. In 1581 the practice of Catholicism was forbidden by the States General, and when peasants continued to practice the "old religion" Sonoy and his men were sent to put an end to it. A number of peasants were captured, tortured to produce the names of other Catholics and only released upon payment of large ransoms. Later Sonoy's troops mutinied and threatened the entire countryside of North Holland with ruin.[65] When the provincial States of Holland made a population survey for tax purposes in the

1590s, it estimated that only a third of the peasants of Holland and Zeeland remained on their land.[66]

Overijssel and Utrecht suffered greatly from mutinying troops and peasant revolt during the 1570s and 1580s as did Gelderland and Friesland. These provinces, poorer to begin with, deeply resented the fact that after their countryside had been despoiled they were still expected to contribute economically to the war effort. By 1601, parts of Overijssel were

> Ganz desert, sonder huis; land desert, mith heyde bewassen; mith busschen bewassen; noch omtrent drie mudde Lantz mith heyde bewassen ende in 20 Jaer niet geseith.[67]

> [Completely deserted, without dwellings; fields empty, overgrown with heather and shrubs; in some areas three-quarters of the land overgrown and unsown for more than twenty years.]

Twenthe was one of the areas of Overijssel which was most ravaged by crossing troops. Records surviving from the period after 1601 frequently mention that farm land in that area is being used for pasture or overrun with thistles and undergrowth and infested with wild animals—a picture very similar to that of Flanders and Brabant during the same years.

Many of the troubles of the northern provinces during the early years of the war were caused by the States' own troops. But Spanish troops played a role too. The excesses committed against the countryfolk by Taxis and Verdugo during their attack on Friesland in 1586 are related by Bor, who also recounts that the peasants organized to fight off the Spanish troops with clubs and farm tools, although they were badly beaten:

> Daer werde aen bijden zijden seer vromelijck gevochten, ende soo de Spaensche soo veele ruyteren niet by haer en hadden gehadt, souden also licht mette buyt niet wegh ghecomen hebben; sy deden een jammerlijcken joort, bysonder onder de Boeren.[68]

> [Both sides fought bravely, and if the Spanish had not been so well supplied with cavalry they would not have gotten off so easily; as it was, they committed a piteous slaughter, especially among the peasants.]

Episodes like this were considered important enough to be included in the popular histories of the United Provinces, when the sober narratives of Bor, Reyd and van Meteren were mined by the writers of the "Spiegels." These pamphlets, used to instruct Dutch schoolchildren, lack Bor's objectivity (all of them omit atrocities committed by the States' own troops) but portray with indignation the suffering of northern villages at the hands of the Spanish. While the Spiegels are far from being responsible histories, the incidents which they relate provide evidence about the role which the war experience of the countryside played in the popular imagination.[69]

The Twelve Years Truce provided a breathing space for the peasants of Flan-

ders and Brabant. Much of the popular literature written to commemorate the negotiation of the Truce celebrates the return to normality of peasant life, and in fact there was a good measure of recovery during these years. However, this first phase of readjustment ended suddenly with the flaring up of the war in the beginning of the 1620s, and difficult years followed for the peasantry of these two southern provinces.

Peace was definitively terminated with the United Provinces' 1622 plundering expedition through Brabant, initiated as revenge for unpaid contributions. The campaign against the peasantry was so effective that it earned the Dutch Stadhouder a new title: throughout Brabant, Frederick Henry became known as the "Boerenplager." He was accused of deliberately warring against civilians:

> Hij stelt het al in roeren/hij draecht hem wonder fijn/Hij oorlogt teghen Boeren/daer geen Soldaten en zijn.[70]

> [He arms himself with muskets/He carries them so tall/He wars against the peasants/who aren't soldiers at all.]

Frederick Henry was not, however, directly responsible for the damage to the countryside which resulted from his 1629 siege of Den Bosch. Holland's reluctance to finance his campaign left him with six thousand unpaid troops who finally were dispatched to winter in the neutral territories of Cleef, Mach and Berg, leaving a trail of brigandage and destruction as they made their way through the south.[71]

The 1630s marked a major escalation of the United Provinces' offensive against the Spanish Netherlands. With France and a group of rebellious southern nobles, the north planned to wrest the southern provinces from Spain and turn them into a jointly administered protectorate. The campaign was successful up to a point, then the States' and French troops mutinied and retired through Brabant in total disorder, plundering as they went. The peasants, however, complained equally of the Hapsburg forces—as so often during the Eighty Years War, the countryfolk appear as a third party, assaulted on all sides by the war effort:

> Passeren daer Spanieards met groote hoopen
> Witte brodt moeten wy terstont gaen koopen. . . .
> Passeren daer het Staeten volck 't is al eene
> Van rooven en Stelen/ sy maeckent ghemeene. . . .[72]

> [When the Spaniards troop by in great bands, / We must go buy white bread. . . . With the States' troops it's just the same, / They rob and steal / just like the Spaniards. . . .]

In spite of the indecisive campaigns of the thirties, the French and the United Provinces continued a joint attack on the south during the forties. This decade saw gains for the north and its ally and increasing exhaustion of the southern military

forces. The situation in the countryside was aggravated by the troops of the Spanish ally, Charles IV, Duke of Lorraine, who pillaged hitherto unmolested provinces.[73]

The overall picture of the rural Spanish Netherlands after 1621, then, is one of patchy recovery, with numerous interruptions and setbacks. Although the military accomplishments of the United Provinces during the 1640s were not as spectacular as those achieved under Maurits in the late sixteenth century, the countryside of Brabant was slow to regain its former affluence. In the years just before the Treaty of Munster, the States of Brabant complained that fields, farms and pastures were still abandoned due to devastation and *vrijbuiterij*, troops having taken "het gene hy (de Landbouwer) met synen arbeyt van een geheel jaer heeft gewonnen."[74]

For the north, the Twelve Years Truce is usually thought of as the *de facto* end of the Eighty Years War, in terms of combat on northern grounds. But in fact, when hostilities resumed in 1621 only the maritime provinces were able to maintain virtual immunity from invasion. In safety, the peasants of Holland and Zeeland prospered and developed new forms of specialized agriculture.[75] The landward provinces, however, continued to be vulnerable to invasion. When Frederick Henry was occupied with the siege of Den Bosch in 1629, Hapsburg troops invaded Gelderland and plunged deep into the heart of the countryside, causing a major panic. Like Gelderland, Utrecht failed to defend itself, and both provinces were occupied by the Imperial forces for three months.[76] Although the eastern provinces were traditionally pro-Orange, their continued vulnerability in the later years of the war and the unceasing burden of taxes led them to join the maritime provinces in a demand for peace negotiations. While the provinces of Drenthe and Overijssel suffered no major invasions after the renewal of hostilities in 1621, the damage caused in the years before 1609 was slow to be repaired. Depopulation, abandonment of farms and pasture lands and decimated herds of livestock continued to be problems in these provinces in the seventeenth century and contrasted with the prosperity of the maritime provinces. The condition of these provinces, along with the southern borderlands like De Meierij, remained a somber reminder of war's effect upon the countryside.[77]

It is clear, however, that after 1609 the rural population of the most important provinces of the north enjoyed immunity from the kinds of violence which had characterized the early years of the conflict with Spain, while Flanders and Brabant continued to be vulnerable to such troubles until 1648. What social and political factors, then, can help explain the continued concern with Peasant Sorrow on the part of Dutch artists and their public in the secure, urban areas of Holland?

First, as we have seen, the experiences of the peasantry of both north and south during the early, "guerilla" years of the war were quite similar. Both areas were afflicted with mutiny, plundering raids and extortion; both areas perceived the conflict, in terms of scale and intensity, as something new and qualitatively

different. Memory of this shared experience need not have evaporated with the changed conditions after 1621.

Second, the major cities of both north and south, where most artists, including those concerned with peasant themes, lived and worked, were not socially immune from what went on in the countryside. Peasants who were driven from their farms in the outlying provinces flocked to the towns as refugees. In fact, even a prowar city dweller felt that the sorrows of the peasants had to be taken into account when he made an argument against renewing the Truce in 1621. The author of a pamphlet from that year is interrupted in his prowar argument by a peasant who taps him on the shoulder, saying

> Ghy hebt al goet kakkelen, maer wij gevoelen die smerte; siet om de Frontieren, hoe de landen bedorven ende overloopen zijn van weerzijden: siet ooch hier in Holland ende over Mase, hoe menich Huysman van sijn wooninge moet ruymen oft ten minste deselve vercoopen ende weer inhuyren . . . tewijl het cleynste officeren datter te Hove in den Krijgh is, vermach sijnen Meester in zijde en fluweel te gaen proncken.[78]

> [That's fine talk, but we're the ones who feel the sting; just look at the frontiers, how the lands are spoiled and trampled from both sides; look, too, right here in Holland and in Overmaas, how many peasants have had to leave their homes or at least sell them and rent them back . . . while the lowest officer from the court who's gone to war can still parade in silk and velvet.]

The comic, demotic tone of the peasant's speech does not undermine the genuine urgency of its message.

Third, the continuing troubles of the southern countryside after 1621 may not necessarily have been viewed by the north as mere devastation of enemy land but, at least by some, as shared misfortune. The sentiment of Netherlands' unity continued long after the resumption of hostilities, and the suffering of the peasants of Flanders and Brabant was viewed as oppression of fellow Netherlanders under the foreign power of Spain.[79] In a pastoral poem from 1623, a Zeeland and a Flemish peasant, thinly disguised as classical shepherds, meet as brothers to discuss their different situations, the Dutch peasant lending a sympathetic ear to the troubles of his southern neighbor.[80]

Finally, the broader issue of relations between soldiers and civilians was one of European, not merely Netherlandish, significance. The effect of new weapons and strategy and of mass armies composed of mercenaries loyal only to the best paymaster was felt for the first time during the late sixteenth and seventeenth centuries.[81] The behavior of troops during the Thirty Years War in Germany had repercussions throughout Europe.[82] Whether the exploitation of peasants by soldiers was viewed as an evil sometimes necessary to the prosecution of a "just war" (Grotius), as an aspect of the larger phenomenon of banditry (the Dutch genre painters and the picaresque novel) or as an expression of universal tendencies in human nature (David Vinckboons) it was a conflict widely depicted and analyzed.

Bruegel's *Massacre of the Innocents* and the Flemish Landscape School

Pieter Bruegel's *Massacre of the Innocents* (Fig. 1) endows the Biblical narrative of Herod's infamy with an arrestingly local and contemporary form.[1] In this painting, the massacre takes place in a snowbound sixteenth-century Flemish village. Against the white background, a troop of landsknechts and armored men enter the central square and there proceed, despite the pleas of the peasant inhabitants, to murder all the male children of the community. This brutal encounter between peasant and soldier in the guise of a "history" painting influenced the development of the theme of Peasant Sorrow in the art of the Netherlands. Later versions of Boerenverdriet, however, are purely secular, forming an exceptional counterpoint to the more frequent portrayal of rural festivity. How did a Flemish peasant village come to be seen as an appropriate setting for King Herod's crime? What historical circumstances may have contributed to the creation of this violent and disturbing work, produced during the same years as Bruegel's pictures of peasant bounty, the *Kermis* [Vienna: Kunsthistorisches Museum] and *Wedding Dance* [Detroit: Art Institute]? How did the iconography of the *Massacre of the Innocents* shape subsequent paintings involving violence between peasants and troops?

As van Mander and other critics have observed, Bruegel's picture makes an initial impression of extreme disorder, which heightens its effect of directly observed reality.[2] Soldiers pursue parents and children, peasant homes are invaded, a peasant man about to attack one of the mercenaries is restrained by his neighbors. In the center middleground, a landsknecht and several pikemen go about their bloody work, a heap of small corpses at their feet, while all around the periphery of the crowd, weeping peasant women carry off the bodies of their children or attempt to flee with those who are still alive. In the right background, in contrast to the tiny corpses littering the snow, two dogs frisk gaily, oblivious to the human tragedy going on around them. The juxtaposition of these many individual episodes at first appears gratuitous, without central focus, a senseless whirlwind which has descended upon the village.

The painting's center forms an island of order in the apparent confusion. The small upright figure of a mounted man in black, surrounded by armored cavalry

with neatly paralleled pikes, contrasts with the disordered slaughter going on else-where. There is little question that the command for the executions stems from this central figure; immediately in front of him and his cavalrymen, several armored men and landsknechts murder infants with their pikes. This is the only episode in the painting in which the armored men are directly engaged in the massacre, as if by this one example they demonstrate to both their commander and the remaining mercenaries the nature of the task at hand. Elsewhere, the slaughter is undertaken by subordinates.

Can it be assumed that the central, black-clad figure is Herod? In earlier ver-sions of the *Massacre of the Innocents* the Biblical king is not so actively involved nor so clearly implicated in the massacre. He stands off to one side as an observer, sometimes quite removed from the scene of the action.[3] There thus appears to be no iconographic precedent for Bruegel's emphasis on the figure in black. If we conclude from the other events depicted that he can only be King Herod, the focus on the Biblical narrative is shifted somewhat from the pathos of the murdered chil-dren. In Bruegel's version of the story, locating responsibility for events portrayed is a chief concern. In fact, none of Bruegel's other works which deal with violent conflict indicate accountability so definitely. In the early, Bosch-like *Triumph of Death* [Madrid: Prado], for example, the skeletal army which attacks the living has no visible leader, nor does the painting have a distinct center. The apocalyptic fig-ure of Death on horseback is off to one side, and does not confront the viewer full-face as the man in black in the *Massacre of the Innocents* does. Similar fea-tures characterize the cavalry battle portrayed in the 1562 *Suicide of Saul*; here, violence seems even more chaotic and inexplicable. In Bruegel's "Justice" print from the *Virtues* series, disparate incidents of torture and execution are organized around the central, allegorical figure of Iusticia, but even so the relation of the main figure to the background scenes is notoriously unclear.[4] This type of ambi-guity is not generated by the central, black-robed man in the *Massacre of the Inno-cents*; his implication in the action is much more distinct. Here, the contempor-aneity of the scene seems to insist, is a modern Herod.

While the precise manner in which Bruegel has structured his *Massacre of the Innocents* differs from earlier versions of the subject, rendering a Biblical theme in a contemporary setting is not his innovation. Flemish painters such as Herri met de Bles, later Pieter Aertsen and Joachim Beucklaer, had already made this a com-monplace in their paintings. Further, the artists of Reformation Germany had in-fused Biblical narrative with concrete historical detail. In Lucas Cranach's *Raising of Lazarus*, for example, Martin Luther appears in the garb of a country priest, while in Cranach's *St. John Preaching* the Baptist declaims to a crowd of six-teenth-century landsknechts. In such works, Biblical narrative is linked unmistak-ably with contemporary persons and political and religious issues.[5] Bruegel's approach, in contrast, is considerably more oblique with regard to explicit portrai-ture and his own historical milieu.

The relationship between Bruegel's *Massacre of the Innocents* and German tradition is more direct in another instance; a secular graphic tradition known as the "Planetenkinder" is a likely source for his portrayal of military attack upon a peasant village.[6] The Children of Mars sheet from this series is an early version of Peasant Sorrow which had made its way north from Italy by the end of the fifteenth century. In an example by the "Hausbuch Master" from around 1480 (Fig. 2), Mars, dressed as a knight, rides his charger across the sky while below a band of soldiers attacks and plunders a peasant village. Here, as in a later version by Georg Pencz (Fig. 3), the small figures, multiplicity of incidents and high horizon are congruent with the composition of the *Massacre of the Innocents*.

In conflating the secular subject with the Biblical one, however, Bruegel introduces substantial changes. In the graphic tradition, the peasants are not helpless victims, totally devastated by the soldiers' attack. Both men and women attempt to drive off their persecutors with farm implements and household tools. In Bruegel's work there is no resistance of this sort. Further, the violence portrayed by the "Hausbuch Master" and Georg Pencz has no causal center: in the Children of Mars representations the action displayed could equally be a plundering raid by a group of undisciplined soldiers or a publicly declared act of war. No cause is specified because, as part of an astrological calendar, the images need not depict any particular historical event. Rather, they refer to human nature, implied to be unchanging and governed by heavenly agency. Those ruled by the planet Mars have innate tendencies to aggression and violence. Bruegel's invocation of Herod's massacre, however, introduces a highly charged moral reference point which orders the chaos of incidents and displays the social relationships which have engineered events. Thus, although at first the placement of the figures in Bruegel's work appears as contingent as it is in the Children of Mars prints, in fact little could be changed without altering the sense of the picture.

The contemporaneity of the *Massacre of the Innocents* (and of other Biblical subjects portrayed by Bruegel) has long provoked speculation about the relationship of these works to the early history of the Netherlands' Revolt. Details such as the red uniforms of some of the soldiers,[7] the armor of the cavalry men, the double-headed Hapsburg eagle on the breast of a herald, coupled with van Mander's claim that Bruegel painted some dangerously sharp political allegories,[8] have led to numerous and conflicting interpretations. The most recent literature on Bruegel remains polarized, with some authors insistent upon the nonpartisan, transcendent nature of Bruegel's art, others maintaining that his work is directly involved with the chief religious and political events of his time.

C. G. Stridbeck[9] and F. Würtenberger[10] are among those who argue for Bruegel's autonomy from explicit confessional and political allegiances. Stridbeck believes that Bruegel's Biblical subjects, like the rest of his *oeuvre*, may be illuminated within the framework of liberal Catholic "Spiritualism." A tendency rather than a creed, this humanist, critical thread in sixteenth-century Catholicism

maintains that Scripture must be interpreted not literally but allegorically, and that Biblical narrative must be shown to be intelligible and useful to lay morality. While Stridbeck does not deal with the *Massacre of the Innocents* at any length, a passage from Spiritualist writings which he quotes in support of his interpretation of Bruegel's *Carrying of the Cross* is suggestive. The citation articulates the significance of Scriptural events for contemporary life:

> The events represented in the Bible must, in each particular case, be taken as allegorical; they have the character of eternal and universal symbols of the religious and moral process that in every epoch plays itself out in individual lives.[11]

In Stridbeck's view, the contemporary aspect of Bruegel's Biblical subjects implies a general moral allegory rather than a response to a specific historical situation. Thus, the *Carrying of the Cross* is an allegory of human indifference to suffering rather than an indictment of the treatment of heretics in the sixteenth-century Netherlands. F. Würtenberger argues a similar detachment from specific creeds in comparing Bruegel's Biblical subjects with those of Lucas Cranach. While he finds Cranach's work to be engaged with local, contemporary political and religious reality, Bruegel's pictures are, he claims, metaconfessional and nonpartisan. Thus both Stridbeck and Würtenberger understand Bruegel's art to be more concerned with the universal validity of Scriptural narrative than with any specific historical issues. Neither fully deals with the problem that in Bruegel's time, just as in Cranach's, political and religious conflict were closely intertwined and Scripture was often interpreted in a highly polemical fashion.

S. Ferber[12] attempts a more explicit connection between some of Bruegel's Biblical paintings and historical events than Stridbeck and others admit. He asserts that the man in black at the center of the *Massacre of the Innocents* is a portrait of the Duke of Alva, who arrived to punish the upstart Netherlands in 1567 accompanied by ten thousand troops. There are, however, serious problems with the pictorial evidence which Ferber marshals to support this identification: for example, the explicitly portraitlike nature of popular prints of Alva as against the much less distinctly individualized face of Bruegel's figure, as well as the fact that in prints and surviving portraits the Duke is typically portrayed in full armor.[13]

Each of these apparently opposing views has merits as well as the drawbacks mentioned above. Würtenberger, in contrasting Bruegel with Cranach, has neatly described the idiosyncratic way in which Bruegel deals with contemporary history. Ferber, on the other hand, is right to attend to the highly polemical political situation in which the *Massacre of the Innocents* was created, even though that author's insistence on a portrait rather than an analogical relation between the Herod figure and Alva is unconvincing.

To conceive Alva as a tyrant similar to the Biblical King Herod was perfectly consistent with current practice in both sixteenth-century historiography and art. Classical mythology, Biblical narrative and ancient history were all drawn upon to

order and comprehend the significance of contemporary events.[14] The outpouring of satirical prints, songs and polemical literature occasioned by Alva's entry into the Netherlands and continuing long after his recall to Spain in 1573 uses analogical and typological deyices to illustrate the Duke's unpopularity.[15] His actions are compared to those of historical, Biblical and mythological tyrants such as Nero, Pharaoh, Nebuchadnezzar and Chronos. In a song which later became part of the *Geuzenliedboek*,[16] in a polemical pamphlet on Spanish tyranny,[17] and in Pieter Bor's *Nederlantsche Oorlogen*[18] Alva's name is explicitly linked with that of Herod, the Biblical king who in order to preserve his religious and political hegemony murdered the male children of Bethlehem.

But while the polemical link between the Duke of Alva and past tyranny may have been widespread in the popular literary and artistic traditions of the late sixteenth century, the relation of Bruegel's *Massacre of the Innocents* to this propagandistic context remains problematic in a number of ways.[19] If the parallel with Alva is to hold, why should the victims of the contemporary Herod be peasants, when most of Alva's victims were urban? Further, how can the simple clarity of the polemical tradition be squared with the moral equivocality which typifies Bruegel's work as a whole? What of the fact that in the *Massacre of the Innocents* Bruegel shows the viewer so much more than is necessary in order simply to take sides?

To begin with the first objection to the relevance of the polemical tradition in understanding Bruegel's *Massacre*, it must be admitted that there is little evidence to suggest that the countryside was the principal target of Alva's punitive expedition. The Duke had been sent by Philip II chiefly to call cities to account for the riots and iconoclasms of 1566.[20] Most of the iconoclasts were not peasants but artisans, with a sprinkling of urban poor. In fact, in some cases peasants had intervened against the image-breakers to protect the holy objects.[21] Thus both the rebellion and the punishments assigned by Alva were largely urban phenomena. It is very unlikely, then, that Bruegel's *Massacre of the Innocents* portrays any actual occurrence from the early years of the Duke's reign. The facts of Alva's regime are relevant only insofar as they account for the development of attitudes which conceived the Duke as a tyrant on the level of Herod and his victims as hapless innocents.

If we keep in mind, however, that any relation between the *Massacre of the Innocents* and Alva's tyranny was likely to be displayed allegorically rather than directly, the fact that Herod's victims are represented as peasants becomes less puzzling. Both the literature and visual arts of the late sixteenth century provide examples in which peasants figure as the innocent victims of unjust war. In a drawing from a projected print series by Joachim Wtewael (Fig. 4), for instance, the trials of Belgica, a female allegorical personage, are illustrated by a scene of attack upon a peasant village:[22] here, as in Bruegel's *Massacre*, the peasants are victims who do not fight back. Similarly, in a *rederijker* drama from 1559, a peasant fami-

ly is featured as a major casualty of unjustified violence, and its members specifically identified as "Innocents" as their names ("D'onnozele," "de onbeschuldige," "de beschaede") inform us.[23]

These literary and visual conventions by which Peasant Sorrow came to represent innocence wronged, coupled with the instances in which Alva is linked with King Herod, suggest that Bruegel's *Massacre of the Innocents* may well be a coming to terms with contemporary political conflicts. But what of the perceptible difference between the complex, hierarchically ordered detail of Bruegel's picture and the simplicity of the popular print and literary traditions which caricature and satirize Alva?

In the polemical tradition the identity between Alva and past tyranny is clearly spelled out. A print depicting Alva as child-devouring Chronos (Fig. 5),[24] for example, renders his distinctive white beard and sharp features immediately recognizable, which is not the case in the *Massacre of the Innocents*. As in so many of Bruegel's Biblical pictures, the figure most crucial to understanding the relation of past and present is smallest and furthest from the viewer. In the *Conversion of Saul* [Vienna: Kunsthistorisches Museum] the chief figure is far in the background, almost hidden by the mercenaries in the foreground. Bruegel's John the Baptist (in *St. John Preaching*, Budapest: Szepmuveszeti Muzeum) is a tiny, anachronistically dressed form amidst the crowd of vagrants, pilgrims and landsknechts who recall the outdoor sermons or "hageprediken" of the 1560s. Christ, in the *Carrying of the Cross*, is almost overwhelmed by the mob of onlookers, troops and market-bound peasants who surround him. The detailed richness of all these works, as well as the enigmatic relation of each of the central characters to his contemporary setting, is quite different from the simplicity and economy of the popular polemical tradition.

Bruegel's *Massacre of the Innocents* shows us more than we need to see to take sides. While Herod's centrality is novel and undeniable, at the same time he is not the only significant feature of the painting, not an isolated target as he is in printed caricature. We have already discussed the hierarchical structure of the picture, the chain of command flowing from the central figure to his subordinates. But as van Mander, the painting's earliest critic, observed, competing sympathies and claims to power are also embedded in the structure of the painting:

> Van den aerdighen Brueghel sonder faute
> Noch in een Kinder doodingh is te siene/
> Dootverwich een Moeder benout in flaute/
> Jae een droevich gheslacht/ tot den Heraute/
> Om een kindts leven verbidden/ aen wiene
> Wel ghenoech melidjen is te bespiene
> Maer toont's Conings Placcaet met sinnen smertigh
> Datmen over geen en mach zijn barmhertigh.[25]

[Moreover, there is in a Massacre of the Innocents by the peerless Bruegel a deathly pale mother, distraught by her trials, and a sorrowful family who implore the herald to spare their child; we can

see his compassion readily enough, but he shows, heavy of heart, the King's Placcaet which orders that mercy be shown to none.]

This representation of divided allegiance is, like the centrality of Herod himself, a feature that is unique to Bruegel's version of the subject. While it is difficult to articulate a precise congruence between the painted division of authority and the historical situation which most closely corresponds to it (the undermining of the local autonomy of the Netherlands' Regent by Spain and particularly by Alva), yet the detail was prominent enough to be recognized by van Mander and adds a dimension to the picture lacking in the functional polemical approach.

It could of course be argued that Bruegel includes this episode, with the herald in the guise of a benign but helpless official, simply to strengthen the case against Alva. Thus his picture might be more comprehensive, but no less polemical, than the print and pamphlet satires. But the social world is not all that is represented in the picture. The natural world is equally significant. Not only do we see the organized devastation of a peasant community, but also the pattern of wintry branches against the snow, the patient draft animals tethered to trees, a flock of birds wheeling over the rooftops and the frisking pair of dogs. If the chief aim of the painting were to incite the viewer to action or to express partisan political beliefs, such detail would be distracting and irrelevant.

Finally, in addition to creating an image much richer than any partisan broadside, Bruegel addresses the viewer in a different way. Rather than engaging the observer at eye level, as the satirical prints of Alva and many later versions of Peasant Sorrow do, the *Massacre* is seen from a very high perspective. Unlike the consumer of polemical prints and leaflets, Bruegel's viewer is unusually privileged.[26] The high viewpoint removes the observer from the immediate carnage, while the richness of episode and detail request contemplation rather than activity. The *Massacre of the Innocents* is an invitation to make sense of a complex reality: to recognize the causal structure of the violence perpetrated, to map the scene of Biblical tyranny against contemporary experience, to acknowledge the tension displayed here and in other Bruegel works between nature and human nature. As such, the picture is a totality which includes, but also surpasses and potentially undermines, the polemical and historically specific vision of King Herod's tyranny.

In the copies and variations which follow on Bruegel's *Massacre of the Innocents*, both the high, detached viewpoint and the moral paradigm of the Biblical narrative are gradually abandoned. Originally a religious subject in contemporary dress, the theme becomes a Boerenverdriet: a secular chronicle of peasant suffering. While this change may be partly explained by new artistic practices (see below, pp. 29–30), it is equally significant that by the 1580s the community of opinion which had united Catholic and Protestant against Alva and the Inquisition had been shattered into warring factions.[27] In this increasingly polarized situation, pictures like the *Massacre of the Innocents*, with its attention to the totality of cause and

effect and appeal to a viewer elevated above the action, may no longer have been possible. When the theme of Peasant Sorrow is represented in the art of the 1580s and after, it is more disorganized, and on occasion more explicitly partisan, than Bruegel's painting.

The process of transformation begins with the *Massacre of the Innocents* itself. In a copy of the work at Hampton Court, the bodies of the murdered infants have been turned into bundles, thus changing the work into a secularized scene of pillage, even though the high viewpoint, many individual poses, and the central, black-clad authority are retained.[28] While a number of copies remain that duplicate Bruegel's picture much more faithfully, the Hampton Court example points the way to the subsequent development of the Boerenverdriet theme. The deliberately structured episodes and appeal to an omniscient viewer which characterize the *Massacre* are gradually neutralized in the works of Bruegel followers like Gillis Mostaert, Martin van Cleef, Lucas van Valckenborgh and others. Valckenborgh is one of the last painters to portray a recognizable *Massacre of the Innocents*; in his version the central figure has been eliminated. Only the bodies of the children lying on the snow indicate that the scene is in any way different from an ordinary plundering. Gillis Mostaert and Roelandt Saverij retain Bruegel's winter setting, but their versions of the *Massacre* are completely secularized. Saverij (Fig. 6) depicts an extraordinarily crowded and chaotic scene of pillage, which even after careful observation does not resolve into distinctive groupings such as we find in the *Massacre of the Innocents*. Saverij's plundering scene has no episodes as such: peasants and their animals are huddled together in a haphazard fashion similar to the objects which the soldiers pile up and cart away. Further, the attention to detail in Bruegel's work—the careful distinctions made between the red-coated Walloon soldiers, the landsknechts, and the armored cavalry—dissolves into a display of soldierly costume which appears more fanciful than accurately observed.[29]

The profuse, imaginative quality of Saverij's picture is, however, rather unusual. Few Flemish landscapists after Bruegel present the pillage of the countryside either as a colorful military spectacle or as an event of exceptional historical significance. On the contrary, Peasant Sorrow becomes commonplace. Horizon lines begin to drop, suggesting a less distant and comprehensive perspective, and violence against persons is accompanied, sometimes replaced, by plunder of property. In Hans Bol's *Landscape with a View of the Scheldt* (Fig. 7, Los Angeles: County Museum), small-figured peasants and soldiers fight it out in the background, while in the foreground, a man fishes, a well-dressed couple stroll along the river bank, and a begger asks for alms. All these activities, the picture indicates, are unexceptional aspects of country life. Similarly, in popular print traditions of the last quarter of the sixteenth century, the sense that violence between peasant and soldier is chronic also prevails. In the 1580s and 1590s, Peasant Sorrow came to epitomize the trials of Belgica to such a degree that Virtues series

represented Patience as a female allegory seated against a background of burning villages, fleeing peasants and plundering, murderous soldiers.[30]

The absence of any reference to particular events, important personages, or specific war parties in many versions of Peasant Sorrow painted in the years before the Twelve Years Truce may well reflect the historical situation of the Netherlands at the time. As we have seen, the seventies and eighties were characterized by constant infringement of troop discipline and were extremely difficult for the rural population of both the northern and southern provinces.[31] Both Spanish troops and those of the United Provinces under Leicester mutinied; both war parties were forced to live off the land while their wages were in arrears. To a peasantry wearied by repeated extortion of food, money and livestock, subjected to kidnapping and personal injury, it probably made little difference whether the soldiers who terrorized them were mutineers or legitimate troops, States' or Spanish, controlled by renegades or lawful officers.

When the war resumed after the Twelve Years Truce, however, the situation had changed. The Truce years had given the peasants of Flanders and Brabant a breathing spell and a chance to recover their former prosperity. Further, the free-lance style of warfare, with its spontaneous raids and mutinies, had been severely curtailed by the new military codes and their stricter sanctions. The old system of plunder, terror and personal injury was replaced by a more sophisticated system of protection monies. When it functioned, the new system could be considerably more humane for the country population, but failures of trust, violations of agreements and violent retaliations continued to occur.

In contrast to the atemporal, nonpartisan character of earlier versions of Peasant Sorrow, several of the pictures of Sebastien Vrancx and Pieter Snayers include details which link them concretely to specific historical events. A number of times, Vrancx painted the invasion of a peasant village not in winter as in the *Massacre of the Innocents*, but in May, as indicated by the festive Maypole visible in the center background of each work.[32] It is unlikely that the Maypole is simply a conventional indication of the peaceful round of peasant festivity which is repeatedly interrupted by marauding soldiers. In both art and literature, the Kermis rather than May Day is typically the counterweight or pendant to the theme of Peasant Sorrow.[33] Moreover, other features of this group of works strongly suggest that a particular incident is targeted. The focus on personal injury in these pictures recalls the moral appeal of the *Massacre of the Innocents* more acutely than many works which immediately followed it. In one example, a dead body is being stripped of its clothing by two soldiers, while nearby a woman and her children are pursued by a soldier with an upraised sword (Fig. 8). Another painting portrays a similar female figure, also prominently placed in the foreground. In other examples of the "Maypole" group of paintings, however, the situation is reversed and peasant men and women, armed with farm tools and household implements, successfully rout the invaders (Fig. 9). Finally, in some of these paint-

ings the allegiance of the marauding troops is clearly specified, the orange, blue and white cockades which the invading soldiers wear proclaiming that they are States' troops.[34]

A number of details, then—the renewed outrage at injury to persons, the clearly displayed allegiance of the troops, the definite temporal locus assigned by the Maypole—suggest that Vrancx' works are intended to commemorate a particular occurrence.[35] The month of May in fact marked one of the most infamous episodes of the second half of the Eighty Years War, when in 1622 Frederick Henry initiated a plundering raid through Brabant in revenge for unpaid protection monies.[36] The event was followed immediately by a burst of popular protest, including a ''Remonstrance'' to the Archduchess Isabella which complains that had she permitted the peasants to pay contribution,[37] the disaster could have been averted. In the lengthy series of couplets which comprise the Remonstrance, the peasantry is portrayed as an aggrieved third party, bitterly resenting the violence and destruction caused by the States' troops as well as the political considerations which led Isabella to forbid the countryside to buy its safety.[38] In Vrancx' paintings, too, the troops of the United Provinces are unequivocally implicated, although their commander Frederick Henry, who had chief responsibility for the raid, is nowhere represented. Further, the pictures appeal very directly to the viewer's sympathy by their low horizon lines, which engage the observer in the immediacy of the action at the same level as the participants. This contrasts with Bruegel's perspective, which privileges the viewer with the entire chain of cause and effect leading to the massacre, and requires deliberation as well as sympathy. Vrancx' versions of Frederick Henry's plundering raid give only a partial picture of the event; there is no attempt, through ordering and allocation of responsibility, to present the viewer with the complex totality of the social forces involved.

Not all of the ''Maypole'' Boerenverdriets painted by Vrancx represent the peasants as helpless victims of the marauding Dutch army. In one version (Fig. 9), attributed to both Vrancx and Pieter Snayers, the villagers fight back, peasant women playing an important role. The contemporary accounts report that while most of the peasants fled Frederick Henry's raid, there were some instances of resistance—''eenige Boeren in 't Gheweer staen om (de soldaten) de passagie te beletten.''[39] While the report states the peasants were armed, Vrancx has portrayed them routing the troops with their farm tools alone. The theme of peasant resistance appears elsewhere in Vrancx' and Snayer's work, unlinked with the specific events of May 1622. In some, though not all, of these examples, peasant women again share significantly in the defense of their towns. In an engraving after a painting by Snayers (Fig. 10), one of the principal episodes is the attack of a fierce peasant wife, armed only with a household implement, on one of the invaders. The actions of the peasant women and the nature of their weaponry introduce a problem which will be discussed in the following chapter on David Vinckboons' *Peasant Sorrow*: the actual role of women in popular resistance and riot in the six-

teenth and seventeenth centuries and its relation to visual traditions involving "bad wives" and other rowdy women.

It is striking that Vrancx and Snayers document local history in such a concrete and unembellished way. Peasant Sorrow and Revenge are deliberately presented in their most chaotic and immediate form. Yet it has been argued that the sixteenth and seventeenth centuries conceived their own history chiefly in allegorical or typological terms.[40] As we have seen, Bruegel's mixture of Biblical past and present in the *Massacre of the Innocents* is consistent with (though not identical to) this tradition, which later produced such typological models as the parallel between the Netherlands' struggle against Spain and the trials of Israel under Pharaoh, or the Biblical siege of Bethulia as a prototype for the sieges of Leyden and Venlo.[41] But, as the paintings of Vrancx, Snayers and others illustrate, the moral paradigm supplied by the Biblical story in Bruegel's *Massacre of the Innocents* has vanished in later versions of the Boerenverdriet.

The absence of such a Biblical type in the Maypole Peasant Sorrow of Vrancx and Snayers is partly explicable by the increased specialization of the genres in the late sixteenth and early seventeenth centuries. These painters were experts in landscape and military scenes, and it is unlikely that they were affected deeply by the humanist culture within which both the typological conception of history and a normative theory of landscape painting had developed.[42] While the theme of Peasant Sorrow, unlike the *Massacre of the Innocents*, could never in itself qualify as worthy "history painting" in the humanist theory of the genres, in a landscape school unconstrained by these hierarchical categories, portrayal of the peasants' trials as such was legitimate.

While the Flemish landscapists document certain aspects of rural history, they in no way glorify it. Vrancx and Snayers portray the rural version of civic defense which in its urban form was so widely celebrated in the great Dutch shooting company portraits.[43] Yet the Flemish pictures cannot be viewed as the country counterparts to the Dutch paintings. For Vrancx and Snayers portray the peasantry in collective, anonymous group form, while Rembrandt and Hals represent the civic militias of Haarlem and Amsterdam as individuals, well-known and respected members of their communities. Further, the Dutch shooting companies, in response to the explicit demand of their members, are shown in their stately role as respectable burghers, not as active military men involved in the actual chaos and danger of defending their cities against siege. Only Rembrandt's *Nightwatch* invokes the drama of a military maneuver, and then interweaves accurately observed practice with emblem and ceremony.[44] The resistance of the peasant militias is, on the other hand, shown in all its immediate disorder and violence. Even though specific details in some cases inform the viewer that a definite, significant event is represented, and the low horizon lines invite involvement and sympathy, the peasants are still viewed as members of a mass.

The large-scale fighting peasant is in fact rare in sixteenth- and seventeenth-

century art, perhaps because such an image could evoke alarming memories of peasant uprising. To monumentalize rural fighters was to run the risk of creating heroic images—living, individual peasants like H. S. Beham's *Acker Conz and Claus Waczer* (Fig. 11), leaders of the German Peasant War. Portraying rural resistance with small-scale, anonymous figures might put the spectre of revolt to rest while recognizing the fact of self-defense against the acknowledged enemy of the land.[45] Even in those instances in Netherlandish art in which Peasant Sorrow and Revenge are enacted by larger figures, the figures often remain anonymous, their violence seemingly a result of their simple nature rather than of any specific historical situation. In Martin van Cleef's *Peasants Attacking Soldiers* (Fig. 12) for example, two burly peasants murder a soldier. One of them grimaces, his face distorted by rage, while the other, viewed from the back, is completely anonymous. While Constantijn Huygens' *Zedeprent* "Een Boer" celebrates the ferocity of the Netherlandish peasant in self-defense,[46] in van Cleef's painting the peasants are rendered grotesque by what they do. The image recalls the senseless rage of the two brawling peasants who illustrate the sin of Wrath in Bosch's tondo of the *Seven Deadly Sins* [Madrid: Prado]. And in both Bosch's and van Cleef's works, wine tankards imply that drink and aroused passions rather than public, political conflict, are the source of the violence portrayed.

In a large-scale version of a peasant/soldier encounter, recently attributed to Pieter Bruegel the Elder but probably by P. Bruegel II (Fig. 13) the countryfolk are represented more favorably.[47] A peasant couple is accosted on a remote road by three marauders of unspecified allegiance, who intimidate the pair and steal their goods. In this case, it is the soldiers who invoke the image of Wrath as it is embodied in the figure of the landsknecht,[48] while the pleading, prayerful passivity of the peasants resembles that of the small figures in the *Massacre of the Innocents*, or the innocent simplicity of Onnozele and his family in the drama *Moordadighe Werck*. But both peasants and soldiers are isolated and anonymous, with no indication of the reason for the attack as there is in Bruegel's depiction of Herod's tyranny.

These large-figured versions of Peasant Sorrow and Revenge, then, involve neither the organized view of violence displayed in Bruegel's *Massacre of the Innocents* nor the particularized, historical description of the works of Vrancx and Snayers. Without any clearly illustrated moral reference point or historical context, peasant and soldier are paired in an apparently timeless cycle of assault and retaliation. One of the most interesting of these large-figured portrayals is the serial version of Boerenverdriet created by David Vinckboons, to be discussed in the following chapter.

3

Peasant Sorrow and Peasant Joy in the Art of David Vinckboons

David Vinckboons, a Protestant refugee painter who fled to Holland, maintains the Flemish tradition of Boerenverdriet in his 1609 version of the theme while at the same time strongly differentiating his work from that of Bruegel and the southern landscape school.

Vinckboons' Peasant Sorrow is novel in a number of ways. The viewer is not presented with the devastation of an entire village, but rather with a drama that unfolds within a single peasant dwelling. More unusual is Vinckboons' serial conception of Boerenverdriet. His two paintings in the Rijksmuseum (Figs. 14 and 15) are not merely pendants with complementary subjects; a narrative unites them. In the first picture we see two soldiers, accompanied by well-dressed women, seated at a table inside a peasant home. One of the soldiers grasps a frightened peasant by the arm, while with his other hand he threateningly brandishes a tankard. A basket of produce overturned at the peasant's feet suggests that the soldier protests such simple food. At the door on the left, another soldier compels an old man to go back into the dwelling. While the peasant women weep, the soldiers' female companions torment their victims and dandle an expensively dressed child. In the second panel, the situation is reversed. We are outside the peasants' house, from which a terrific commotion erupts. Armed with axes, pitchforks, poles and knives, both men and women drive their unwelcome guests from their home.

The narrative character of Vinckboons' Boerenverdriet is displayed more fully in four prints made by Bolswert after Vinckboons' paintings (Figs. 16–19).[1] Here, the events represented in the two Rijksmuseum paintings are amplified and in the final print peasant and soldier are apparently reconciled. The first episode shows three soldiers breaking into a peasant house, while behind them a companion holds up a document as if to justify the onslaught. Beside the soldiers are their women (one characterized as a sutler by her supplies and utensils) and children. The second print parallels the first Rijksmuseum panel, while the third episode, that of Peasant Revenge or Boerenvreugd, corresponds not to the Rijksmuseum version but to another Vinckboons work in a private collection (see note 1). A sig-

nificant change in this *Boerenvreugd* is that here peasant women lead the attack. One wields a soldier's spear, another is about to beat one of the cringing military men with a pair of hearth tongs. The fourth and final print resolves the conflict initiated by the symmetrical injury/revenge motif with a scene of reconciliation. Soldier and peasant, sutler/prostitute[2] and peasant wife chat, drink, dance and sport together. Only a minor episode of cheating at cards hints that hostilities might resume.

The verses accompanying Bolswert's four prints proclaim that they and the original paintings represent an allegory of the Twelve Years Truce (in the Atlas von Stolk, the four plates are collectively described as "Zinneprent op het Bestand").[3] The caption to the first print depicting the soldiers breaking into the peasant house reads:

> Hou boer doet op siet daer ist belet.
> Doet ghy niet op so svanckt mijn nosket.

[Hey, peasant, open up—see, we're billeted on you./If you don't open, I shoot.]

With the second couplet, the peasant within replies:

> Dryght so ghy wilt met schieten of kijven
> Ghy sijt naer buiten en sult daer blijven.

[Whether you threaten with words or shooting,/you'll sit outside and there you'll stay.]

The second print showing the successful invasion of the soldiers to the peasants' hearth is accompanied by a caption in which the soldiers and their companions gloatingly taunt their hosts and demand richer food and drink:

> Ja vertuyvelden boer, ergen ouder drasbroeck
> Pleendij ons soo met een vischgen te paijen
> Flucx brengt capoentgiens, ras haelt 't geldt uit den broeck
> Of ist gaeter deur, en daer sat geen haen na craijen
> Och lief bedenkt u, laet d'oude man lope
> Hij sal 't brengen al en ons 't wijntje gaen cope.

[You damned boor, old sack-breech,/you dare serve us a fish?/Quick, fetch capons, get the money out of your pocket,/or it will go ill with you./O, my dear—answers one of the women—let the old man go,/he'll bring it all quickly and buy us wine too.]

In this third print portraying the peasants' revenge, the caption reads:

> Tsa schelmen, 't wet nu uwen keer
> Voor hoentgens salmen u vlegel brood geven
> So wijf so maeckt u dapper in de weer

Die hoer die loose meer brengtse vrij om 't leven
Eij vinnigen ghuit sal u reisgeldt lange
Of ghij bit, 't bloet is verhiet, so Griet raeck met te tange.

[You rascals, it's your turn now./We'll give you a taste of our flails instead of our fowl—/so,
Wife, go to it with your weapons;/ kill that loose whore—you'll all wish/you had your traveling
money,/now that our blood is hot. So, Griet, strike with those tongs!]

The caption of the final print depicting the reconciliation scene is the first to men-
tion the Twelve Years Truce and to proclaim that it will be yet another kind of
reversal:

Siet nu hoe den trefves alles verkeeren gaet
Den moetwillige Soldaet, comt bij den Huisman bancken
Tis ick brengt u lansknecht, a nous cameraet
Maer geeft juffere een praet, int gaen salmen bedanken
Com legt een blaetgen om, vlijt u bij ons wilt schransen,
't boertige dom soent 't boertge waerom, soumen niet dansen.

[Look now how the Truce turns everything upside down—/the cruel soldier sits down with the
peasant./Now it's "to you, Landsknecht," "To us, my friend." . . . Come chat up the ladies;
we'll set a fine table/and gorge ourselves. The peasant hugs his wife. . . . Let's dance!]

The themes portrayed in the paintings, prints and their captions (rapacity of
the mercenary compared to the simplicity of the countryfolk, ferocity of peasant
revenge, shared feasting) and the form that they take (that of the intimate encoun-
ter/dialogue) are closely related to the popular literature from the years around the
signing of the Truce. Yet, the connection between Vinckboons' *Boerenverdriet*
and this literary tradition has not yet been examined. De Coo correctly sees Vinck-
boons' works as related to Bruegel's *Massacre of the Innocents* and as a particu-
larly Flemish theme, but does not acknowledge similar themes in literature.[4]
Goossens, in his monograph on Vinckboons, is equally indifferent to popular liter-
ature, and furthermore mistakenly assumes that the soldiers portrayed by Vinck-
boons must be Spanish, although there is no evidence for this.[5] Although the hired
soldiers of the Eighty Years War had no standard uniforms, their political alle-
giance could be indicated by the color of their sashes or cockades, or by insignia
displayed on banners.[6] The soldiers in the Amsterdam panels, however, wear no
colors especially associated with the Spanish troops. The verses which accompany
the Bolswert prints, like many of the Truce pamphlets, are equally noncommittal
on the question of the soldiers' allegiance.

It is, however, not only the relation of Vinckboons' *Boerenverdriet* to the
Truce literature which earlier research has neglected. Vinckboons' use of earlier
pictorial traditions needs to be considered as well. In this regard, the popular prints
of the late sixteenth and seventeenth centuries, including the "World Upside
Down" series, are as relevant as the tradition of Peasant Sorrow in Flemish paint-

ing. Finally, we will see how Vinckboons' portrayal of peasant oppression and revenge seems to embody an older, more conservative view of violence and human nature in contrast to certain attitudes developing in the seventeenth century.

Between 1607 and 1609, the pro-Truce faction in the United Provinces produced a number of pamphlets dramatizing the desire for peace in the form of pithy dialogues between peasant and soldier. Far from the elegiac, classicizing mood of van Mander's *Boereklacht*, the tone of many of these verse pamphlets is humorous, playing upon comic stereotypes of both the military and countryfolk. But their humor was not incompatible with a serious social intent, and the peasant, for all his comic simplicity, represents the interests of peace, while the mercenary stands for nearly a half-century of warfare. The outcome of the dialogue—who gets the last word—reflects either optimism or pessimism about the chances for a successful peace.

Almost all of the Truce literature displays strong structural similarities with Vinckboons' portrayal of Peasant Sorrow. The dialogue form, a direct exchange between individual speakers rather than a report by a narrator, specifically parallels the intimacy of Vinckboons' depiction of peasant/soldier relations as opposed to Bruegel's more detached and universal viewpoint. Similarly, the Truce poems are rich in reversal motifs—soldiers laying down their weapons in exchange for farm tools, peasants helping themselves to the soldiers' wine and otherwise outsmarting their oppressors— which also inform the two central episodes of Vinckboons' series. Finally, a number of the Truce pamphlets close with some kind of mutual reconciliation—whether it be a handclasp, a shared glass of wine, or a mutual recognition that while war may make a soldier out of a peasant, peace may reverse the process, turning the wine-guzzling, musket-bearing mercenary into a milk-drinking, flail-wielding farmer.

One example from the Truce literature includes all of these elements.[7] Here, the peasant begins the dialogue by asking the soldier what he will do now that he must stop his marauding. The soldier rudely answers that the peasant has no business asking this question, but receives an equally terse retort that the peasants no longer need to obey the soldiers, rather the tables are turned: "Soldaet daerom moet ghy nu switche, Wij boeren sulle niet meer vluchte door u kleyn ofte groot." The soldier, however, is far from ready to give up his power, and points out that the time may not be far away when the peasant will again have it hard. The soldier advises the peasant to go home, milk his cows and feed his pigs, and leave talk of war to the people whose business it is. The dialogue continues in the same way for several more stanzas, both parties refusing to back down and the peasant continuing to encroach on the soldier's territory, even to the point of claiming the right to "drincken den koele wijn," traditionally a luxury reserved for the soldier:

> Met pap en melc laet u ghenoegen
> Daer toe dorschen, wannen, ploeghen
> Wy Boeren drincken den Wyn.

[Now you'll have to be contented with porridge and milk/ so go to it, thresh, winnow, and plow/ while we peasants drink wine.]

The soldier is still unwilling to accept the reversal of roles that peace will bring, but in a few more lines the peasant convinces him, and the poem ends with the soldier calling for wine, so that together he and the peasant may celebrate the Truce:

> God wil de Lande neering gewinne
> maer voor al eerst de weerdinne
> Want wy drincken soo geerne. . . .

[May God grant that the country flourish—/but let's call the innkeeper, we need drink. . . .]

Another pamphlet employs the dialogue form and similar reversal motifs, but ends more pessimistically.[8] This poem opens with a short section praising the Truce in the high pastoral style, then develops into a comic conversation. The two speakers launch into an exchange of grievances expressed in the form of proverbs—the peasant, for example, accuses the soldier of "koecken van one deegh" (cooking with our dough) as a way of discharging his resentment over mercenary pillage of the peasantry. The soldier complains feebly that with the arrival of the Truce he's feeling quite ill, whereupon his companion offers to bury him on the spot. But the soldier flatly refuses, saying that he'll die in the battlefield or not at all, and so the two part ways, with the soldier leaving ominous indication of his continued vitality:

> Ick sterf nog niet/ ick wild u hooren praten
> Wijkt nu van hier/ en wandelt uwe straeten.

[I'm not ready to die quite yet/ Now that I've heard your chatter/ Get away from here/ and back to your own streets.]

The low, popular style of these and other Truce pamphlets, all products of anonymous *rederijkers*, incorporate aspects of the Boerenverdriet theme as it is portrayed in earlier *rederijker* products like the *Geuzenliederen* and the popular drama. The theme of peasant simplicity as against the more hedonistic ways of the mercenary, an issue both in the Truce literature and in Vinckboons' works, is the most common motif of the songs emerging from the early years of the Eighty Years War. "Melc drincker, kaesjager" are frequent taunts levelled by the soldiers at their unwilling hosts, as they themselves demand wine and capons. The motif derives its critical edge from the suggestion that war gives the soldier an illegitimate chance to indulge his appetites at the expense of others, while the peasant must work for his few satisfactions. In a song from the *Geuzenliedboek* dating from the Truce years, departing mercenaries lament the end of high living and the return to work. Each nationality has a pet war-learned vice that must be

given up now that it's peacetime—for the Germans, wine; the French, women; the Italians, gambling. With the end of the Truce, however, the cycle starts up all over again and the first thought of the returning mercenaries is how they'll be able to get the peasants to pay for their pleasure again:

> Mein liebste Schatzlein last trauren
> Dan der krieg fangt weder ahn,
> Hael mich der Teuffel de loose Bauren,
> Wil ich idt sundt verieren than,
> Bisz ich bekum ein gutten lohn
> Dan der Fried hat itz einen loch
> Nun lasz ons lauffen, Fressen en sauffen
> De Bauren mussen betzalen doch.[9]

[My dearest little treasure, you may well grieve/ Since the war has started up again/ The Devil, bring me to those lazy peasants/ I'm ready to celebrate once again/ Since the peace is up/ I'll soon get good wages/ So now let's go to it, drink and stuff ourselves/ But let the peasants pay.]

A number of *rederijker* plays from the last quarter of the sixteenth century engage similar motifs of exploitation, excess and their cyclical, recurring nature.[10] In one drama, a mercenary, Moedwillig Bedrijf, comes to a peasant, Gemeemen Huisman, for food and lodging.[11] After having extorted a lavish meal from the peasant, the soldier invites him to sit down and drink with him. But his host is suspicious, recounting in an aside to the audience the ills he has suffered at the hands of the soldiers, and refuses to join the unwanted guest. The soldier becomes annoyed, and insists that his host obey after first forcing him to his knees—a humiliation also inflicted by the soldiers in Vinckboons' *Boerenverdriet*. After successfully humbling the peasant, Moedwillig Bedrijf calls for more food and drink, promising that he'll refrain from violence if he is adequately served and if the peasant will join him at table. He goads the peasant to prove his "manhood" by showing the amount that he can drink:

> Zoo zullen wij malkander een hallef bier toe kitten
> U en sal niet besmitten, dus spoed u als een man dan.[12]

[So let's enjoy beer together;/ come on, it won't poison you, so act like a man.]

The two finally drink together, but the meal that follows fails to satisfy the soldier, and, like the mercenaries in Vinckboons' painting, he once again demands more. For the first time, the peasant reacts strongly, and tells his guest that he's not going to supply anything more. When Moedwillig Bedrijf threatens to bring his companion pikemen, the peasant pretends to go off meekly for more food and drink but remarks in an aside to the audience:

> Ziet, hier kon ik aan gaan als een arm knaap;
> Maar ben ik nu een schaap, ik kan wel een wolf werden.[13]

[Look, I seem like a poor sort of fellow,/ but though now I'm a sheep, I'll soon become a wolf.]

When he returns, the soldier tries to extort money from him on the condition that he will prevent his comrades from coming, but the peasant refuses to be intimidated. He would sooner run his guest through with a pitchfork than hand over his hard-earned money:

> Was zeker wilt gij hooi over den balk eten
> Men zal 't u ongemeten met vorken toesteken.[14]

[Before I let you make free with my money/ I'll run you through with my pitchfork.]

Better yet, adds the peasant, perhaps he'll join his brothers fighting under "Den Leegen Dop"—the rebel peasants of Overijssel. (See above, Ch. 1, pp. 10–11 for a brief account of the revolt. In the play discussed here, the rebellion is presented as a defensive measure against the injuries inflicted on the countryside by mercenaries.) Moedwillig Bedrijf tries to laugh off this threat, but instead finds himself being driven from the peasant's house with a pitchfork—exactly the same motif employed in Vinckboons' scene of peasant revenge. Here, however, the peasant does not win the victorious last word. Though he is temporarily rid of the mercenary, the latter is already plotting a revenge for him, suggesting that the cycle will soon start up again. Gemeenen Huisman reacts to the parting threats of Moedwillig Bedrijf with resignation, as if his energy is exhausted by this last encounter:

> Ik mag mij bereiden dan om te gaan drijven
> Na de stee toe; ziet, ik dorf hier niet blijven
> Want gaat hij hem verstijven met hulp van ander knechten
> Om leed te wreken en moedwil aan te rechten,
> Zoo helpt mijn vechten daar gansch niet tegen.[15]

[Perhaps I'll prepare to flee to the city;/ I don't dare stay here, since he's gone to get others/ who'll be just as cruel as he. . . . / My fighting against them doesn't help at all.]

The play concludes with a surprising plea to the soldiers in the service of the United Provinces, asking them to behave dutifully and for the first time implying that the mercenary portrayed here is of a specific political allegiance. This is in contrast to Vinckboons' soldiers, whose allegiance is not specified.

In a later play from the Truce years, G. H. Brueghel's *Soldaten geweld* (1613), the sympathy for the peasant's predicament which animates *Moedwillig Bedrijf* (and other plays) and justifies the peasant's attempt at resistance is replaced by a more ironic attitude.[16] Here, an encounter between soldiers and peasants becomes the occasion for a display of the follies of two comic types. Two soldiers of unspecified allegiance pass by a peasant home and decide to make some trouble. They demand twenty goldpieces from the old man who finally lets them in, and

when he refuses threaten to take his livestock and burn down his farm. Just in time the peasant's young wife appears, bringing with her the money. Temporarily satisfied, the two soldiers head for a tavern to enjoy their booty. After their departure, the peasant and his wife set out for market, the peasant grumbling about the lost money, his wife comforting him by saying that she'll water the milk and salt the butter to make up for it. Meanwhile, the soldiers are gambling, and one of them has lost badly at cards. Looking for someone to pay up for him, he sees the peasant's wife returning from market, and invites her in to drink with him and his companion. She finally agrees, and ends up drunkenly singing and flirting with the two men who have just squandered her money. When her husband comes to fetch her, she's unwilling to leave, saying that she never was content with such an "oude Grijs" anyway. Her companions jeer at the old peasant, and insist that he pay for their wine. He agrees, only in order to get his wife back. On the way home, violence explodes—not between peasant and soldier, but between husband and wife. The play ends with the wife running away after an exchange of blows, the peasant after her in hot pursuit. Thus, in this farce, everyone comes off badly. Certainly the soldiers try to exploit the peasants, but on the other hand the peasant wife is just as ready to exploit her customers at market by tampering with her goods. The social issues raised by *Moedwillig Bedrijf*, and some of the Truce literature, are evaded, although the common themes of oppression and shared feasting persist after a fashion.

The various attitudes toward peasant/soldier conflict in the Truce literature, popular song, and drama indicate that the theme is charged with meanings which, in Vinckboons' pictorial treatment of the theme as well, are not immediately obvious. While at first Vinckboons' portrayal seems a straightforward narrative of oppression, revenge and reconciliation—an appropriate visual metaphor for a truce—viewed in the context of literary tradition it seems more ambiguous. In the literature, peasant resistance is not always seen as justified, nor is it always successful. What is Vinckboons' attitude towards the revolt of his peasant household? Does he take sides? We have also seen that shared feasting does not always signify resolution of conflict: Moedwillig Bedrijf forces Gemeenen Huisman to drink with him, and the tavern scene in *Soldaten Geweld* provokes argument rather than accord. Does Vinckboons' final episode simply show that all's well, or does it suggest that the sources of conflict are still part of the festivity? Finally, in some *rederijker* productions which we have not discussed in detail above (but see note 9; esp. *Moordadighe Werck* and *Een Nassausche Perseus*) peasant suffering comes to epitomize all suffering in war, and is used to criticize, from a Christian standpoint, war itself rather than any particular historical conflict. Does Vinckboons intend such a universal critique in his portrayal of Peasant Sorrow? Is his Boerenverdriet actually concerned with the notion of war as publicly declared, systematically enacted violence? We will address each of these questions in turn, considering the issues in the context of not only literary, but also visual traditions in which the Boerenverdriet theme is significant.

The two central episodes of Vinckboons' Boerenverdriet display one of the most common reversal motifs in the Truce literature and *rederijker* drama: the rout of the soldiers by peasants, in this case both men and women. An iconographic tradition which became popular in the seventeenth century—the so-called World Upside Down broadsheet type—is equally relevant to these two episodes. In the World Upside Down tradition, peasants are sometimes portrayed being ridden by their military oppressors (Fig. 20), a transformation which has an element of absurdity absent in Vinckboons, or, when the situation is reversed, shown sitting while their masters stand or riding while their masters walk. One of the most popular themes of the World Upside Down is sex role reversal. As in Vinckboons' series, women are shown fighting men (though frequently the men they fight are their husbands); in some cases wives are portrayed going off to war while their husbands sit home and spin, in others women's militias storm or defend city bastions. It has been argued that these reversals, though intended to be comic and often depicted in the context of others even more absurd, had a serious social intent. [17] The World Upside Down broadsheet, emerging out of the social upheavals of the Reformation, aimed to provide images which at least on some level could focus the energies and support the efforts of those who challenged existing social hierarchies. Do the two central scenes from Vinckboons' series have a similarly critical intent?

The answer to this question is not easily given, first because of the comic detachment with which Vinckboons seemingly views both peasant and soldier, and second because of the way the two episodes are embedded in a narrative series which implies that the conflict has been resolved. Vinckboons achieves his ironic effect by drawing on the stock stereotypes of both peasant and soldier which can be found in the Truce pamphlets, drama, and popular song. While it is clear that his mercenaries genuinely harass the peasant household, yet they are portrayed as foppish, gluttonous bullies rather than cruel oppressors (compare, for example, the mercenaries painted by Bruegel and Vrancx, who actually inflict grievous harm). In the scene of peasant oppression, we are amused at the soldiers' expense: the elegantly dressed mercenary standing at the hearth is quite unaware that the child dandled by one of the women urinates on his stylish shoes. It comes as no surprise to see that these bullying dandies are cowards as well, who, in the scene of revenge, can be driven away ignominiously by simple peasants, their wives and their household pet. The peasants, too, are portrayed in a manner which owes much to the conventions of comedy. Though the figures of the fighting peasants are on a large scale (unlike those of Vrancx and Snayers) they lack the dignified presence and individualized faces which characterize the portraits of revolutionary peasants from the German print tradition. Nor does their behavior have the social character which we see in the paintings of Vrancx and Snayers, where we see entire village militias driving away marauding soldiers. Rather, peasant fury and mercenary cowardice in David Vinckboons' work seem to have more in common with the spontaneous outbursts which occur in earlier representations of the sin of Wrath,

or, later, in the brawls and revelries in rural inns portrayed by Brouwer and Ostade. Vinckboons' peasants share with Brouwer's and Ostade's an element of the grotesque: their rage distorts them and renders them more distant, especially to a nonpeasant viewer. For the artist and the viewer, peasant rage may have been both humorous and disturbing in much the same way that peasant behavior at Kermis was.

But the relationship of comedy to serious social intent is a complex one, as the Truce pamphlets and the World Upside Down series have shown. Certainly, in the visual tradition represented by the World Upside Down, absurdity is essential to its radicalizing thrust. In order to believe that anything at all can be changed, it may be necessary to imagine that everything can be changed—fish can fly, animals eat their owners, women wage war. In fact, one of the motifs most potentially subversive of the seventeeth-century social order—that of sex role reversal—was also considered the most humorous and was frequently represented.[18] Vinckboons' own version of this theme merits a closer look. What relation does it have to comic convention? Does it touch on the social reality of seventeenth-century warfare, as the paintings of Vrancx and Snayers do? Does Vinckboons glorify, denigrate or simply portray the role of women in popular resistance?

Scenes showing women engaged in violence are very rare in the art of the Netherlands. Even in cases where the themes of Peasant Sorrow and Revenge are portrayed, women are frequently depicted restraining, rather than aiding, their men in their struggle against marauding mercenaries (see, for example, Jan Steen's *Sauvegarde van den Duyvel*, Fig. 41). When peasants are painted brawling among themselves, often their wives play a similarly placating role (see, for example the peasant brawl embodying the sin of Ira in Bosch's Prado *Seven Deadly Sins*; also the copies of Brueghel the Elder's lost peasant fight by Rubens and Lucas Vorsterman). While Vrancx and Snayers show peasant women driving away mercenaries with their farm tools (see Ch. 2, p. 28) these figures are on a smaller scale and considerably less impressive than the forceful peasant women we see in Vinckboons' Budapest painting and the third episode of the Bolswert print series. To find an image comparable to Vinckboons' in scale and energy we need to look to the sixteenth century, to Bruegel's *Dulle Griet* [Antwerp: Mayer van den Bergh Museum].

Bruegel's painting of 1563 displays a rangy, grey-haired woman, carrying a sword in her right hand and striding forcefully across the foreground of a Bosch-like landscape. Although there is no indication that the painting is a direct source for Vinckboons' figure, Dulle Griet's aggressive pose—weight forward, mouth open as if to utter a battle cry—closely resembles that of the woman in the later work. The features of Bruegel's figure, too, have the bold coarseness of Vinckboons' peasant wife. The iconographic traditions involved here—on the one hand the legend of the devil-vanquishing Saint Margaret of Alexandria, on the other the theme of Peasant Revenge—though seemingly distinct, are in fact linked

through the common image of the "Bose Griet" or unruly wife, who parades through World Upside Down prints and separate broadsheets like Jan de Wasscher.[19] The captions to the Bolswert prints tell us that the peasant wife is also called "Griet," a name which conjures up a host of popular associations and traditions concerning feisty, unruly women, among them the print series just mentioned.[20]

Social historians have argued that images of fighting women and "bad wives" in painting, popular print traditions and folklore may have contributed to the opening of new choices for women, rather than simply serving as a comic "safety valve" to maintain social stability.[21] Certainly, every popular revolt which involved women in either spontaneous or organized violence helped in turn to strengthen the popular cultural tradition and make its images more convincing. While the role of peasant women in the rural militias organized for local defense in the early years of the Eighty Years War is never clearly specified, it is well known that women often played a prominent part in the defense of Dutch towns. During the siege of Haarlem in 1573, Kenau Simonsdr. Hasselaer helped to fortify the town and organized a women's militia.[22] Her exploits were not only recounted by contemporary historians like Strada and van Meteren, but were also celebrated in popular songs and prints. One example (an etching by Matthias Quad), shows Kenau in full-length portrait, left arm akimbo, right hand grasping a pike, with a sword attached to her belt. Like the portraits of the German peasant rebels Claus Waczer and Acker Conz, this print is serious, even dignified: Kenau addresses the viewer as an equal. Beneath the image, a poem praises the deeds of the "Amazon women" and commends them for their courage in defending their country. The type of action in which Kenau was involved—defense of her own community—was one of the situations in which women commonly fought in the seventeenth century. Where little or no formal training in weapon handling was necessary, and when the issues were ones which deeply concerned the local community, women could be found in the forefront of violent confrontations, joining in with rocks, sticks, or the nearest household tool or farm implement.[23] The action of the mercenaries in Vinckboons' Boerenverdriet, striking at the interests of the peasants in the most intimate and essential way—threatening their home and food supply—thus portrays precisely the kind of occasion in which women could and would lead the fight.

But how do Vinckboons' feisty peasant women measure up to the heroic image of Kenau Hasselaer and the equally powerful, although somewhat sinister, figure of Dulle Griet? Is Vinckboons' third episode an unequivocal celebration of local resistance? It could be argued that the cowardly nature of the soldiers to some extent undermines, and even belittles, the ferocity of the peasant women's attack. The implication (which runs throughout popular series like Jan de Wasscher as well) is that the soldiers are miserable, "unmanly" men who can be driven away by "mere women." Further, unlike "Captain Kenau" who had her own regiment

of women, Vinckboons' peasant wives are supported by their men in their attack—they do not initiate it independently. Finally, and relevant as well to the question of Vinckboons' attitude toward peasant violence, the scene of the women's onslaught is capped by the episode of reconciliation, in which the peasant woman takes the traditional female role of wetnurse to the sutler/prostitute's child. The world has been turned upside down, but has anything really changed?

The final scene in Vinckboons' series comes as more of a surprise than do the accords reached in the Truce pamphlets. This may be simply because it is part of a visual rather than a verbal sequence. In the dialogues, we hear the peasant gradually convince the soldier of the need for peace, while in the Bolswert prints the festive scene immediately follows, without transition, the violence of peasant revenge. Does the final episode function to defuse the conflict portrayed in the other prints, and to still any fears that Vinckboons' energetic portrayal of popular rage might cause in nonpeasant viewers? It may do both. However, there are indications, even within the banquet scene itself, that all is not well. For one thing, all the activities portrayed here—drinking, dancing, gambling—are ones which lead very easily to argument, as a number of Kermis paintings demonstrate. Rowdiness in the special sphere of the Kermis celebration might be viewed as tolerable and even expected,[24] but violence erupting between peasant and soldier can only recreate the cycle of events which Vinckboons has just shown us. A small incident in the lower right of the print suggests that such an explosion will soon happen. One of the soldiers' female companions is stealing a glance at a peasant's cards as the traditional enemies gamble together. Perhaps Vinckboons is only expressing pessimism about the durability of the Truce—one theme of the pamphlet literature is that a real peace would be preferable to a truce, which postpones but does not resolve the conflict.[25] But it is equally possible that Vinckboons' indication of recurring trouble aims at something deeper—at the cyclical character of human violence.

The occasion of peace-making often includes recall of the violence out of which it emerges. In fact, peace rites have been known to include the exchange of mock blows—in one non-Western culture, peace can only be concluded after each side has been given ceremonial freedom to strike the other.[26] Vinckboons' celebration of the Truce of 1609, with its central, symmetrically balanced oppression/revenge motif, has structural similarities to this ceremonial reenactment of violence. Yet there are important differences. In the peace rite cited above, the distinction between mock and real violence sometimes breaks down, and the ritual blows of pacification are mistaken for the real ones of combat. The ceremony can thus become a battle, demonstrating that recurring violence is a casualty of the peace-making structure, a possibility of misunderstanding which is part of the ritual. The cues which Vinckboons gives us, on the other hand, suggest that conflict between soldier and peasant is ever-present, and that violence is intrinsic to human nature.

As we have noted above, elements of Vinckboons' final scene of festive peace-making—dancing, drinking, love-making, gaming— all form part of the standard iconography of the Kermis, which Vinckboons himself painted a number of times. Another Vinckboons composition, his *Merry Company* (1608; Berlin: Dahlem-Gemäldegalerie) also depicts rustic types feasting before a country inn in an intimate format similar to that of the final episode of the Boerenverdriet. Both these traditions, as portrayed by Vinckboons and others, make a specific link between feasting and fighting, their implication being that in ''simple people'' like the peasants the passions run close to the surface, and are stimulated easily by wine and carousing. The Boerenverdriet series focuses in a similar way on the nature of individuals as the source of conflict. No detail of the soldiers' dress informs us about their allegiance, so that the question of a particular secular authority, and the justice or injustice of its actions, does not appear to be at issue (as it is in the Peasant Sorrow as depicted by Bruegel and Vrancx). Rather, all we are shown of the conflict is framed in terms of the relation between those traditional enemies, peasant and soldier.

While ancient literature typically separates the warrior and the farmer, making each the representative of a different way of life,[27] in a Renaissance visual tradition their two natures are linked in a manner that is relevant to Vinckboons' series. In print series of the vices or sins, peasants and soldiers are used alternately to illustrate the sin of Wrath (Ira). Bosch's tondo of the *Seven Deadly Sins* [Madrid: Prado] shows two drunken, fighting peasants, restrained by their wives, as an emblem of this sin. As the vices series were absorbed into more secular traditions, brawling peasants appeared in isolation or occasionally as part of broadsheets representing the evils of drink. But the original meaning of the Bosch tondo still surfaces occasionally in seventeenth-century works, as in a wedding portrait by Molenaer in which a pair of fighting peasants signifies the threat which anger raises to marital accord.[28]

The soldier embodied the sin of Wrath more frequently. In vices series by Burgkmaier and Callot, Wrath is represented as a classical warrior with a drawn sword, precisely as Cesare Ripa prescribes in his iconographic handbook.[29] But in offshoots of the Vices, like the Four Temperaments or the Evils of Drink, the soldier often is dressed in more contemporary garb. Crispijn de Passe depicts three gambling mercenaries as the Choleric temperament (Hollstein, v. XVI, #1254) and in the Temperaments of P. de Jode (Hollstein, v. IX, #101-105), Coler, a sixteenth-century mercenary, struts across the foreground with his sutler companion while in the background other soldiers raze and burn a peasant village.

In these graphic series (and in others like the Children of the Planets—see Figs. 2 and 3),[30] the implication is that there is something in the very nature of peasant and soldier which will lead them to violence. Whether under the baneful influence of the planet Mars, of the Choleric humor, or of drink, sooner or later they must come to blows—peasants and soldiers among themselves or against

each other. Wrathfulness is seen as a part of their nature, fixed rather than mutable, private rather than public. It is thus very different from the angry peasants portrayed in the German graphic tradition from the years of the Peasant Wars; the German peasants are rarely shown in isolation and their rage, whether depicted with sympathy or not, has a clearly social cause.

It was characteristic of the late sixteenth and early seventeenth centuries to look to individual human nature for an explanation of war and violence.[31] The concept of war was confusingly assimilated into all types of interpersonal conflict—brawling, duels, rape. Images in art like the wrathful mercenaries and peasants described above emphasized the association between personal aggressiveness and public conflict, thus blurring the boundaries between spontaneous, unofficial acts of violence and deliberate, publicly declared acts of war. Humanists in the tradition of Erasmus and Vives believed that wrathful human nature might be modified through improved education and nurturance, and that war might thus be eradicated. But this optimistic view was countered by a political realism which assumed human beings to be perennially violent and princes necessarily warlords.

Vinckboons' attitude toward violence and war does not conform neatly to either of these two intellectual traditions. He certainly does not share the radical optimism of the Utopian humanists, any more than he supports the popular Utopianism represented by the World Upside Down broadsheets. The subversive, world-changing impetus of his two central episodes is undercut by the final print, which resolves conflict and yet implies that it remains an ever-present potentiality. On the other hand, Vinckboons is far from embracing the realist view which explicitly assumes violence to be necessary. As we have seen, the questions which preoccupied the political and legal writers—the justice of particular conflicts, what is permissible in a just war—do not concern him at all. Rather, Vinckboons' conception of the nature of violence is more closely related to an older view, represented in art by the late-medieval Children of the Planets print series. Although formally Vinckboons' conception of Peasant Sorrow owes little to the earlier version, both express a view that violence is cyclical, an ever-present potentiality of human nature. Peasant and soldier may fight and make peace in turn, but whatever happens, they remain paired. As intimate enemies, their relation can be neither severed nor changed.

4

Peter Paul Rubens' *Landsknechts*

Peter Paul Rubens' so-called *Carousing Landsknechts,* painted sometime between 1632 and 1638 after his retirement from diplomatic life, is informed by, and yet in important respects differs from, earlier portrayals of the Boerenverdriet theme.[1] The painting, sold to the Spanish King Philip IV after Rubens' death and later destroyed by fire, survives only in a number of copies and in a print by F. Wijngaert. A preparatory drawing by Rubens' own hand also survives [Coll. F. Lugt, Paris]. From the two best-known copies, those in Munich and Budapest (Figs. 21 and 22), and from the print and drawing (Figs. 23 and 24), we can reconstruct the original composition.

The action depicted in the painting is episodic and confusing, and the titles traditionally assigned to the work fail to explicate it. In the inventory of Rubens' estate in 1640 the painting was listed as "Une troupe de Suisses qui contraignent les paysans de leur donner de l'argent, et couvrir le table."[2] An eighteenth-century inventory describes one of the copies, now in Budapest, as "Soldaten Plünderung in einem Dorfe."[3] Rooses' 1890 catalog of Rubens' works titles it "Soldats Maltraitants des Paysans," while H. G. Evers simply entitles it "Landsknechts."[4] A recent catalogue entry describing the Budapest copy as "Carousing Landsknechts" suggests that

> The probability is that Rubens simply depicted Spanish rowdies harassing the peasants, perhaps after an affray or merely on the occasion of one of their "peaceful visits."[5]

Like Vinckboons, Rubens is dealing in this painting with large, rather than with landscape-scale, figures. The setting is the courtyard before a village inn, characterized by the grape vine climbing over the arbor and the empty tankard hanging on a hook. Two peasant men and a woman with a child strapped to her back stand in attitudes of supplication in front of the inn, while one of a group of soldiers threatens them with the blunt end of a halberd. The rest of the soldiers pay very little attention to the peasants. One of them, at the far right, shoots at a brace of doves in a tree at the center of the courtyard. Another, a pikeman, stands looking at a soldier wearing a peasant cap on his head despite his regulation slashed

trousers and sword. The soldier sports with a young woman, oblivious to what is going on around him. By far the most striking of the landsknecht figures, however, is the soldier seated at the center of the painting, who gazes directly out at the viewer, and with the upraised glass of wine in his right hand, seems to offer a toast or mocking challenge. A light gun, its butt hidden by the head of the dog at his feet, rests across his thighs. The man's left hand supports a grossly oversized sword, which could never fit into its sheath, while his legs are spread wide apart in an aggressively sexual stance. His costume, with its asymmetrically slashed trousers and sleeves and feathered cap, as well as his swaggering pose, recall the landsknecht figure as he appears in sixteenth-century German, Swiss, and Netherlandish prints. Thus the assumption that "Rubens simply depicted Spanish rowdies harassing the peasants" must be challenged, since this figure is clearly an anachronism.

Seated at the feet of the central landsknecht is a woman who is evidently not one of the peasant party. Her low-cut dress and pose mirroring that of the landsknecht led Evers to identify her as an army prostitute.[6] As we have seen, prostitutes were an accepted part of most armies at least until the end of the sixteenth century, and landsknecht and prostitute are often paired in Northern art (see Urs Graf's portrayal of landsknecht and whore entitled *Got geb uns Glück*; for a Netherlandish example, the overdressed ladies of easy virtue in the Boerenverdriet series by Bolswert after Vinckboons (Figs. 16-19). Furthermore, in the preparatory drawing for Rubens' painting, all that remains by the artist's own hand, we see a frightened peasant man emptying coins into the hand of a seated woman. The head and torso of the female figure are truncated where the drawing was later cut, but the outline of the pose and the sleeve with its frilled edge correspond to the finished painting. Assuming that in the painted composition the money the woman holds has been collected from the peasants, although we no longer see the coins actually falling into her hand, she would appear to be an accomplice, not a victim, of the soldiers. Finally, a later version of Boerenverdriet by David Rijckaert III, evidently based on Rubens' composition, clearly depicts the finely dressed woman as a soldier's moll: she sits on the soldier's lap, holding a *roemer* of wine in her own hand, as he embraces her (Fig. 25; also Fig. 26).

There are, however, some serious objections to identifying this figure as a prostitute. First, the final composition differs in many ways from the preparatory drawing. In both the Budapest and Munich copies, the drawing's constellation of the soldier forcing an old peasant to deliver his money into the outstretched hand of the woman has been replaced by a group of three imploring peasants, one of whom, a woman with a child, extends her purse to the soldier who threatens the group with his halberd. The clarity of the gesture which, in the drawing, transferred the coins directly from the peasant's hand to that of the seated woman is gone—the woman's action, hand offering coins to the swaggering landsknecht, might just as well be read as that of a wealthy victim of the soldiers, tendering up

her money in response to their demands. If in fact she is victim rather than accomplice, her seated posture and the odd gesture she makes with her hat are also more intelligible. In a Dutch tradition of the seventeenth century, wealthy victims of marauding troops are portrayed in similarly imploring attitudes. Consider, for example, the plundering scene by J. Duck in which a well-dressed woman, stripped of her jewelry, kneels before an officer (Fig. 28). Evers interprets the hat gesture of Rubens' figure as an attempt to steal the chicken attached to the peasant woman's belt; behavior, in his view, appropriate to the sly ways of an army wench.[7] But the removal of a hat is everywhere a sign of deference (see the hatless victims in Pieter Codde's plundering scene in the Frans Hals Museum, or the peasant man who kneels, cap in hand, in J. M. Molenaer's portrayal of a plundered farmhouse (Fig. 34); further, her attempt to cover the capon with her tiny cap might be seen as a pathetic effort to protect the peasants' only remaining possession. Finally, the position of the figure in question in the overall scheme of the painting suggests that her role, like that of the peasants, is as victim to mercenary violence. Like the countryfolk, she is at the left of the painting. While the halberdier does not appear to threaten her as directly as he does the peasants, the scowling glance of the standing landsknecht with his hand on the hilt of his sword is directed, in a long diagonal, toward her—it is to his threat that she responds. When her gesture is viewed together with the clasped imploring hands of the peasant men and the outstretched offering of the women, it fits very well into a semicircle of appealing, conciliatory gestures.

There are stronger reasons yet for discarding the view that Rubens' seated woman in black represents a prostitute. Nor, for that matter, is it certain that she is simply a wealthy victim of the landsknechts. Her clothing is not really compatible with what either a successful prostitute or a well-to-do bourgeoise of the late sixteenth or seventeenth centuries would have worn. We have seen that the popular literature of the late sixteenth century mocked the prostitutes' taste for velvet and gaudy trinkets, and that Vinckboons' portrayal of the soldiers' companions in his Boerenverdriet series is very much in this spirit—his women are bedizened with lace, pearls, ruffs, elaborate headdresses. The attire of Rubens' figure is simple in contrast. She wears no jewels, and her dress is black, the somberest color in the painting, with an underskirt of grey. The small hat which she has removed has none of the feathers and ribbons which we see on Vinckboons' figures and also in the representations of prostitutes by Altdorfer and Graf. The only trace of ostentatious wealth which her costume displays is the sheen of her satin underskirt and the strip of ermine on her right shoulder, which hints of royal rather than bourgeois status.

The elegant sobriety of her dress, as well as her supplicating attitude, link this seated woman with a number of female allegorical figures which Rubens also designed in the 1630s. Virtually all of them appear in contexts involving issues of war and violence which concerned Rubens during these years and which are raised

in *Landsknechts*. We find supplicating, somberly dressed female allegories in Rubens' decorative scheme done in 1635 for the Joyous Entry of the Cardinal Infante Ferdinand. Characteristically the figures represent the dejected city of Antwerp, bereft of trade with the closure of the Scheldt, the distraught figure of Belgica begging for deliverance from war, and so on. In the allegorical *Consequences of War* in the Pitti, painted in 1638, the figure which Rubens designated as war-desolate Europa is similarly dressed in black, to express her mourning, and stripped of her jewels.

Behind the central landsknecht, and in fact almost hidden by him, is a figure which has been variously identified. Evers correctly points out that this old, bearded man is blind, with half-closed and rheumy eyes, but interprets the action of the man's one visible hand as stirring something in a concealed container.[8] If we compare the man's half-hidden gesture, however, with any of the numerous representations of blind hurdy-gurdy players so popular in the seventeenth century, his identity becomes apparent. The figure is intelligible as one of the blind-beggar musicians appearing in graphic series and occasionally in representations of the Kermis.[9] The argument for this identification of the figure is strengthened by the fact that when we look at Rijckaert's Boerenverdriet, painted later than Rubens' and directly influenced by Rubens' conception, we see once again a blind hurdy-gurdy player—with his instrument, and the little boy who serves as his guide—who is quite prominent as he stands next to the feasting soldier and the soldier's woman companion.

Each of the figural groups in Rubens' *Landsknechts* forms a distinct center of interest, with the terror of the peasants on the left contrasting with the self-absorbed pleasure of the couple on the right, locked in rough embrace. But unifying the composition, and making order out of these different incidents, is its wheellike structure, with all episodes revolving around the central, seated landsknecht. In contrast to earlier versions of the theme, which generally give equal attention to both peasant and soldier, Rubens here stresses the figure of the landsknecht above all the others—as we view the painting, we constantly return to the landsknecht as if he were the key to understanding the work as a whole. The peasants, on the other hand, are placed at the far left side of the painting. While they command attention and sympathy, the sense we get of their oppression is somewhat different from that given by Vinckboons' works. Central to Vinckboons' conception is the soldiers' invasion of the peasants' own dwelling. In Rubens' work, the theatre of action is public—the open space before an inn, which the peasants may have been patronizing themselves, or which they may have passed on the way to market. This makes the violent encounter seem more random—anyone could have been passing by at the moment the troops decided to descend on the inn—while in the Vinckboons series, peasant and soldier are paired more deliberately and defined as intimate enemies. The sense of dialogue in Vinckboons' works, paralleled in the Truce literature, is absent from Rubens' painting.

We see the peasants only as they cringe in terror from the soldiers' threats, since the countryfolk apparently have no means of defense. Nor do they eventually share in the feasting, as they do in the Bolswert print series. In Rubens' painting, the feasting is at the peasants' expense; they remain terrified spectators. Moreover, the dominance of the central landsknecht, as well as the presence of the well-dressed woman, break with the iconography of Peasant Sorrow established by Brueghel, the Flemish landscapists and David Vinckboons.

Rubens' portrayal of the landsknecht is both historically anachronistic and, like Vinckboons' noncommittal on the question of the mercenary's political allegiance. If Rubens intended to allude to the contemporary state of war in the Netherlands as one of the chief issues of this work, as Evers suggests, why did he choose to portray his central figure as a sixteenth-century adventurer rather than as a seventeenth-century professional who actually could have served in the States' or Hapsburg forces? Vrancx' and Snayers' troops, with their longer trousers and up-to-date cartridge belts, are historically more accurate, as a military handbook of the period demonstrates.[10] But like Vinckboons, who portrays the antagonism between peasant and soldier as something timeless as well as topical by refusing to bind it to a particular historical conflict or war party, Rubens may have chosen the sixteenth-century garb as a way of establishing a continuity between the lawless adventuring of the early years of mercenary warfare and the disorder caused in his own lifetime by nearly eighty years of war.

It is difficult to single out a precise source in the Northern sixteenth-century print tradition for Rubens' landsknecht figures. The types he portrays were extremely popular in the art of Germany (Dürer, Altdorfer, the Behams, Erhard Schoen), Switzerland (Urs Graf) and the Netherlands (A. Claesz, Lucas van Leyden, Goltzius and De Gheyn). Almost any example of a single standing landsknecht from this period could serve as a model for the counterpart in Rubens' painting, who rests both hands on his sword as he glares at the seated woman. Albert Altdorfer's print *Footsoldier with a Sword* (Fig. 29) is a typical specimen of this genre whose pose corresponds well with Rubens' figure.

The central landsknecht combines both the martial and festive aspects of the professional soldier's life which we find in the Northern print tradition. His pose, with widespread legs and upright sword, resembles a seated landsknecht etched by Urs Graf though the glass of wine is absent from the print and Rubens' landsknecht is if anything even more triumphant. The confidently splayed legs clearly signify a triumphant self-assurance, and in fact Rubens used the same pose in his 1618 *Hero Crowned by Victory* and again in his portrait of the crusading emperor Charles V for the Joyous Entry decorations in 1635. Festivity, as suggested by the raised *roemer* of wine, however, is common to scenes involving landsknechts in taverns and brothels. In an example by Urs Graf, a lady of ill fame beckons a landsknecht with a beaker of wine while he points to the money he had laid out to defray his expenses. Engraved on a bedstead above the couple is the motto "GOT GEB V̌S

GLVK,'' a play on the double meaning of the word ''Glück'' as both joy and luck.[11]

The pairing of the landsknecht with notions of festivity and the fickleness of fortune is a favorite theme in the art of Graf and others. In some of Graf's work it takes a more ominous turn, as in the woodcut which depicts two landsknechts chatting with a fashionably dressed woman in a landscape, while above them in a withered tree, the figure of Death looks down on the oblivious trio and points to his hourglass, as if to warn that their time, as well as their good fortune, will soon run out. Death's role in this woodcut forms a ghoulish parallel to the role of the blind hurdy-gurdy player standing behind the landsknecht in Rubens' painting. The suggestion that their revels may end in beggary and sudden reverse of fortune is something the troop of rowdies do not stop to consider—hence the half-hidden pose of the beggar, who seems to address his blind gaze to the viewer rather than to any of the figures in the painting.

The connection between mercenary license and beggary is spelled out more explicitly in Callot's famous series of etchings from 1633 entitled *Les Grands Misères et les Malheurs de la Guerre*. Here, in a narrative sequence recalling Vinckboons, we see a troop of soldiers pillaging a village, sacking a large farmhouse, and killing and raping its inhabitants. Along with the official punishments the soldiers suffer, portrayed in the subsequent prints, is the unofficial curse of beggary, the last recourse of those who have become cripples through the exercise of their profession. The fact that the scene of the courtyard filled with crippled soldiers follows hard on Callot's catalogue of military punishments suggests that the soldiers have received their just reward for their infamous behavior in the earlier scenes, but the caption implies that the notion of Fortune, of the sheer risk of the soldierly profession is also being invoked here:

> Voyez, que c'est du monde et combien de hazars
> Persecutent sans fins les enfans du Dieu Mars
> Les uns estropiez, se treinent sur la terre
> Les autres plus heureux s'élevent à la guerre
> Les uns sur un gibet meurent d'un coup fatal
> Et les autres s'en vont du Camp à l'Hospital.[12]

[See how the world goes, and how many misfortunes / constantly pursue the children of the god Mars. / Some, crippled, drag themselves along the ground. / Others, more fortunate, receive promotion in war. / Some die on a gallows by a fatal blow, / and others go from the camp to the hospital.]

Rubens' portrayal of the threat of poverty, in contrast to Callot's, is suggested rather than fully displayed. In comparison to the looting scene in Callot's *Misères,* the violence directed at the peasants in Rubens' work seems relatively harmless—while they are threatened, they are not actually injured. Far from the brutal rape in the etched series, the woman in the embrace of one of the soldiers seems quite

willing as she rests her hand on the man's arm and looks up into his face. The seated landsknecht seems to invite the viewer to share in his enjoyment of his wine. Only the blind beggar hints at the vulnerability of soldierly existence.

Another iconographic context which conforms more closely to the mood of Rubens' seated landsknecht, blind beggar-musician, and pair of lovers is that of the tavern scene from the story of the Prodigal Son as it is portrayed in painting and the graphic arts. It is customary in this tradition for prostitutes to accompany the Prodigal Son, which may be one reason why the seated woman in *Landsknechts* has been identified as such (but see my objections above, pp. 46–47). David Rijckaert, when he painted his version of the Boerenverdriet, viewed Rubens' central group of figures within this Prodigal Son mode. It was a favored theme among Netherlandish artists in the sixteenth century, and we know Rubens was especially concerned with the Northern tradition in his work of the 1630s. Further, the Prodigal theme unites images of revelry, excess, poverty and changing fortune in a way that informs us about Rubens' interpolation of the same themes into the traditional Flemish subjects of Boerenverdriet.

In one example of the Prodigal Son story, the *Sorgheloos* woodcut series executed in Amsterdam in 1541 (Figs. 30-32), the tavern scene is portrayed in three separate episodes. In the first, the Prodigal is shown at a table eating and drinking with his companions, Weelde, a prostitute, and Gemack, a landsknecht (whose name, in the sixteenth century, connoted greed and self-seeking).[13] The Prodigal toasts his female companion, while Gemack, glancing at the wine cooler, seems about to call for more drink. In the second episode, the same group is shown dancing. The Prodigal and Weelde do not embrace, but in the middleground another couple are kissing, and behind them is a curtained bed. The stiffness of the embracing pair is far from the obvious enjoyment of Rubens' amorous couple. In the final print of the Tavern episode, the Prodigal has just lost the last of his patrimony at cards. This reversal of Fortune is accompanied by the appearance of three new figures. One of them, dressed as a landsknecht, is entitled Lichte Fortune. As we have seen, the landsknecht is frequently linked with the notion of Fortune (see above pp. 49–50). Here the landsknecht figure represents not the neutral concept of Fate, but specifically the fickleness and inconstant quality of luck.[14] The two other figures are a beggarman (Pover) and his wife (Armoede). They do not appear diffidently, however, as the blind hurdy-gurdy man does in Rubens' painting, barely visible behind the landsknecht, but advance aggressively toward the Prodigal, beckoning him to join them in their misery. In the final scene of the entire series, the Prodigal is shown living in abject poverty with the two beggars, his clothes reduced to shreds.

In a painted version of the Tavern scene (by the Master of the Prodigal Son: Vienna, Gemäldegalerie) the festivities also are haunted by a beggar. In this case he is a crippled musician, though a lute player rather than a hurdy-gurdy man. He is driven from the table by one of the Prodigal's female companions, thus deliver-

ing not only a warning about future poverty, but a condemnation of the Prodigal for wasting his riches on feasting rather than charity.

The moral condemnation which is so clearly a part of both the *Sorgheloos* series and the Vienna painting is reduced in Rubens' work to an enigmatic suggestion. Only the position of the blind hurdy-gurdy man at the center of the painting suggests his importance. Further, the revels which he shadows are not portrayed unattractively; there is a great deal of energy in the cocky pose of the landsknecht and in the embrace of the soldier and peasant girl. The chief element of discord is the indifference of the revelers to what is going on around them—the terrorizing of the peasants and seated woman. Viewing *Landsknechts* in the context of the iconographic traditions discussed above, it seems that the beggar musician warns here of an impending change in Fortune, and of the vulnerability of all concerned— but especially the landsknecht—to the capriciousness of Fate.

The landsknecht's special relation to Fortune is a motif frequent not only in the visual arts, but also in the popular literature of the late sixteenth and seventeenth centuries. Like David Vinckboons' Boerenverdriet, Rubens' painting has much in common with the "low" style of the Truce pamphlets and their emphasis on such themes as mercenary greed, rapaciousness, victimization of the peasantry. The central figure of Rubens' swaggering soldier closely resembles the bullying mercenary in the *rederijker* play *Moedwillig Bedrijf* as well (see above, Ch. 3, pp. 36–37).

But important differences remain. Both the Truce pamphlets and *rederijker* theater stress the parity of peasant and soldier through the use of symmetrical dialogue which sustains our curiosity about who will have the last word. In Rubens' *Landsknechts* there is little question who wins: only compare the triumphant pose of the landsknecht with the abject stance of the peasants. The central mercenary, rather than the huddled countryfolk, is the focus of the painting.

The common soldier's experience, with its low-life and adventurous aspects, was a frequent theme in a genre which reached a peak of popularity in the seventeenth century, the picaresque novel. The changing roles of the picaresque hero, who goes from rags to riches, peasant to rogue, nearly always include a stint as mercenary soldier. The danger and fatality of the soldier's life, coupled with its opportunities for trickery and high living, are important to the picaresque world view, which emphasizes the fickle nature of Fate and the lawless, irrational quality of human appetites. Similarly, the chaos and disorder of a society at war form a variation on the favored picaresque setting of the criminal underworld, with its reversal of normal values.[15]

One of the best-known novels of this genre, H. C. von Grimmelshausen's *Adventures of a Simpleton* (1669), is set in Germany during the Thirty Years War.[16] Its hero, a peasant boy, is at first the victim of marauding soldiers and later joins with them in their plundering raids. Like Callot's *Misères*, the novel spares none of the grotesque catalog of war miseries inflicted on the peasantry. A lesser

work, closer to the buccaneer rather than grisly mood of Rubens' *Landsknechts,* is the pseudobiographical *Estebanillo Gonzales.*[17] Published in Spanish in 1646, *Estebanillo Gonzales* was distributed in Antwerp and went through a number of editions, although it was never translated into Flemish.[18] Although, as the date of publication indicates, the book cannot be considered a literary source for Rubens' painting, there are some striking similarities between the adventures of its narrator and the landsknecht as represented by Rubens.

Like Grimmelshausen's novel, *Estebanillo* is set against the background of the great military conflicts of the seventeenth century, the Thirty and Eighty Years Wars. But the novel is concerned not with the legitimate aspects of war—its causes, the great battles and their generals, the counsels of kings and states—but with its seamy, lawless underside. In its hero, Estebanillo, a long tradition of mercenary life as risky, licentious, pleasure-seeking and exploitative is synthesized. The miseries of war are seen through the eyes of the "soldier of fortune," who maintains a mocking detachment from it all. A self-seeking profiteer parasitic on war, he cares for nothing but his next meal—causes, national loyalties, soldierly honor mean nothing to him.

Estebanillo, a ne'er-do-well from a respectable family, first comes into contact with the army during a sojourn in Italy, where he finds the carefree life he has always dreamed of. He lives in farmhouses and forces the peasants to provide for everything, until an order comes that the Imperial troops must leave for the Netherlands to fight the rebel provinces. The threat of real battle proves too much for Estebanillo, and he decides to supplement his income by becoming a sutler. He finds camp-following, along with pimping, lucrative, but runs out of luck temporarily when he is captured by the Dutch. In typical rogue fashion he cons his way out of captivity and becomes attached to a nobleman whom he accompanies every summer on his military campaigns. Estebanillo's main concern on these occasions is to stay out of the field of battle and to make the best of things for himself by robbing wealthy sutlers and peasants in the surrounding countryside.

The novel avoids any explicit critique of war and its moral excesses—it is left to the reader to judge the exploits of Estebanillo, the wily opportunist who sees in the mercenary life and in the other professions parasitic on warfare a way of enjoying high living at little cost. From Estebanillo's point of view, the life of a mercenary, if one can survive its risks, can be "as merry as a Kermes."[19]

As we have noted above, the paired figures of landsknecht and beggar-musician at the center of Rubens' painting and their relation to the Prodigal Son tradition suggest that changing Fortune, the erratic nature of Fate, is an issue relevant to our understanding of the work. Similarly, in *Estebanillo Gonzales,* and in the picaresque genre more generally, Fortune is a significant concept. The picaresque hero is at once master of his fate, as trickster and opportunist, and victim of fate, buffeted about by circumstances he cannot control.[20] The mercenary soldier is a perfect emblem of this double-edged character of Fortune. On the one hand, a

mercenary can take advantage of the state of war to enrich himself, either through plunder and booty or at the expense of the peasants; on the other, he is vulnerable every day to poverty, torture, imprisonment and death. In picaresque literature, the uncertainty of the soldier's life and the lawlessness of war become an extended metaphor for the human condition:

> Man's life is a warre-fare upon earth, there is no certainty therein; no settled assurance, no estate that is permanent; no pleasure that is perfect; no content that is true; but all is counterfeit and vaine.[21]

It is important to attend to the associations of anarchy and lawlessness which adhere to the landsknecht as he appears in Rubens' pictorial sources and in the literary parallels. Both in visual traditions and in the picaresque, the mercenary is identified with types of violence (plunder, mutiny, rapine) already, by the 1630s, long designated as unlawful.[22] In his central landsknecht, Rubens must have sought to embody the most illegitimate and capricious aspect of war, for certainly, in other works of the thirties such as the Joyous Entry decorations and the warrior-saint George in the Antwerp *Madonna and Saints,* Rubens portrays masculine aggressiveness and martial prowess quite favorably.[23]

The concept of war itself as a condition out of control, answerable only to chance and fate, is not in keeping with Rubens' determined efforts to influence the great conflict of his time, the Eighty Years War. Until 1633, when, with the death of the Archduchess Isabella, he retired from court and diplomatic life, Rubens was continually engaged in negotiation to bring about peace in the Netherlands, although he never questioned the justice of the Hapsburg cause. His efforts in this direction imply a commitment to the belief that conflict can be resolved by rational means—diplomacy, negotiation, treaty. But *Landsknechts* was painted during the artist's retirement, when, as both his letters and his pictures testify, the possibility of ending the war by negotiation began to seem remote, and he became increasingly concerned with the irrational and apparently uncontrollable aspects of the conflict in question.

The late twenties and early thirties mark the high point of Rubens' diplomatic career and at the same time a military situation of increasing gravity for the Spanish Netherlands. In 1629, Rubens successfully concluded a treaty between England and Spain, a diplomatic triumph which earned him a knighthood and capped a political career dedicated to the cause of peace. But this hopeful event took place against a background of Dutch military gains and increasing internal unrest in the southern Netherlands. The abortive coup of a group of Flemish nobles against Spain, coupled with an attempt by the Duke of Aerschot to sabotage Rubens' political career, made the early 1630s uncertain years for the painter. In 1633, Isabella died, and Rubens' diplomatic life officially came to an end.

There is evidence that Rubens would have been happy for his political missions to have ended even earlier. Already in 1629, he wrote his friend Gevaerts

from London, "Best of all, I should like to go home and remain there all my life."[24] By the time of his actual retirement, Rubens was certainly disillusioned with political intrigue and also with the chances for a successful peace in the Netherlands and in Europe. In 1630, he had taken the unprecedented step of visiting the Dutch ambassador Joachimi at the Hague, under his own initiative. Whether this move was made out of a sense of desperation about the course of the war, or out of a supreme confidence in his own statecraft, is unknown. Rubens does not report the incident in his letters, possibly because it did not have the effect he had intended. His efforts for peace met with a severe snub. But while Rubens' own correspondence gives no clue as to his real motives in this matter, the report which Joachimi made to the States General of the United Provinces notes that one of the issues which Rubens wished to discuss with him most urgently was the state of emergency in the countryside of Brabant.[25]

The letters of the thirties display an increasing frustration with public affairs, not only because of Rubens' own ill-treatment at the hands of the Duke of Aerschot and Joachimi, but because of a sense of powerlessness in the face of events. In 1631, he wrote to his friend Woverius

> I am so disgusted with the Court that I do not intend to go for some time to Brussels. . . . My personal ill-treatment annoys me, and the public evils frighten me. It appears that Spain is willing to give this country as booty to the first occupant, leaving it without money and without any order. I sometimes think I ought to retire with my family to Paris. . . . In the meantime, perhaps the storm will pass, but up to now I have not made any decision and I shall pray the Lord to inspire me to do the best thing.[26]

By 1635, the theme of war as an erratic and unpredictable force emerges more emphatically yet in Rubens' writings. In the aftermath of the fierce French-Dutch onslaught on Brabant he wrote

> It is incredible that two such powerful armies, led by renowned captains, have not accomplished anything worthwhile, but quite the contrary, it is as if Fate had upset their judgment. . . . I hope that his Holiness and the King of England, but above all the Lord God, will intervene to quench a blaze which (not put out in the beginning) is now capable of spreading throughout Europe and devastating it.[27]

The implication that conflict in the Netherlands had become lawless, ruled by chance rather than any human agency, is congruent with the image of war embodied in Rubens' *Landsknechts*. The central soldier, as we have seen, represents in his picaresque guise all that is most uncontrollable in warfare: plunder, mutiny, desertion. The letter of 1635 also demonstrates that by this time, Rubens was beginning to lose confidence even in those "legitimate" makers of war, the Court and the generals.

In the thirties, Rubens explicitly discusses his political concerns in his correspondence. But the art which he produced during the last ten years of his life is

often characterized in the art-historical literature as withdrawal from public life. Rubens evidently valued the freedom which his retirement from the Court gave him to pursue his "beloved profession," and a good deal of attention has been given to the "personal" nature of many of his late works—his landscapes celebrating his love for his native Flanders, his portraits of his young wife Helene expressing his joy in his second marriage. However, the 1630s also saw the production of two projects of substantial political significance which sum up Rubens' mature views on the great conflicts of his time: the decorative scheme for the Joyous Entry of the Cardinal Infante Ferdinand into Antwerp in 1635, and the allegory known as the *Consequences of War,* now in the Pitti.

In 1634, the Dutch attitude toward the closure of the Scheldt remained implacable, and the only way to regain control of the river and to restore Antwerp's economy seemed to be the resumption of aggressive warfare. The Cardinal Infante Ferdinand, young hero of the Imperial victory at Nordlingen, seemed the perfect candidate to lead such a new effort. The needs of the city magistrates upon his arrival in 1635 were twofold: first, to flatter the Infante for his military prowess, and second, to make him aware of the desperate plight of their city. Using the classical, allegorical mode, Rubens intertwined these two themes in his decorative plan for the ritual entry of the young Cardinal.[28]

Prior to the Temple of Janus, the arches and stages along the processional route either eulogized the Hapsburgs or extolled the victories won by Ferdinand. The Temple of Janus introduces the somber note of the misery caused by prolonged war. The distinctive feature of this work, which survives in an oil sketch by Rubens as well as in Van Thulden's engraving, is that the door of the Temple—which when closed signifies a state of peace—is here being thrust open by the figure of Furor. On the right side of the design, a female allegory of Peace, with the caduceus as her attribute, struggles vainly to close the door against Furor's emergence. Near her are the Empress Isabella, in convent garb, who also puts out her hand to attempt to close the door, and the figures of Piety, Tranquillity and Security. Above this group, on the upper part of the painted panel, stand two figures representing the blessings of peace, Abundance and Fertility, characterized by the overflowing cornucopias which are the traditional attribute of peace. Near them is what can only be called a "peace trophy," made of an assembly of agricultural tools, the crossed sheaves which signify a successfully completed harvest, fruit, flowers and a basket with two white courting doves nesting upon it.

On the left side of the stage, where the havoc wrought by war is represented, all is in disorder. Two hags pull open the door of the Temple, overturning a vessel filled with blood. Near them, paralleling the group with Tranquillity and Security on the side of Peace, a soldier drags a woman off by her hair, while her terrified child clings to her arm—behind them, the skeletal figure of Famine is in pursuit. This motif, of soldierly attack upon the helpless and innocent, is also present in Rubens' *Landsknechts,* in the form of the poor peasant woman with her child

strapped to her back, who offers up her meager purse to the threatening lands-knechts. Similarly, in the preparatory drawing for *Landsknechts*, a soldier grasps an old peasant by the hair and forces him into a humiliating posture, although this brutal gesture is excised from the final painting. On the second story entablature of the left side are two allegorical figures who parallel the figures of Abundance and Fertility on the side of Peace. Here, Grief, clad in mourning and with covered head, clasps her hands imploringly while Poverty, dressed in rags, rests her head on her hand in an attitude of melancholy. Thus Rubens makes the link between war and poverty in the high, allegorical mode; in *Landsknechts*, we see it made in the context of a low-life, Northern tradition: the figure of the blind beggar who ominously shadows the central landsknecht.

The allegorical painting entitled *The Consequences of War*, painted in 1638, develops further the theme of the opened Temple of Janus. According to Rubens' own description of this work,[29] we see the war god Mars just as he has left the Temple, the door gaping wide behind him. Although the Temple now stands empty, its door ajar, a malign force still seems to issue from it, sweeping all the figures in the painting in its path like a strong wind. The force of war, unleashed, brings with it the destruction of Fecundity and Charity (represented by the frightened woman with the child in her arms), of Harmony (represented by the woman with the lute), of the sciences and arts (represented by the fallen architect with his instruments and sketchbook). In Rubens' words,

> The grief-stricken woman clothed in black, with torn veil, robbed of all her jewels and other ornaments, is the unfortunate Europe who, for so many years now, has suffered plunder, outrage, and misery, which are so injurious to everyone that it is unnecessary to go into detail. Europe's attribute is the globe, borne by a small angel or genius, and surmounted by the cross, to symbolize the Christian world.[30]

While it is true that the figure of Europa is clearly identified by her attributes, and that the woman seated at the mercenary's feet in *Landsknechts* has no such identifying features, yet there are similarities between the two figures. Both are dressed in somber black, the color of mourning, and bereft of jewels despite their rich clothing. Although their poses are not identical, both lean forward in beseeching attitudes, and if Europa's face were turned from its three-quarter view to profile, it would bear an expression very similar to that of the figure in *Landsknechts*.

The Pitti allegory also develops, in the relationship between Mars and Venus, a theme which Rubens portrayed many times throughout his career, and which illustrates his deepening pessimism about the possibility of containing war and violence. R. Baumstark has pointed out that in Rubens' earlier portrayals of this subject, the god of war is completely in Venus' power.[31] For example, in a version of the theme now in Königsberg, Venus gently removes Mars' sword, while two putti tease off his helmet and shoes. The implication is that war can be contained by strategy—force is no part of this gently playful composition. Such a conception

might reflect the optimistic view about the fortunes of the war which prevailed in the southern provinces during the Truce years, when the Königsberg *Mars and Venus* was painted. In the better-known *Allegory of Peace* commissioned for Charles I of England in 1629-30 [National Gallery, London], the relationship between the two lovers is greatly changed. Venus still represents peace and plenty, but the power is no longer in her hands—Mars must be driven forcibly away by Minerva, a clear indication that the power and aggressiveness of Mars are mightily increased. By 1638, when the Pitti allegory was painted, the high hopes Rubens had for the peace between Spain and England—he had seen it as a link in a chain which would end war in Europe—were dashed. The relationship between Mars and Venus in the Pitti painting emphasizes disequilibrium. Virtually every element in the composition conspires against Venus' gesture of restraint as she grasps Mars' arm while his cloak slips through her fingers. Since she can no longer summon Minerva, goddess of reason and wisdom, to her aid there is absolutely no way she can contend against Mars and the force of destruction which sweeps everything in its path. A final image testifies to the triumph of war over peace, violence over reason and love: at the center of the painting is Mars' sword, not only unsheathed, but dripping blood.

At the center of Rubens' *Landsknechts,* too, we see an unsheathed sword which, though unbloodied, is vastly oversized and triumphant. What is the relation between its owner, the mercenary with his connotations of illegitimate plunder and rapine, and the antique god of war, coming from a tradition whose authority confers legitimacy even upon his violent actions? Many of the works engaging themes of war and peace which have been discussed so far are painted in the classical, high Baroque allegorical mode. But in the last ten years of his life Rubens was also deeply preoccupied with the Flemish landscape and the Northern tradition in painting, an interest of which *Landsknechts* is one expression. This concern has long been linked with Rubens' homecoming and rediscovery of the Flemish landscape from the privileged point of view of the Castle Steen. It has recently been suggested, however, that Rubens' images of the rural North are not completely autonomous of major allegorical works produced during the same years.

In the stage of the Temple of Janus from the Joyous Entry celebration, the door to the Temple is open, showing that war is temporarily ascendent, yet the design balances the horrors of war and blessings of peace against one another. This juxtaposition draws upon an antique tradition in literature and art, stemming from Virgil and Ovid, and revived in the Renaissance by Erasmus and others. In Erasmus' *Querela Pacis*, the Northern humanist contrasts images of war and peace in a fashion similar to that of the Janus stage:

> Do you long for war? Consider first then, what good peace brings and what evil war, and then decide whether it is useful to exchange peace for war. Is there any thing more admirable, than a land in which everything prospers, with well-founded cities, well-ordered fields, good laws, respected arts and sciences, with decency and chaste customs? Consider, I must destroy this good

fortune if I go to war! And the other side—when you have seen the cities in ruins, destroyed villages, burned churches, abandoned fields, this dreadful spectacle, then think, that this is the fruit of war.[32]

Svetlana Alpers has recently suggested that the peace motifs which balance the war and chaos on the left side of the Janus stage—the figures of Abundance and Fertility, the cornucopias and crossed sheaves, the courting doves—might well have their northern, Flemish counterpart in the image of agricultural bounty and unrestrained festivity which Rubens created in his *Kermes*.[33] Such a vision of the blessings of peace is particularly Flemish, not only in the comically excessive behaviors it portrays, but in its lineage, direct from the *Kermes* and *Wedding Dance* of Bruegel the Elder. Could Rubens also have found in Bruegel's *Massacre of the Innocents* a prototype for a Horrors of War in the Flemish mode? After Bruegel's death, Peasant Sorrow became a typical subject for the landscape school of the southern Netherlands as well as for the emigré Vinckboons. As such a quintessentially Flemish theme it was certain to have captured Rubens' attention in the last years of his life. Moreover, by midseventeenth century the theme of peasant suffering at the hands of troops was portrayed, in both painting and literature, as the companion subject to the Kermis, an opposite pole of rustic experience (See Figs. 26 and 27).[34]

Insofar as *Landsknechts* can be described as a typically Netherlandish Boerenverdriet, we might view it as the pendant or companion piece to Rubens' celebration of peace in the *Kermes*. But in fact *Landsknechts* does not closely conform to the iconography of Peasant Sorrow as established by Bruegel, Vrancx, Snayers and Vinckboons. The figure of the woman in black remains problematical. If she as well as the peasants is a victim of the troops, then Boerenverdriet is an inadequate description of the painting. As a wealthy victim of the marauders she renders the title too narrow, but recognizing her as a figure on the level of the female allegories Antwerp and Belgica from the Joyous Entry celebrations introduces a still greater anomaly: a mixture of the high and low pictorial modes in an unresolved manner atypical of Rubens.[35]

In yet another instance, Rubens breaks with the earlier iconography of Peasant Sorrow. *Landsknechts* includes a prominent portrayal of an embracing couple. Certainly, sexual encounters between soldiers and peasant women are depicted in other versions of Boerenverdriet: the violent assaults of Vrancx' and Snayers' troops, as well as the comic embrace of the couple in the final scene of Vinckboons' series. But Rubens' amorous pair is quite different from these. In Vinckboons' picture, the action takes place in an overall mood of drunken festivity, and the gesture of the lusty peasant resembles a comic attack more than a caress. Is his partner genuinely willing, or will the next moment see her retaliate, setting the wheel of violence in motion once more? The embrace of Rubens' couple, in contrast, contains no hint of brutality. The right hand of the soldier gently touches the peasant woman's face, and she looks trustingly into his eyes without

attempting to escape. Her partner's dress also implies readiness to dispense with war-making in favor of love-making: though he still wears the slashed leggings and sword of the hireling soldier, he alone of all the troops wears no armor and sports a brimless peasant cap. He seems in fact to be in metamorphosis, not quite soldier and warrior, not quite festive peasant, ready for a Kermis romp. The embrace itself can be a sign of harmony and security: as such, it is depicted again and again among the crowd of dancers. Further, in the high allegorical mode, Rubens used the embrace explicitly to connote peace. For example, in the decorations for the Whitehall ceiling, in the allegory of Good Government under James I, peace is represented by the embrace of Pax and Abundantia.[36] More appropriate to an embrace of the two sexes, the history of the relations of Mars and Venus is an indication of Rubens' views on the fortunes of peace, from the gentle caresses of the pair at Konigsberg to Venus' desperate attempt to restrain her departing lover in the Pitti allegory.

While the gap between the antique lovers and the "low" mercenary and peasant girl in *Landsknechts* is great, establishing a parallel between the two pairs may prove illuminating. In his *Kermes*, Rubens tempered Bruegel's moral ambivalence to the human appetites with an affirmative humanism to produce a Flemish celebration of peace. Faced with the brutal sexual relations portrayed by Vrancx and Snayers (and by Callot in his *Misères de la Guerre*), Rubens created in *Landsknechts* a similar transformation. Instead of portraying the relationship between a soldier and peasant girl in its roughest, most immediate form, he has tamed the encounter, and shaped it into an image which suggests the possibility of resolved antagonism.

The couple is not the only hopeful element in the painting. At the far right, we see a marksman firing at doves. The black bird falls, wounded or dead (this is clearest in the Budapest copy), while the two white ones escape. Paired white doves, as we have seen, were included in the "peace trophy" from the stage of the Temple of Janus. Courting birds traditionally symbolize harmony, the opposite of discord.[37] As such, in *Landsknechts*, they are the counterparts of the embracing couple.

To a certain degree, then, Rubens' *Landsknechts* might be understood as a Flemish parallel to the juxtaposed images of war and peace on the Temple of Janus. In both instances, war dominates over peace: in the Joyous Entry decorations, the open door of the Temple proclaims the temporary ascendancy of Mars, while in *Landsknechts* the mercenary with his unsheathed sword implies that war is for the moment triumphant. But the fact that the central image of the painted panel is a landsknecht, infamous not only because of his antics in sixteenth-century Northern prints but also because of his actual role in the Netherlands' wars, may render the "low" image of unchecked violence more immediate. The mercenary and his peasant victims are less historically remote than the classical gods who populate the Temple of Janus. In fact, the hireling soldier was perhaps

the most concrete symbol of all that was unpredictable in late sixteenth- and seventeenth-century warfare: his mutinies had terrorized the countryside and virtually paralyzed the Army of Flanders during the last years of the sixteenth century, and opened the way to States' victories which were ultimately decisive in the outcome of the Eighty Years War.

5

The Dutch Boerenverdriet after the Twelve Years Truce

By midcentury the Boerenverdriet was widely depicted in the work of Vrancx, Vinckboons, Rubens, Rijckaert and others. Certainly, the troubled situation in the countryside of Flanders and Brabant even after 1621 helps to account for the continued relevance of the Peasant Sorrow theme to the artists of the Spanish Netherlands and their public. But what can explain the persistence of the same subject in the more tranquil North? For, in spite of Fromentin's sweeping comment on the fundamentally peaceful nature of Dutch art, the disruption of peasant life by military intervention remained of concern to some Dutch artists throughout the seventeenth century. The energy and conviction of the Flemish versions of the theme, however, as well as the low, comic mode employed by Vinckboons, are replaced in many cases by a tamer, more subdued representation of Peasant Sorrow. Only Jan Steen's idiosyncratic vision of Boerenverdriet retains the scale, vitality and popular comic quality of some of the earlier versions.

The reason for this change is not difficult to determine. In the early years of the conflict with Spain, the countryside around Haarlem, Leyden and Alkmaar had been ravaged during the famous sieges. But when hostilities resumed after the expiration of the Twelve Years Truce, fighting was confined to areas bordering the United Provinces and to outlying districts such as Gelderland. The urban centers of the maritime provinces, where most artists lived and worked, were thus far removed from any direct experience of rural disruption. Since the trade wars with England were marine conflicts, the United Provinces retained its near-immunity from land warfare right up to the French invasion of 1672. The panic and lack of organized resistance during the combined French-English assault on Utrecht reflects in some measure Dutch complacency, and certainly forms a striking contrast to the fierce local resistance of the late sixteenth century. Until the "Rampjaar," the North could afford to concern itself with the affairs of others—for example, the disasters caused in the German countryside by the Thirty Years War.[1] Romeyn de Hooghe's prints cataloging the French atrocities in the Dutch villages of Zwammerdam and Bodegraven in 1672, however, bring the Boerenverdriet home once again, with a vengeance.[2]

From 1621 until the French invasion, then, the sorrows of real peasants can hardly have affected Dutch artists and their public in any very vivid way. But cultural, as well as political and military change, is equally significant in understanding the character of later, northern portrayals of the Boerenverdriet. It is interesting, in this respect, to compare the literature produced at the time of the Twelve Years Truce with that occasioned by the Treaty of Munster in 1648.

Much of the pamphlet verse celebrating the conclusion of the 1609 Truce employs peasant and soldier as comic types drawn from a long tradition of popular theater and song. Though the stock types allegorize the benefits of peace as against war, they do so in a crude, demotic fashion. In later pamphlets, intimate dialogue between peasant and soldier is replaced by classical allegory and elevated imagery.[3] One of the most famous commemorations of the Treaty of Munster, Vondel's *Leeuwendalers,* conforms very closely to this new, classical style favored by the Amsterdam patriciate.[4]

Prints commemorating the end of the Eighty Years War show a similar shift in style. Admittedly the comic mode of Bolswert's prints after Vinckboons was not the only convention favored even in 1609, but by 1648 it had almost completely disappeared. When Peasant Sorrow does appear, as an auxiliary to a central allegorical scene, it is the small-figured landscape Boerenverdriet rather than the large-scale, comic version.[5]

A significant trend in both Dutch literature and Dutch art, then, seems to be the substitution of classical, allegorical rhetoric and imagery for the pithy dialogue of "real" peasants and soldiers. Certainly one reason for this change was the existence, by midcentury, of a large, literate and sophisticated urban populace aware of the international Baroque style and less readily amused by what was crudely "boorish."[6] The Boerenverdriet theme, with its focus on low stereotypes and peasant violence, was difficult to assimilate for a taste which had adapted to the high pastoral of the Italianate landscape painters and the more tranquil rustics of Adrian van Ostade's later works.

Given this shift in taste which, though limited, prevailed in a very important social group, why were there any versions of Boerenverdriet in the United Provinces after midcentury? What needs and attitudes might these versions express? In answering these questions, it will be helpful to consider the works in three main groups: first, the pictures of the genre or "guardroom" painters of Amsterdam, Utrecht and Delft; second, the small-figured landscape versions of Boerenverdriet produced by the Catholic artists Esaias van de Velde, J. C. Droochsloot and Philips Wouwerman; and finally, the large-figured Peasant Sorrow by Jan Steen.

The works of the genre painters of Amsterdam and Utrecht share some features with Vinckboons' 1609 series.[7] Generally in these works, action takes place in ramshackle interiors, the allegiance of soldiers remains indeterminate, and the focus is usually on a few central figures (e.g., Figs. 33 and 34). But the violence which characterizes the second and third episodes of Vinckboons' series is attenu-

ated in these paintings. In one example by Jan van Velsen (active from 1625 to 1656 in Delft and Amsterdam), an old peasant couple stand before a seated soldier, the woman tendering up a coin while her husband stands with clasped, imploring hands (Fig. 33). Behind them, one soldier removes his cartridge belt while another places his musket on a rack. The focus of the painting is not the human relation between the soldiers and their victims—compared to Vinckboons' Boerenverdriet, there is almost no dramatic interaction between them—but rather the display of armor and weapons lying on the floor in the foreground. The accurately depicted seventeenth-century armor, the sword, sheath and leather objects are portrayed with an attention to surface detail appropriate to a still life. However, the objects themselves are not particularly exotic or glamorous. In contrast to the Flemish painter of guardroom scenes, David Teniers II, who portrayed archaic heavy armor in elaborate and artifical displays, van Velsen paints the standard equipment of the seventeenth-century soldier as it is shown in the military handbooks of the period.[8] Further, the weapons and gear are strewn casually about the floor of the soldiers' lair; nothing in their arrangement suggests a link to the representations of discarded arms which sometimes signify peace in Dutch emblem literature.[9]

In another example from this group of paintings there is little emphasis on the "still life" properties of objects possessed by peasants or soldiers; rather, some of the dramatic intensity (but not the violence) of Vinckboons reappears. The picture, attributed to the genre and portrait painter J. M. Molenaer (1610-1668, Haarlem and Amsterdam), portrays what is evidently the inside of a peasant dwelling (Fig. 34). While his men enter and sack the place, a glamorously dressed officer threatens an old peasant man and the man's wife. A woman behind the officer attempts to restrain him, with a gesture similar to that of the prostitute in Vinckboons' Boerenverdriet. With his free hand, the officer appears to ask a boy to fill his tankard, echoing a motif present in Vinckboons' second episode as well as in late sixteenth-century literature. The indications of exploitation present in the foreground seem partly offset, however, by an episode in the middleground: here, a seated soldier chats with a woman who nurses her child. She is soberly dressed, resembling not at all Vinckboons' elaborately garbed sutler/prostitutes. Is she peasant or camp-follower? Her relation to the troops is not clearly indicated.

While Molenaer's painting in some respects resembles Vinckboons' series more closely than it does van Velsen's picture, its precise context and function remain difficult to establish. Vinckboons' Boerenverdriet is explicitly linked to the pamphlet literature celebrating the conclusion of the Twelve Years Truce. But by midcentury, when the works of Molenaer, van Velsen and other genre painters were produced, the theme of peasant/soldier conflict had largely vanished from occasional literature as well as from the *rederijker* and professional stage.[10]

The genre-style Boerenverdriet may have responded to the same demand which produced scenes of plunder and the literary characterization of banditry as

comic roguery. Pieter Codde, Anthonis Palamedesz, Pieter Quast, Jacob Duck and Willem Duyster all executed scenes of wealthy persons being plundered by soldiers (Figs. 35 and 36). The theme was not new to Northern art; there are many representations of similar subjects by Vrancx and Snayers. The Dutch versions, however, as in the case of the Boerenverdriet theme, are considerably less violent. In a number of Dutch plundering scenes, the appearance of confiscated objects is emphasized in a manner rather similar to the exhibition of arms and armor by Jan van Velsen.[11] Frequently, a standing officer, dressed in a cloak and wide-brimmed hat, dominates the scene as similar figures do in the Boerenverdriets of Molenaer and Codde. In one of Jacob Duck's plundering scenes (Fig. 35), the widespread legs and aggressive demeanor of the central officer, seated amid a disply of extravagant booty, recall the pose of Rubens' landsknecht (Fig. 21), emblem of the most illegitimate aspects of warfare. In another scene of pillage by Pieter Quast (Fig. 36), a rich couple are detained by a group of armed ruffians who are portrayed in a grotesque mode which resembles Callot's theatrical print series. (In the background of Quast's picture, a peasant man and woman can be seen pleading with a horseman, so that a clear connection exists here between Boerenverdriet and banditry.

Virtually all of these pictures endow pillage with a certain glamor. The marauding captains never stoop to the acts of brutality depicted in plundering scenes by Vrancx; the alluring visual qualities of the victims' fancy dress and the jewelry and fine metalwork which most often comprise the booty are lovingly rendered. Yet, at the time these works were painted, military law had long ruled out the kind of free-lance plunder which they represent. An elaborate code obtained, by which booty could not be accumulated or sold at the whim of individual officers, but had to be brought to a central authority who would decide how to dispose of it.[12] Furthermore, legal writers such as Grotius and others agreed that going to war for the sake of plunder (in antiquity a perfectly acceptable practice) was a crime.[13]

Notwithstanding their appearance in the visual arts, it has been argued that outlaws and bandits played an insignificant role in Dutch popular culture.[14] Seventeenth-century Holland produced no legendary "social bandit" of the Robin Hood type,[15] nor does the native literature portray the buccaneer hero, as exemplified, for example by *Estebanillo Gonzales*. The sole instance in Dutch drama in which a bandit plays a major role is Samuel Coster's *Thysken van der Schilden*, and its hero, represented as a *vrijbuiter* from the early period of the Eighty Years War, is not viewed sympathetically.[16] In fact, at the end of the play he is executed, and his death serves as a moral example to all. Thus, Thysken's exploits can hardly be said to be a literary parallel to the Amsterdam and Utrecht plundering scenes, in which marauders never physically harm their victims, there is delight in the richness of plunder, and no indication is given that the plunderers are either likely to get caught or deserving of punishment. How, then, can the attraction of precisely

those activities defined as unlawful—an attraction to which this group of paintings clearly testifies—be accounted for?

The overall tone of the plundering scenes displays that fascination with lawlessness which characterizes the picaresque genre. Picaresque novels, while popular in the United Provinces in translation, never flourished as a native form.[17] However, the picaresque attitude surfaces in a little-studied area of Dutch literature known as the *grillen,* basically, a type of comic anecdote.[18] One anthology of this sort, entitled *De Gave van de Milde St. Martin,*[19] contains a number of pieces involving *vrijbuiters* (see above, Ch. 1, p. 2) and *boerenplagers* (literally, peasant plaguers, which could refer to any soldiers, renegade or legitimate. See Ch. 1, pp. 3–4). A ''conscientieuse Struykroover'' makes a vow to keep only half of what he steals, thus considering himself virtuous.[20] Another episode concerns an encounter between a peasant and the captain of a troop of soldiers billeted in his village. The soldiers have robbed the peasant, and he goes to the captain to complain, but the captain only responds with a question: when they took your money and cloak, were you also wearing other clothes? When the peasant answers affirmatively, the captain then announces that the robbery certainly wasn't committed by his men, for they would have stripped the peasant down to his very shirt.[21]

In both these tales, and in others in this collection of *grillen,* banditry and *vrijbuiterij,* as well as exploitation of the peasantry, are seen as occasions for comedy. The soldiers and outlaws, all of unspecified allegiance, are not condemned for their behavior; on the contrary, it gives them a certain panache. Further, in this collection the boundaries between ''Peasant Sorrow'' (a sharply defined theme in the 1609 Truce literature) and mere banditry are blurred. The same is true of the paintings of the Amsterdam and Utrecht genre painters, although the level at which they engage our sympathy for the wealthy or peasant victims of soldiers and marauders does vary from work to work. The pictures of Duck, Quast and Molenaer are closest to the tone of the *grillen,* while those of Palamedesz, Codde and van Velsen are more sober. Although David Vinckboons' Boerenverdriet is far from being a somber catalog of peasant wrongs, and has in common with these works an intimate interior setting and a popular style, the evident potential for violence in peasant/soldier encounters seen in the earlier series is largely banished from the later paintings. Such a casual attitude toward banditry and rural plunder could only have flourished in an area which had been safe from both for many years.

Despite the prevalence of the tamed version of Boerenverdriet in the work of the genre painters discussed above, violent portrayals of Peasant Sorrow did not totally disappear from Dutch art. In Haarlem before 1648, both Esaias van de Velde and his pupils Jan van Goyen and Pieter Molijn had produced landscape Boerenverdriets which closely resemble the Flemish tradition of Vrancx and Snayers (Fig. 37). However, in Esaias' and van Goyen's works Vrancx' explicit partisan references are absent. Soldiers are not identified by sashes or cockades,

nor is any particular historical event portrayed. Further, the figures in Esaias' paintings are sparser and the episodes of violence somewhat less brutal than they are in the works of the Flemish school. In some cases, Esaias seems to introduce the theme of a night raid on a peasant village simply to demonstrate his skill in rendering the spectacular lighting effects of fire at night.

The Catholic artists J. C. Droochsloot and Philips Wouwerman produced Dutch versions of Boerenverdriet in which partisan concerns are central.[22] Droochsloot (1586-1666, active mainly in Utrecht), a little-known painter who executed scenes of peasant festivity in the Flemish tradition and a smaller number of religious works, painted the subject of Peasant Sorrow many times (e.g., Fig 38). While his versions of the theme are rather wooden and lifeless compared to those of Vrancx and Snayers, they are almost always of a partisan nature like the works of the Flemish painters. While Droochsloot does not identify his troops with the orange, blue and white cockade of the States' army, prominent in his scenes of ravaged villages are tonsured monks who are led away by soldiers. Such focus on molestation of the clergy is not a part of Vrancx' partisan view; Vrancx portrays chiefly incidents in which ordinary peasants are harassed by Protestant troops. However, both the Flemish painters and Droochsloot often depict a village church going up in flames.

Philips Wouwerman (1619-1668, active in Haarlem and in France), a much more accomplished artist than Droochsloot, specialized in military subjects. In his case, portrayal of Peasant Sorrow seems to have emerged from a concern with aspects of soldierly existence rather than from the round of peasant life. Many of the subjects which he painted—drinking or gambling soldiers gathered at a sutler's tent, armies setting up camp, small-scale military skirmishes, fights between anonymous troops and peasants—were used in the seventeenth century to decorate military handbooks and siege prints. In Callot's 1628 *Siege of Breda*, for example, the walled city and the deposition of the offensive troops are shown from an elevated perspective, while in the foreground and middleground, from a lower point of view, we see a group of soldiers gambling, as behind them countryfolk and troops battle over possession of livestock in front of a rustic dwelling. This type of incident became standard in the siege paintings of the time; see for example, the *Siege of Hertogenbosch* painted by P. van Hilligaert. Since siege prints and paintings were largely commissioned by rulers who wished to use them as aids to military education, it is likely that the kinds of incidents portrayed are fairly accurate representations.[23] Often a siege meant months of tedious waiting, so that troops may well have amused themselves with dice and cards;[24] certainly siege technique meant disruption and disaster for the surrounding countryside (see Ch. 1, p. 3). Wouwerman selects the realistic incidents which Callot and others used in their siegecraft portrayals—living off the countryside, campmaking, gaming—and makes each the subject of individual pictures. In the process of divorcing these activities from their functional military context he also embellishes them to a de-

gree. Stopping by a sutler's tent becomes a festive occasion; incidents between peasants and soldiers escalate into full-scale battles (Fig. 39).

Like Droochsloot, Wouwerman also introduces religious conflict into his portrayal of the Boerenverdriet. In one example (Fig. 40), a troop of soldiers slaughter a peasant community, leaving the dead bodies of the countryfolk where they have fallen over their makeshift weapons. In the left middleground, a tonsured monk is led away, while at the center of the painting a chalice, crucifix and scattered fragments of the Host are trampled by a cavalry officer's horse. Droochsloot's Boerenverdriets take place in villages closely resembling the Flemish locales portrayed by Vrancx and Snayers, but in this picture the hilly landscape and the architecture are not characteristic of the Netherlands. Elsewhere, Wouwerman portrays the theme of Peasant Sorrow in level terrain dotted with windmills and dikes, suggesting a Dutch setting.[25]

Boerenverdriet, in the hands of the genre painters of Amsterdam and Utrecht, can express a roguish vision of banditry and plunder. What function can the works of Droochsloot and Wouwerman, which continue the focus on violence and the historical specificity characteristic of the Flemish landscape school, have served in the Northern provinces after the Treaty of Munster? In the Dutch pictures, it is true, we have no definite allusions to particular events, as we do in the "Maypole" Boerenverdriets of Vrancx and Snayers. Yet the other features which the two groups of pictures share suggest that the Northern pictures may be related to historical occurrences in a similarly concrete and descriptive way.

It is well-known that although the 1618 Synod of Dort made orthodox Calvinism the dominant faith of the United Provinces, even at that time the Calvinists were by no means a majority. Especially in the countryside, the process of Calvinization proceeded extremely slowly.[26] In some cases, for example, the tyranny of the States' general Sonoy over the peasants of North Holland (see Ch. 1, p. 13), Calvinism was brought to the rural populace by force of arms. As one historian has described it,

> Een troep soldaten werd naar een bepaald dorp gezonden, eiste daar de kerk op, richtte een beeldenstorm aan en geinstalleerde de meegevoerde 'Legerpredikant' in het gezuiverde kerkgebouw.[27]

> [A troop of soldiers would be sent to a certain village, there demand that the church be opened, perform acts of iconoclasm, and finally install in the purified church the "Army-preacher" who had accompanied them.

Do the pictures of Droochsloot and Wouwermans commemorate such events for the benefit of a Catholic audience? Since Catholic popular culture in the Netherlands has been so little studied, we can only speculate about whether this kind of event entered into popular historiography, pamphlet literature and painting as did Frederick Henry's 1622 plundering raid in Brabant. The question is also relevant

to a version of Boerenverdriet very different from the versions of Wouwerman and Droochsloot but also produced by a Catholic painter: Jan Steen's *Sauvegarde van den Duyvel*.

While the relation between Steen's confession and his art has been investigated (if not resolved), research has focused chiefly on his religious and historical paintings, leaving his genre paintings aside.[28] In his version of Peasant Sorrow to be discussed here, Steen conflates the comic mood, large-scale figures and aggressive energy of Vinckboons' Boerenverdriet with the partisan strife introduced to the theme by the Flemish landscapists.[29] The picture (Fig. 41), taking its title from the small, lettered plaque visible in the upper left corner, includes a powerful image of peasant wrath, in contrast to the tranquil scenes of the Amsterdam and Utrecht genre schools and the passive acquiescence of the villagers depicted by Droochsloot and Wouwermans. At first Steen's picture appears to be a confusing free-for-all between the flail-wielding peasant, a Protestant dominee, a Catholic friar and a troop of soldiers and their captain.[30] But although monk and minister are at the center of the composition, it is in fact not religion but rather the captain's amorous pursuit of a peasant girl that is the immediate cause of the conflict. Like the wrathful peasants painted by Bruegel, Martin van Cleef, and Vinckboons, the boer who comes to her defense verges on the grotesque; his eyes protrude with rage, and his wife, playing a traditional role for peasant women, attempts to restrain him (see Ch. 3, p. 40). At the far right of the painting, two figures who seem more festive than martial lead off a heavily laden ox. Their relation to the lascivious captain is unclear. Are they members of his party who are plundering the peasants while he sports with the girl? Are they peasants fleeing with what few things they can salvage from the soldiers' onslaught? Why do they brandish grill and kettle, traditional festive noisemakers of the Carnival and Shrovetide holidays?

The literature on this picture is scanty and addresses few of these questions specifically. Because Peasant Sorrow was a popular theme for dramatic treatment during the first half of the seventeenth century, and because of Jan Steen's involvement with various *rederijker* kamers and the Amsterdam stage, one author has suggested that the picture may represent a theatrical performance.[31] But no work from the latter part of the century has been found which has any direct bearing on the events portrayed, nor do the surviving plays from the early century seem directly relevant.

The title of the picture is in itself suggestive. According to L.G. Rogier, the early years of the Reformation in the North sometimes saw the armed installation of Protestant priests in unfriendly villages. These military escorts were known as *sauvegardes*. It is true that such troops sometimes engaged in iconoclasm, razing Catholic churches and destroying holy objects; the violence of the soldiers, however, does not seem to have often been directed against persons nor to have taken the specifically sexual character of the assault by Steen's captain. The troops

in Steen's picture hardly seem preoccupied with religion at all: it is the monk who seems the dominee's protector rather than the so-called *sauvegarde*. If the actual practice of *sauvegarde* escort, as a component of what has been called the "forced Protestantization" of the Netherlands,[32] has any bearing on Steen's *Sauvegarde van den Duyvel*, it must be highly mediated, for not only was the practice defunct by the 1660s but the entire tone of the picture relies heavily upon comic conventions.

Steen's lustful mustachioed captain follows the tradition of the blustering, wenching officers who invade the peasant dwelling in Vinckboons' *Boerenverdriet*, and who ultimately derive from the high-living soldiers in fifteenth- and sixteenth-century Northern prints. Similar figures appear elsewhere in Steen's art; for example, in his *Brawl before an Inn* [Berlin: Dahlem] where the captain draws his sword against a peasant in a gambler's quarrel. S. J. Gudlaugsson believes this officer type comes from the *commedia dell'arte;* the type is called Il Capitano, famous for cowardice and a preference for wine and women.[33] But whether the source for this figure is Italian theater or Northern visual tradition, the captain's comic significance is evident: his pursuit of the peasant girl is far removed from the brutality of the soldiers shown by the Flemish landscapists as well as by Droochsloot and Wouwerman.

Like the captain, the monk portrayed in the *Sauvegarde van den Duyvel* is a comic type, although his antecedents are less clear. His habit, with its cowl, towbelt and neutral, brownish-grey color, roughly resembles that of a mendicant friar, but is not distinctive enough to identify him as a member of a specific order.[34] Nor do the holy objects scattered on the ground—a missal, wooden crucifix and devotional pictures—identify him any more precisely. The position of the Cross on the back of his habit is baffling—clearly it is intended to be derisive, yet the monk's peace-keeping role and courage seem positively viewed.

The meaning of this figure becomes less puzzling when we consider a second instance in which Steen portrays an affray of monks, soldiers and peasants. In this picture [formerly Col. John Crichton-Stuart, Marquess of Bute: London],[35] a group of friars and peasants are seated around a table, drinking together, when a troop of soldiers interrupts their enjoyment. During the Reformation, drinking monks were frequently the target of satire, in the visual arts[36] as well as in the writings of Luther, Erasmus and others. The equivocal, teasing tone of Erasmus' *Praise of Folly* turns into polemic when he attacks the monastic orders "who shrink from the touch of money as if it were deadly poison, but are less restrained when it comes to wine or contact with women."[37] In the Marquess of Bute picture, however, the monks seem to be viewed sympathetically rather than antagonistically. The festivity of the friars is shared with the peasants; moreover, both here and in the *Sauvegarde van den Duyvel,* the monks attempt to intervene to stop the violence initiated by the troops. Steen's view of the monastic order appears anachronistic; in some respects closer to that of Rabelais than to anyone in his own historical

period. Rabelais' writings portray the festive activities of the mendicant orders affirmatively, as part of the antihierarchical, utopian world of the old church calendar.[38] Similarly, the comic aspects of Steen's monks integrate them into village life rather than making them objects of ridicule. It is the soberly dressed dominee, forced ignominiously to the ground, who seems an intruder.

Popular festive customs, frequently portrayed by Jan Steen, also make their appearance in the *Sauvegarde van den Duyvel*. Along with the brawling peasant, oddly garbed monk and lustful captain, the two male figures at the right of the picture articulate the comic mood. The taller of the two figures, a portrait of Steen himself,[39] brandishes a roaster or grill with which he is about to strike the overturned kettle on the head of his younger companion. These kitchen implements were typically used as holiday noisemakers—"Op de rooster spelen" was the proverbial expression for merry-making of this sort.[40] We also see grill and kettle, along with other implements, deployed in this fashion in Steen's portrayal of Driekonigavond[41] and, much earlier, in Pieter Bruegel's *Battle between Carnival and Lent*. But while these objects have well-known functions in the traditional celebrations of Shrovetide and Carnival, their place in the context of Steen's version of Peasant Sorrow is unclear. We have seen that in David Vinckboons' Boerenverdriet, peasant men and women use farm tools and kitchen implements to drive away their unwanted military guests. Their posturing with these tools is unambiguously aggressive (see Figs. 14–19). The mood of the two figures in Steen's picture is, however, one of playful mirth. What might account for the presence of these elements in the *Sauvegarde van den Duyvel?*

Earlier, we have noted that interruption of peasant festivity is often a feature of Peasant Sorrow in art and literature. Vrancx and Snayers show May Day celebrations interrupted by Frederick Henry's plundering raid: David Rijckaert's pendants *Boerenkermis* and *Boerenverdriet* and Huygen's Zedeprent "Een Boer" portray the normal round of peasant life as a peaceful festive one disrupted only by intruders. But whereas May Day and Kermis were collective holidays, celebrated by the entire village, in Steen's *Sauvegarde van den Duyvel* only two figures are portrayed in the festive mode. Further, the other important standard features in the representation of Kermis and May Day—in the first instance, dancing and drinking; in the second, the Meiboom—are absent from Steen's work.

One folk practice widespread in seventeenth-century Europe involved the festive use of kitchen implements and was performed by small groups of young men. This was the noisy, sometimes costumed demonstration directed against local wrongdoers, practiced in France under the name of *charivari* and known in the Low Countries as *scherminkelen* or *ketelmuziek*.[42] The occasions for such enactments of folk justice were varied, but they centered chiefly on sexual matters. A husband cowed by a domineering wife, a widow or widower making a second marriage, an older man courting a young girl were all vulnerable to this ritual ridicule. Because *ketelmuziek* was often instigated by village youth groups, the last target

(the overage suitor) can be viewed as a result of resentment against the loss of an eligible bride to someone considered inappropriate. Typically, a *charivari* focussed on an overaged suitor would contain a good deal of sexual innuendo. In addition, if the suitor came from outside the community, the ceremony could become violent.[43]

The popular festive use of kettle and grill in Jan Steen's *Sauvegarde van den Duyvel* may be a variant on *charivari* or *ketelmuziek*. Although Steen did not portray this particular practice in other works, the specifically sexual character of the custom is appropriate to the events depicted in the *Sauvegarde van den Duyvel*. By the criteria of folk justice, the leering captain is an unworthy suitor for the peasant maid on two counts: his age (though not a graybeard, he is considerably older than the girl he pursues)[44] and the fact that he is an outsider to the community. As in the final episode of Vinckboons' *Boerenverdriet*, sexual innuendo deflects attention, to a certain extent, from the social aspects of peasant/soldier conflict, and renders the action more farcical. Only the smoke from a burning village in the distance and the rage of the flail-carrying peasant (though this also has its comic side) undercut the festive mood of Steen's picture.

So far, we have attempted to sketch the kinds of activity represented in the *Sauvegarde van den Duyvel,* and to establish its place in the tradition of the comic *Boerenverdriet.* But in order to understand how Steen's work, as the last major version of Peasant Sorrow painted in the seventeenth century, interweaves the comic with the partisan, religious features associated with the theme, we need to look more closely at the historical context of the work.

In the 1660s, when the *Sauvegarde van den Duyvel* was painted, popular festive customs such as those represented by Steen in this picture and elsewhere were the focus of religious and social controversy.[45] The Synod of Dort could not create a Calvinist majority by fiat, and even by 1650 only half the population of the United Provinces was officially Protestant.[46] Catholic practices continued, especially in the countryside, to the dismay of the Synods. Along with the banning of Catholic worship and the prohibition of Catholics from public office, an attack was launched on popular festivities tainted by their connection to the Roman church. Throughout the latter part of the century, the Calvinist church hierarchy protested celebration of Kermis, Driekoningenavond (Twelfth Night), Carnival and other holidays, as well as more informal practices such as *rederijker* comedies, public dancing and wedding skits.[47]

The Synods had strong reasons for objecting to such popular celebrations. Theologically, the festivities smacked of superstition and popery. On the ethical side, popular entertainment such as the Kermis led to dancing, drinking and other sorts of uncontrolled reveling. The social consequences of such activity could be grave. Although the interplay between popular cultural forms and social conflicts in the seventeenth-century Netherlands has been little studied, research on rural society in France in the same period has shown that the continued practice of Car-

nival, Kermis and other fetes, particularly in areas where they had been suppressed by Protestants, nearly always assumed a political cast and in some cases exploded into violence.[48]

In this battle between the Calvinist church authorities and popular festivity, which side did Jan Steen take? In spite of what is known about his confession, evidence for explicit affirmation of threatened Catholic culture is equivocal in both the *Sauvegarde van den Duyvel* and the other instances in which Steen paints popular celebrations. It is true that in his version of Peasant Sorrow, Steen includes himself as one of the revellers. But this need not necessarily imply total support of or identification with the revelry, any more than does Rembrandt's self-portrait as the Prodigal Son.[49] In fact, Steen's self-portrait shares some of the self-consciousness of Rembrandt's: he too looks out at the viewer, alone among the other participants in the melee in showing awareness of his role. Detachment from the activities depicted is indicated in other ways as well. The large figure of the wrathful peasant, for example, is very much in the low comic tradition of Bosch, Bruegel and Vinckboons (see Chs. 2 and 3). It is also a measure of Steen's distance from the reality of peasant life that the invasion of a village by troops, portrayed by Vrancx and Snayers in all its chaotic immediacy and brutality, is here treated so gaily. While we have argued earlier that the theme of Peasant Sorrow sometimes pierced the comic and pastoral conventions in which peasant life was usually framed, the *Sauvegarde van den Duyvel,* perhaps even more thoroughly than Vinckboons' *Boerenverdriet,* assimilates the theme to the comic mode. It would thus be mistaken to assume that Steen, any more than Bruegel or Vinckboons, painted for or was a social advocate of the peasantry.

On the other hand, it could be said that comedy was itself a weapon in the struggle between the Protestant church elite and the old popular culture. Is it significant that the popular *Boerenverdriet*, omitted from the literature and art celebrating the Peace of 1648, surfaces nearly twenty years later in the work of a Catholic artist? The most recent study of Steen's religious pictures maintains that what is fundamentally anti-Protestant about them cannot be defined iconographically, but inheres instead in Steen's comic interpretation of Scripture.[50] By portraying, for example, Samson in the role of a drunken captain and Delilah as a greedy prostitute, Steen violated the sober literalism of the Protestant attitude toward Biblical narrative. Whether Steen's paintings of such popular festive forms as Shrovetide, Kermis, *rederijker* jubilees and *ketelmuziek* represent an affirmation of Catholic culture remains to be seen.[51] Certainly, though, the *Sauvegarde van den Duyvel,* with its juxtaposition of violence and festivity and suggestion of religious conflict, is charged with an energy absent from the versions of Peasant Sorrow produced by the Amsterdam and Utrecht genre painters. Only the print series made by Romeyn de Hooghe after the French attack in 1672 matches Steen's work in intensity, and in de Hooghe's series Peasant Sorrow is presented as brutally as it is in the works of Vrancx and Snayers, unshaped by the popular forms which temper the works of Vinckboons, Rubens and Steen.

Conclusion

In the study, we have examined the varying visual traditions and historically specific functions of the Boerenverdriet theme in Dutch and Flemish art. We have contrasted the violence and chaos of the small-figured Flemish versions with the more ordered pictures of Vinckboons, Rubens and Steen, and observed that Peasant Sorrow appears to come full circle in Romeyn de Hooghe's occasional prints depicting the French atrocities in the Dutch villages of Zwammerdam and Bodegraven in 1672.[1] In conclusion, it is important to attend to the continuity which links, as well as the differences which separate, the works which we have considered as variations on the theme of Peasant Sorrow.

In some measure all these representations are concerned with the actual havoc wreaked by mercenary armies in the late sixteenth and early seventeenth centuries. But caution is required when inferring specific links between these works of art and large-scale historical changes. Recently, the representation of military violence against civilians in the art of the seventeenth century has been claimed as evidence for the development of a new and more humane attitude toward warfare. Theodore Rabb rightly points out that the character of warfare during this period, with its vast armies and protracted disruption of civilian life, led to an increased concern with limitation of war excesses:

> The momentum that the violence [of the Thirty Years War] built up had been so powerful that it took two years after the signing of the peace [of Westphalia] to bring the serious skirmishing to an end, and another four years to persuade soldiers to return home from their garrisons and end their state of readiness. No wonder it seemed that the avalanche of combat might shatter European society beyond recall, or that the relief at its end should have been immense enough to change the nature of warfare: to end, for a while, the "swath of destruction" policy enunciated by Gustavus. . . . Although armies continued to grow, their viciousness and spoliation declined—a unique reversal that signifies how deeply the European conscience had been seared by the events of the 1620s to 1640s.[2]

Art, Rabb argues, occupied the vanguard of this changing consciousness, contributing to the new sensibility which he says ultimately tamed armed conflict in the late seventeenth and eighteenth centuries. Works such as Callot's *Misères de la Guerre* and Rubens' Pitti allegory make radical departures from old patterns and

are important examples of the new attitude. In Callot's 1633 print series Rabb claims that the marauding soldiers who are brutally punished for plunder and rapine are viewed as sympathetically as the peasants and other civilians they harass: "These are the victims of war as much as the perpetrators of its crimes."[3] Moreover, Rabb sees Rubens' *Consequences of War* as the visual correlative of a profound change of heart, a "recantation of awesome proportions"[4] from the painter of Hapsburg military heroes and the martial Decius Mus series.

Neither these interpretations nor the explanatory use to which Rabb puts them are convincing. Not only is much of the art which Rabb deals with perfectly in accord with, rather than in advance of, existing political practice, but also a number of works which from his point of view appear to exhibit general revulsion from excess in war are in fact local, limited and partisan in their subject matter. By adhering to the common view that Callot's *Misères* is a critique of war itself, Rabb along with others denies the possibility that the print series might simply describe current practice as represented in the military handbooks of the period. The types of punishment meted out to Callot's unruly troops were, as we have seen in Chapter 1, explicitly justified by the new military codes.[5] There is every reason to suppose that Callot found such discipline acceptable, and that the final print of the series which shows obedient troops rewarded for their legitimate acts is perfectly straightforward and unsatirical. Further, Rabb's assertion that Rubens' Pitti allegory signifies a renunciation of martial values ignores the fact that as late as 1635 Rubens continued to celebrate *just* war in his depiction of Hapsburg victories for the Joyous Entry of the Cardinal Infante Ferdinand. Rubens' art, with its unflagging support of the Hapsburg cause, is congruent with much of the "just war" theorizing which had developed since the Renaissance. According to this doctrine, war in the proper hands is a legitimate means of maintaining order.[6] *Carousing Landsknechts* can also be comprehended within the "just/unjust war" distinction: its focus on the specifically illegitimate and unpredictable side of warfare by no means expresses a new sensibility critical of war itself.

Similarly, Bruegel's *Massacre of the Innocents* is not an expression of "outrage against the violence of war,"[7] but rather an indictment of the unjust use of political authority, although the artist leaves it to the viewer to make out who the contemporary Herod may be. Vrancx and Snayers single out the excessive actions of the enemy in their portrayals of the States' plundering raid on Brabant, just as Romeyn de Hooghe attributes responsibility to French license, not to warfare itself. De Hooghe could have chosen to document the outrages committed in 1672 by troops hired to defend the United Provinces; that he did not is significant.[8]

Thus Rabb's suggestion that art of the early modern period communicates a new, nonpartisan revulsion against war excess is unconvincing. What about the merit of the causal claim that a crisis of conscience led to milder conflicts in the late seventeenth and eighteenth centuries? Whether such improvement actually occurred is debatable; in any case, George Clark and others[9] suggest that any amelio-

ration in war practices may have been a side-effect of increased rationalization and centralization of state power rather than the result of troubled conscience. It was in the practical interest of the great powers to maintain orderly armies and not to antagonize potential allies by unchecked raiding and plunder of civilians. Moreover, seventeenth-century theorists did not unequivocally condemn exploitation of civilian populations during the prosecution of a legitimate conflict. In the case of Grotius, for example, the way to harassment of civilians remained open to arguments of expediency.[10] At least on the political level, then, explanation of changed conditions in the later part of the century does not require the interjection of a ''new attitude'' toward war.

Art, of course, need not necessarily reflect the apparent pragmatism of political and military thinkers. Thus it is somewhat surprising to find that so many painters of the Boerenverdriet, Vrancx, Snayers, Wouwerman and de Hooghe among them, did take sides even when apparently neutrally reporting an event. In instances in which the allegiance of the combatants is left open, it is less clear that art reflects the prevailing political realism. In the versions of Peasant Sorrow produced by Vinckboons and Rubens, the image of the landsknecht and his victims at first appears to satisfy the requirements for a nonpartisan symbol of the horrors of seventeenth-century war. Vinckboons, however, renders the historical specificity of the image ambivalent by associations to the unchanging human passion of anger, while Rubens balances *Landsknechts* with the Joyous Entry festivities which assume that in the right hands war is necessary and just. Thus the Dutch and Flemish Boerenverdriet rarely challenges, but more typically reinforces, prevailing views on warfare and violence.

1. Pieter Bruegel, *The Massacre of the Innocents*

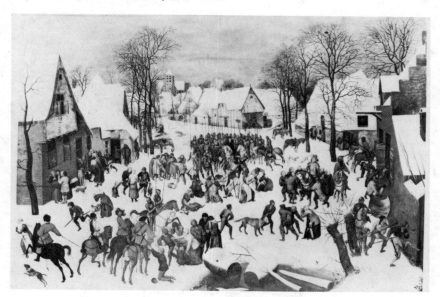

2. ''Hausbuch Master,'' *The Children of Mars*

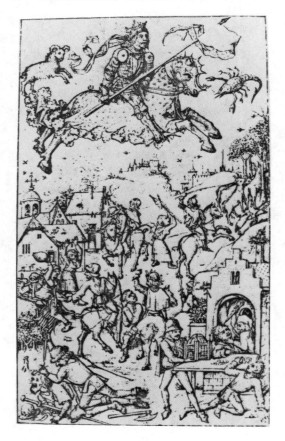

3. George Pencz, *The Children of Mars*

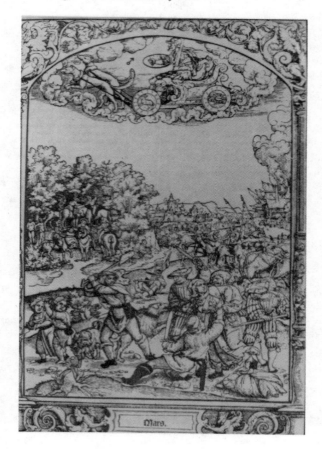

4. Joachim Wtewael, *The Maiden Plundered*

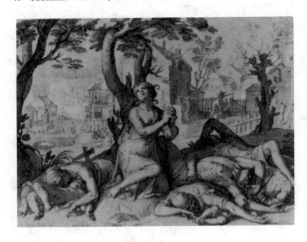

5. *Alva as Chronos*

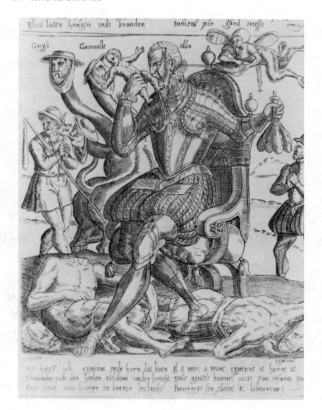

6. *Roelandt Saverij, Plundering*

7. Hans Bol, *Landscape with a View of the Scheldt*

8. Sebastien Vrancz, *Plundering*

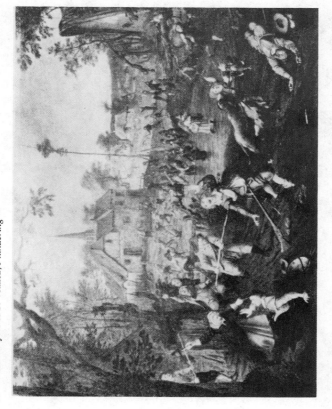

9. Pieter Snayers or S. Vrancz, *Plundering*

10. After P. Snayers, *Plundering*

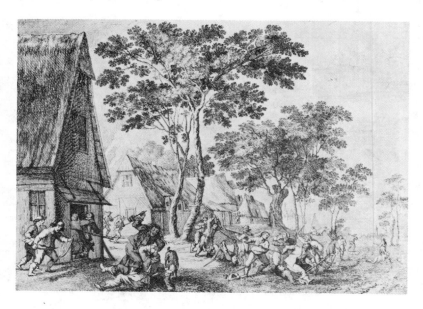

11. H.S. Beham, *Acker Conz and*
 Claus Waczer

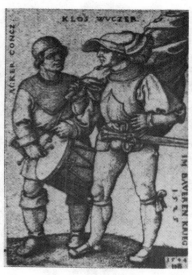

12. Martin van Cleef, *Peasants Attacking Soldiers*

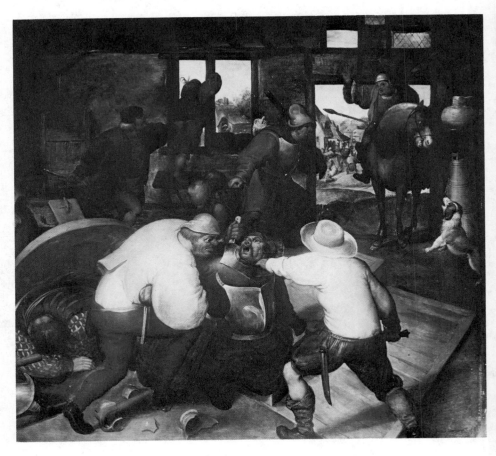

13. Pieter Bruegel II, *The Attack*

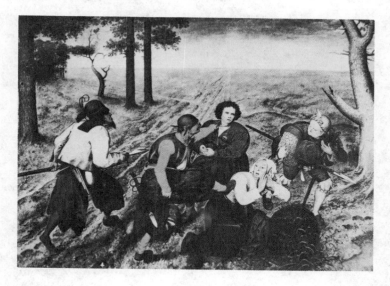

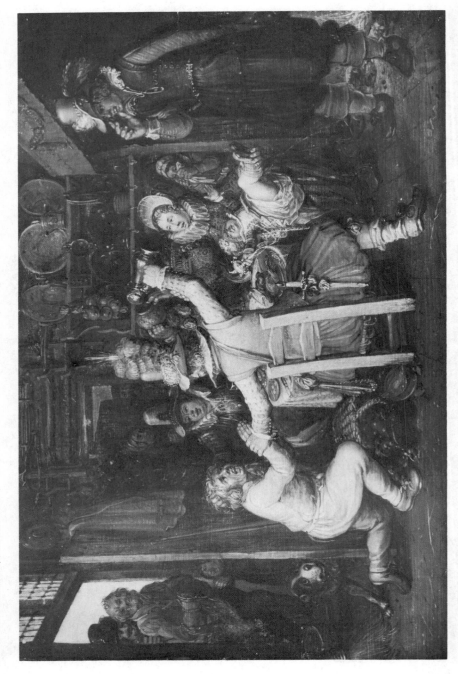

14. David Vinckboons, *Boerenverdriet*

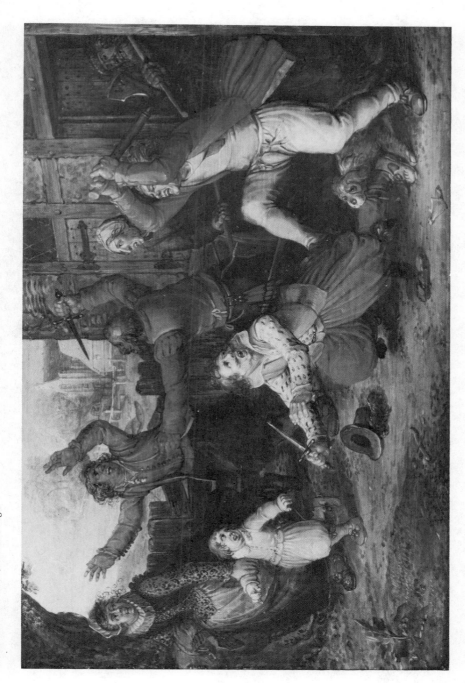

15. David Vinckboons, *Boerenvreugd*

16. Bolswert after Vinckboons, *Zinneprent op het Bestand*

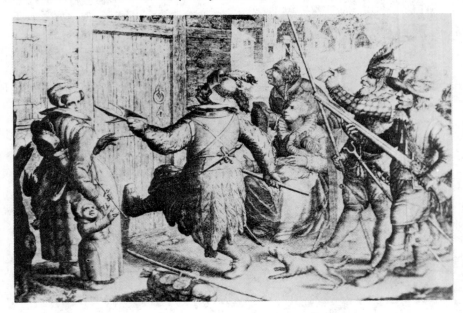

17. Bolswert after Vinckboons, *Zinneprint op het Bestand*

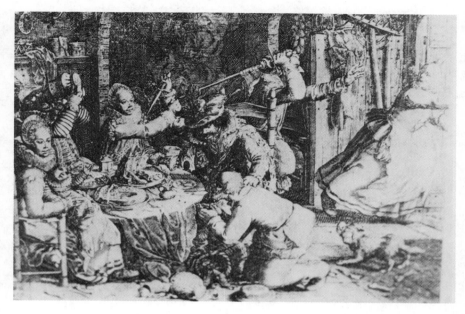

18. Bolswert after Vinckboons, *Zinneprint op het Bestand*

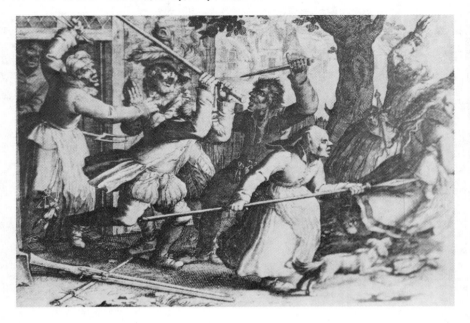

19. Bolswert after Vinckboons, *Zinneprint op het Bestand*

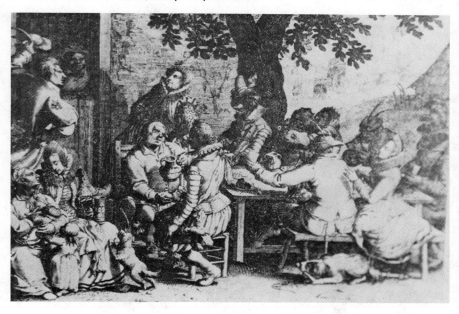

21. After P.P. Rubens, *Carousing Landsknechts*

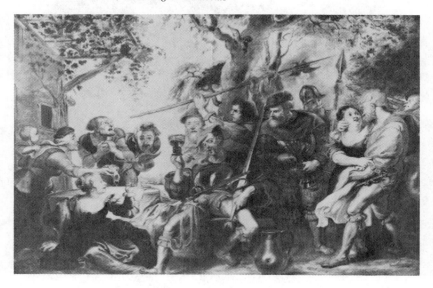

22. After P.P. Rubens, *Carousing Landsknechts*

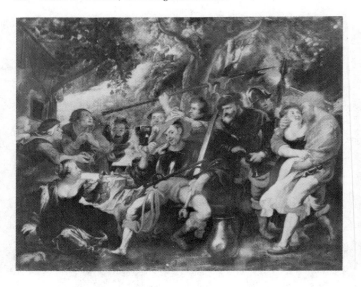

23. F. Wijngaert after P.P. Rubens, *Carousing Landsknechts*

24. P.P. Rubens, *Carousing Landsknechts*

25. David Rijckaert III, *Plundering*

26. David Rijckaert, *Plundering*

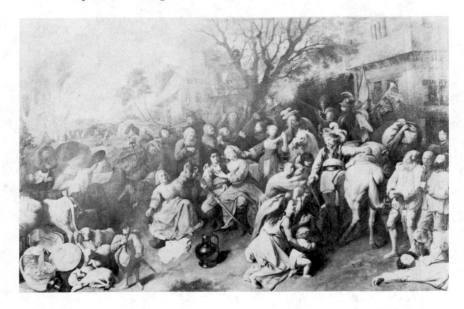

27. David Rijckaert, *Kermis*

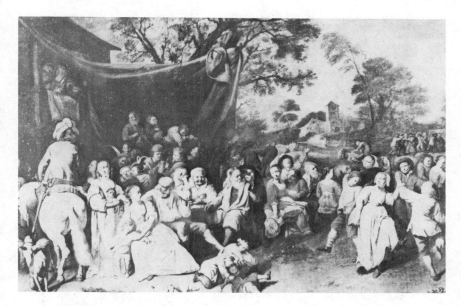

28. Jacob Duck, *Plundering*

29. A. Altdorfer, *Footsoldier with a Sword*

30. C. Anthonisz, *Sorgheloos at the Inn*

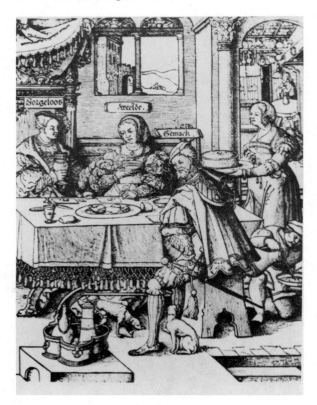

31. C.Anthonisz, *Sorgheloos Dances*

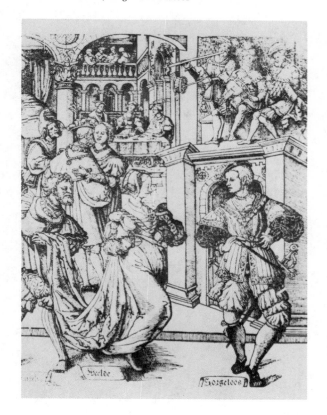

32. C. Anthonisz, *Sorgheloos Gambling*

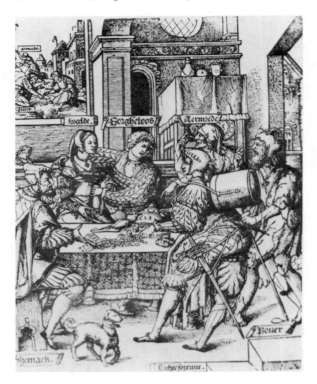

33. Jan van Velsen, *Peasants and Soldiers*

34. J.M. Molenaer, *Sack of a Farm*

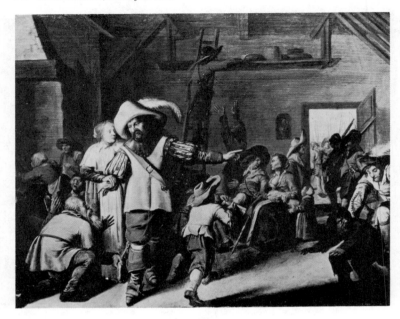

35. Jacob Duck, *Plundering*

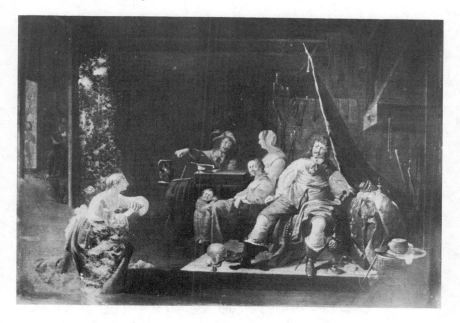

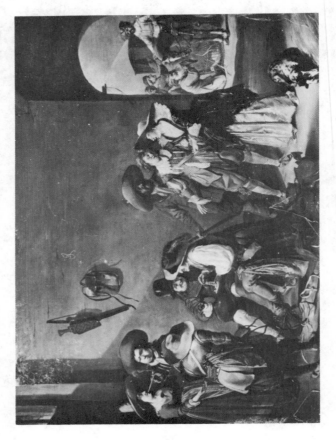

36. Pieter Quast, *Bandits*

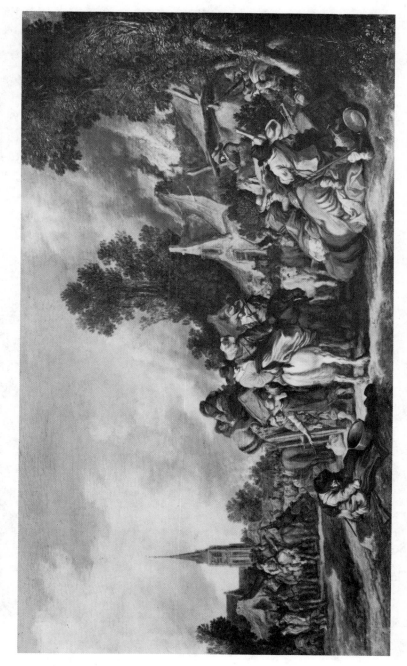

37. Pieter Molijn, *Raid on a Village*

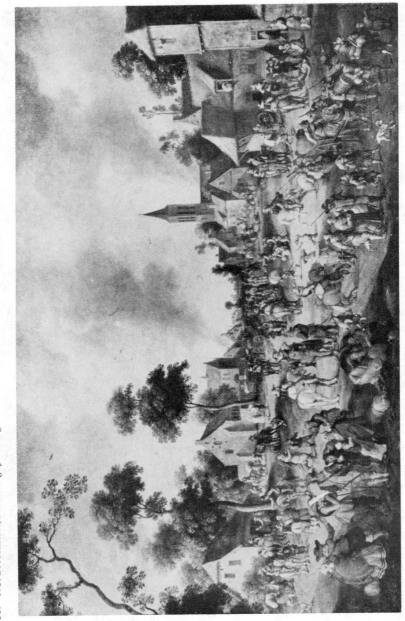

38. J.C. Drooischloot, *Plundering of a Village*

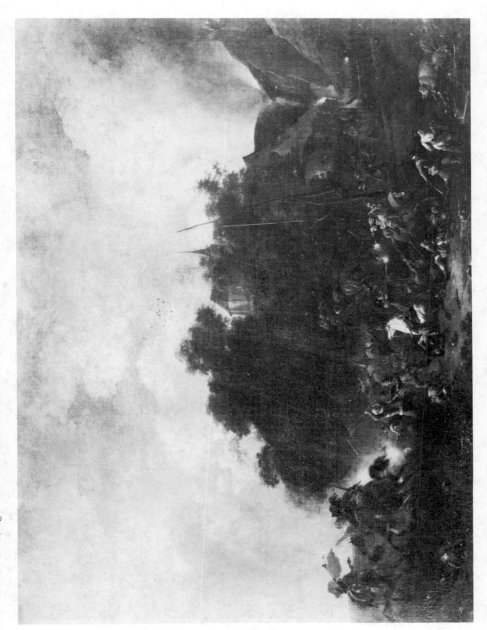

39. P. Wouwerman, *Fight Between Peasants and Soldiers*

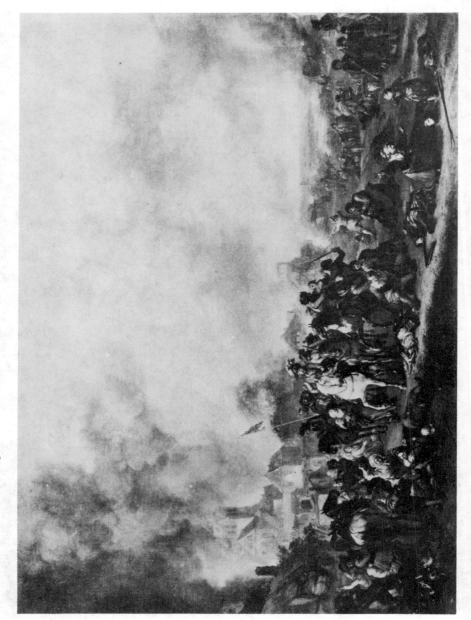

40. P. Wouwerman, *Raid on a Village*

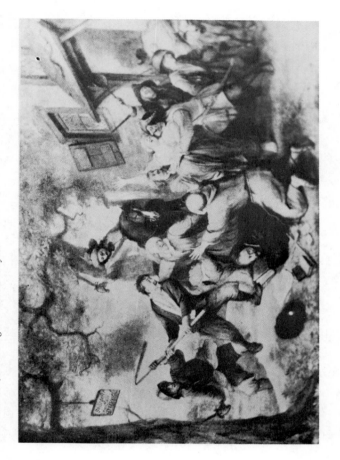

41. Jan Steen, *De Sauvegarde van den Duyvel*

Notes

Introduction

1. While there is no question that the immediate motivation for *Guernica* was the 1937 bombing, it is ironic that the pictorial sources of this picture, which more than any other has come to symbolize the *public* calamity of twentieth-century war, have proved to be deeply personal and private. H. Chipp (in: *"Guernica:* Love, War, and the Bullfight," *Art Journal* 1973-74: v.33, no. 2) has shown that *Guernica* incorporates imagery portraying the history and break-up of Picasso's love affair with Marie-Thérèse Walter.

2. See, for instance, Anthony Blunt, *Picasso's Guernica* (New York: 1969) and Rudolph Arnheim, *Picasso's Guernica: Genesis of a Painting* (Berkeley and Los Angeles: 1962). Arnheim maintains that Goya's *Desastres* and Callot's *Misères* are sources for *Guernica*.

3. For a Marxist critique of both *Guernica* and its critical history, see Bram Dijkstra, "Painting and Ideology: Picasso and *Guernica*," in *Praxis* Spring 1976, no. 3. Dijkstra argues that *Guernica* responds to the liberal need to see "modernism" as a style capable of social responsibility. Dijkstra's interpretation is to some degree based on an earlier article by Max Raphael ("Discord Between Form and Content," in *The Demands of Art* (Princeton: 1968).

4. Diane Wolfthal, "Jacques Callot's *Misères de la Guerre*," *Art Bulletin* June 1977, pp. 222-33.

5. Eugène Fromentin, *The Old Masters of Belgium and Holland* (1882; rpt. New York: 1963), pp. 147-49.

6. On this subject, see: George Clark, *War and Society in the Seventeenth Century* (Cambridge: 1958), J. R. Hale, "Sixteenth-century Explanations of War and Violence," in *Past and Present* 1971: v. 51, pp. 3-26, and below, Conclusion, notes 6 and 10.

Chapter 1

1. Schoffer ("Did Holland's Golden Age Coincide with a Period of Crisis?" in *Acta Historiae Neerlandica* 1966) summarizes some of the difficulties in reconciling Holland's epoch of prosperity with the notion of a general European crisis in the seventeenth century.

2. See Michael Roberts, *Essays in Swedish History* (London: 1967) for an account of the revolution in warfare which occurred in sixteenth-century Europe.

3. Geoffrey Parker, *The Army of Flanders and the Spanish Road* (New York and London: 1972), pp. 10-19.

4. F. Redlich ("The German Military Enterpriser and his Workforce," *Vierteljahrschrift für Sozial- und Wirtschaftsgeschichte* 1964-65: v. 47-48) discusses the growth and organization of merce-

nary armies in the sixteenth century. Parker (*Army of Flanders*) deals specifically with the nationalities, work conditions and behavior of the mercenaries hired by Spain; for the professional soldiers in the service of the United Provinces, see Ten Raa and De Bas, *Het Staatsche Leger* (Breda: 1919) and J. W. W. Wijn, *Het Krijgswezen in de Tijd van Prins Maurits* (Utrecht: 1934). V. G. Kiernan ("Foreign Mercenaries and Absolute Monarchy," in *Crisis in Europe 1560-1660*, ed. by T. Aston, New York: 1967) discusses the political advantages and disadvantages of mercenaries to governments in the seventeenth century.

5. Parker, *Army of Flanders*, pp. 165-66.

6. Ibid., pp. 17-18.

7. Ibid.

8. J. W. W. Wijn, in *Het Krijgswezen in den Tijd van Prins Maurits*, gives the best account of the character and scope of Maurits' military reforms. A more recent article by Werner Hahlweg ("Aspekte und Probleme der Reform des niederlandischen Kriegswesens unter Prinz Moritz van Orangien" in *Bijdragen en Medelingen betreffende de geschiedenis der Nederlanden* Deel 86: 1971) deals with the political implications of Maurits' policies. J. B. Kist's introduction to the facsimile edition of *The Exercise of Armes* (New York and Toronto: 1971) places military handbooks in the larger context of modernization.

9. Wijn, *Krijgswezen*, p. 360. See also J. Presser et al.(eds.), *De Tachtigjarige Oorlog* (Amsterdam: 1948), pp. 226-30, for a similar view.
 Few modern historians have dealt with the role of the peasantry in the Eighty Years War. The older general histories of agriculture in the northern provinces (H. J. Koenen, *De Nederlandsche Boerenstand* [Haarlem: 1858]; H. Blink, *Geschiedenis van den Boerenstand en den Landbouw in Nederland* [Groningen: 1904]) mention the troubles of the 1680s and 1690s in passing, but offer no data on specific abuses and no information about the peasantry's response to military violence. The most up-to-date study of northern agriculture (J. de Vries, *The Dutch Rural Economy in the Golden Age* [New Haven: 1974] focuses particularly on the maritime provinces, which after 1600 were undisturbed by land warfare. Some regional histories (B. H. Slicher van Bath, *Een Samenleving onder Spanning: Geschiedenis van het Platteland in Overijssel* [Assen: 1957]) offer more specific information, but claim that there is little documentation from the early years of the war.
 For the peasants of the Spanish Netherlands, the historiographical situation is even worse. There is no specialized study of the peasantry of Brabant and Flanders during the later years of the sixteenth and first half of the seventeenth century, though some of the older literature provides a general survey of those years (V. Brants, *Histoire des classes rurales aux Pays Bas jusqu'à la fin du XVIII siècle* [Brussels: 1881]). The most recent historical studies of agriculture in the southern provinces during the seventeenth century are principally concerned with technical rather than social questions (P. Lindemans, *Geschiedenis van de Landbouw in Belgie* [Antwerp: 1952]; "De Vlaamse Landbouw in de 16de tot de 18de eeuw en zijn betekenis voor de landbouw in West Europe" in *Landbouwgeschiedenis* [The Hague: 1960]). Some regional studies of the southern provinces are helpful, expecially those of A. Cosemans (*De Bevolking van Brabant in de XVII en XVIII Eeuw* [Brussels: 1939]); "Het Uitzicht van Brabant op het einde der 16de eeuw," in *Bijdragen tot de Geschiedenis van het Hertogdom Brabant* (1936: Deel 27, pp. 285-351) and A. de Vos "Strijd tegen Vrijbuiters in Oudburg," in *Handelingen der Maatschappij voor Geschiedenis en Oudheidkunde te Gent* (1957: v. 11). Herman van der Wee (*The Growth of the Antwerp Market and the European Economy* [The Hague: 1963]) provides some useful information about the Flemish countryside in the late sixteenth and seventeenth centuries; see especially his Ch. VIII, "Rural Devastation."
 The contemporary histories of the period (Bor, van Reyd, van Meteren, Strada and others)

frequently mention specific instances of peasant oppression by soldiers and the general theme is a favored one in the poetry, pamphlet literature and song of the period. While the sheer volume of this material is impressive, it cannot always be relied upon for an accurate picture of peasant/soldier relations.

10. Tibor Wittman (*Les gueux dans les "bonnes villes" de Flandre* [Budapest: 1969]) discusses the relation of the peasantry of the southern provinces to the Protestant rebels. L. G. Rogier (*Algemene Geschiedenis van Nederland,* v. V, Ch. XI) deals with the Protestantization of the countryside in the northern provinces from the earliest years of the war to midseventeenth century; his view of "forced Protestantization" has been challenged by H. A. Enno van Gelder ("Nederland Geprotestantiseerd?" *Tijdschrift voor Geschiedenis* 1968: v. 81, pp. 445-64).

11. For example, in the ballad "Belgica, bloeme pleysant" from J. van Vloten, *Nederlandsche Geschiedzangen,* v. II (1572-1609), pp. 408-9.

> Alle Mars dienaren,
> Het moester al teren op den boer,
> Capiteyn, soldaet, knecht en hoer,
> Capiteyn, soldaet, knecht en hoer
> Al die int Nederlant waren.

See also *Het Geuzenliedboek,* ed. P. Leendertz (Zutphen: 1924), #127, #205, #206; and *Politieke Balladen, Refereinen, enz.* (Gent: 1847), p. 159, "Referyn-1579."

12. *Grote Placaetboek: Inhoudenden: De Placaten ende Ordonnantien van de Hogh-Mogende Heeren Staten Generael der Vereenighde Nederlanden, ende van de Edel Groot Mogende Heeren Staten van Hollandt ende West-Vrieslandt* (The Hague: 1664), v. II, p. 87, 1586.

13. Parker, *Army of Flanders,* pp. 166-67.

14. Everaert van Reyd, *Historie der Nederlandscher Oorlogen* (2nd edition, Amsterdam: 1644), Bk. II, p. 42.

15. *Politieke Balladen en Refereinen,* pp. 162-63.

16. Parker, *Army of Flanders,* p. 185. Parker (Ch. VIII) gives a general history of mutiny in the Spanish army.

17. For example, Gabriel Wymans, "Les mutineries militaires de 1596-1606," *Standen en Landen,* 1966: 39, and E. Rooms, "Een nieuwe visie op de gebeurtenissen die geleid hebben tot de Spaanse furie te Antwerpen," *Bijdragen tot de Geschiedenis* 1971: 54.

18. Typical was the experience of one village at the hands of mutineers:

When the depredations of the mutineers of Diest in 1591 provoked the townsmen of St. Truiden to raise a sort of Home Guard for their defense, the mutinied veterans did not rest until they had hunted down and annihilated the makeshift militia in pitched battle. [Parker, *Army of Flanders,* p. 189.]

19. A large part of Maurits' *Artikelbrief* or military code of 1590 was devoted to sanctions against mutineers. The entire code is published in Wijn, *Krijgswezen*; articles 8, 10, 11, 25-27 relate to mutiny.

20. Niet alleen had men aan alle zijden tekampen met de vijand zodat wel haast nieuwe troepen moesten worden aangeworven, maar ook met den treurig toestand van het eigen leger. De Staten van Holland verklaren . . . dat over 1500 soldaten van honger al rede gestorven ende verlopen

waren, bij gebreecke van betalinge. Geheele vendelen soldaten en een menighte ruiters trokken naar Gooiland waar zij bleven "nae Jaren appetijte," sonder iemands last of bevel, zodat de dorpen gemachtigd werden om gewapenderhand tegen hun op te treden. [Ten Raa and De Bas, *Staatsche Leger*, v. I, p. 74.]

21. Ten Raa and De Bas, *Staatsche Leger*, v. II, p. 319, note 1.

22. Ibid.

23. Ibid,., v. III, Aantekening Nr. 2, p. 5.

24. De Vos, "Strijd tegen Vrijbuiters in Oudburg," p. 134.

25. Ibid., p. 140.

26. Ibid., p. 143.

27. Jacob Duym, "Benovde Belegheringhe der Stad Leyden," in: K. Poll, *Over de Toneelspelen van den Leidschen Rederijker Jacob Duym* (Groningen: 1898).

28. *Het Geuzenliedboek*, "Een Nieu Liedeken, op de wijse: De Boerman is een Heer," v. I, pp. 144-46.

29. Wijn, *Krijgswezen*, p. 354.

30. Van Reyd, *Nederlandsche Oorlogen*, Bk. II, p. 109.

31. Wijn (*Krijgswezen*, p. 345) explains the tax compensations offered to peasants after inundation; C.M. Schulten and J.W.M. Schulten (*Het Leger in de Zeventiende Eeuw* [Bussum: 1969], p. 89) discuss peasant sabotage of inundations.

32. Quoted in Parker, *Army of Flanders*, p. 142.

33. *Artikelbrief* of 1590, Item #15.

34. The practice of *Brandschat* and *Sauvegarde* is thoroughly discussed by F. Redlich, in *De Praeda Militari: Looting and Booty 1500-1815* (Wiesbaden: 1956), pp. 45-47.

35. Redlich, *De Praeda*, p. 47, and Wijn, *Krijgswezen*, p. 356.

36. Redlich, *De Praeda*, p. 36.

37. Van Reyd, *Nederlandsche Oorlogen*, Bk. II, p. 42.

38. *Grote Placaetboek*, v. II, p. 87, 4 April 1586: Ooch vele Huysluyden of andere dagelijcks onder eenigen schijn of pretext, of ooch sonder, te doen ghevangen halen, de selve in vuyle diepe ende zware gevangenissen werpen, ende onverdragelijck tracterende, afdruckende sulcke rantsoenen als haer goet dunckt ende ghelieft.

39. From the second half of the year 1590 comes a plakkat:

> Waerbij scherpelijck verboden de schaden . . . die bij het Volck van Oorlog in dienste van de Staten wesende, ghedaen worden. Alsoo verscheydene klachten dagelijcx gedaen worden, dat niet tegenstaende het Volck van oorloge, in dienste deser Lande wesende, so een-paerlijk ende redelijk betaelt wort, als ons mogelijck is, de selve hun onderstaen, contrarie onse verscheydene voorgaende Ordonnantie ende Placaten, vele schaden, ongeregeltheden ende excessen . . . gegeven de Dorpen en Ingeseten onder des vijands ghewelt sittende. [*Grote Placaetboek*, v. II, p. 102.]

In 1591, a *plakkat* was issued against the "free-lance" style of warfare already outlawed by the 1590 military code (*Grote Placaetboek*, v. II, p. 103). The 1591 *plakkat* was issued in response to

reports of bands of soldiers plaguing peasants in lands under the States' *sauvegarde*. These bands of ten to twelve men, without any officers or official authority, would hide in woods and fields, robbing the countryfolk, capturing and holding them for large ransoms, driving away their live-stock, and making it unsafe for them to go from one village to another. Essentially the same *plakkat* was reissued in 1595 and 1597 (*Grote Placaetboek*, v. II, p. 109). A long *plakkat* detail-ing excesses of troops in lands under *sauvegarde* and neutral neighboring territories was issued eight times between 1603 and 1642 (*Grote Placaetboek*, v. II, p. 11 "Waerbij den overlasten en Foules der Soldaten verboden, ende op het in en doortrecken, ofte uytloopen der selven op Neut-rale ofte Contribuer ende Land, precise order gestelt wert"). To the standard list of grievances (extortion, capture and ransoming of persons and livestock, personal injury) this *plakkat* adds a section on the obligation of soldiers to pay for their accommodations and not to request more than their share. A *plakkat* issued in 1638 specifically addresses the issue of the ineffectiveness of earlier prohibitions:

> De Staten General . . . verstaen habbende dat niet tegenstande Placaten tegen het uytlopen van het Krijgsvolck in dienst van desen Staet van tijdt tot tijdt uytgegeven, de extortien, foulen ende overlasten van 't selvde Krijgsvolck niet en ophouden, maer dagelijcks meer ende meer ghepleeght worden over all contribuerende dorpen, ende Ingesetenen van dien, ende voornamentlich over onse Dorpen, alwaer de Soldaten sich vervorderen sonder eens heur verlof te toonen, met heyle ende oock verdeylde troupen van het eene Dorp en het ander, hun uytgevende voor andere dan sy sijn, ende alsoo heure exactien ende overlasten pleegende.

40. *Grote Placaetboek*, v. II, p. 122, 30 October 1648; repeated 18 April 1651.

41. Parker (*Army of Flanders*, p. 266) relates that "The Dutch ended their struggle with Spain owing their troops wage arrears of 3.6 million florins, while the States of Holland alone were saddled with a consolidated debt of 140 million florins in 1651"—a sobering comment on the effective-ness of the pay system initiated by Maurits.

42. A. Cosemans, "Uitzicht van Brabant," p. 310.

43. Joost van den Vondel, "Verovering van Grol door Frederick Henry," in *Werken van Vondel* (Amsterdam: 1942), Deel III, p. 134.

44. A. Cosemans, "Uitzicht van Brabant," p. 296

45. *Politieke Balladen en Refereinen*, p. 162.

46. A. Cosemans, "Uitzicht van Brabant," p. 311.

47. See J. A. Jolles, "Schuttersgilden en Schutterijen in Limburg," *Publication de la Société Histor-ique et Archéologique dans le Limbourg* 1936: v. LXXII for an account of some rural militias in the province of Limbourg.

48. Parker, *Army of Flanders*, p. 193.

49. *Grote Placaetboek*, v. II, p. 236.

50. F. A. Scott, *Nederlandse Spreekwoorden en Gezegden* (Zutphen: 1974), #176.

51. P. Bor, *Nederlantsche Oorlogen* (Leyden: 1621), Bk. XIV, p. 194.

52. Van Reyd, *Nederlandsche Oorlogen*, Bk. II, p. 44.

53. P.C. Hooft, *Nederlandsche Historien* (Amsterdam: 1642), pp. 685,597.

54. Luther's view on the revolt of the German peasants (quoted in F. Engels, *The Peasant War in Germany*, New York: 1966):

The heads of the peasants are full of chaff. They do not hearken to the Word, and they are senseless, so they must hearken to the virga [staff] and the gun, and this is only just. We must pray for them that they obey. Where they do not, there should not be much mercy. Let the guns roar among them, or else they will make it a thousand times worse.

55. Constantijn Huygens, "Een Boer," from *Zedeprenten*, edited by H. J. Eijmael (Groningen: 1891).

56. Bor (Bk. XXII, pp. 95-97) and van Meteren (*Belgische ofte Nederlantsche Historie/van onsen tyden* [Delft: 1599]; Bk. XV, p. 295) describe the devastation of the South and its attendant economic ills—poor harvests leading to inflated grain prices and famine. Contemporary travel accounts comment on the disruption of the countryside (Thomas Overbury, *Observations in his travels upon the state of the XVII Provinces*). The States of Flanders and Brabant wrote continual pleas to the central government on behalf of their peasantry, cataloging their troubles and requesting exemption from further war contributions—see A. Cosemans, "Uitzicht van Brabant," pp. 285-327, passim, who quotes some of these letters and also Kervyn de Volkaersbeke, *Documents inédits concernant Les Troubles des Pays-Bas*, v. I, no. CLV; v. II, nos. CCLXXIX, CCLXXX, CCCXVI ,CCCCXCII. The literary sources are prolific in their accounts of peasant misery—see P. J. Meertens, *De Lof van den Boer* for some of the most famous, also *Politieke Balladen, Refereinen, Liederen en Spotgedichten der XVIe eeuw* (Maatschappij der Vlaemsche Bibliophilen, Gent: 1847); Paul Fredericq, *Het Nederlandsch Proza in de zestiendeeuws pamfletten* (Brussels: 1907); Maurits Sabbe, *Brabant in't Verweer* (Antwerp: 1933).

57. Van der Wee, *Growth of the Antwerp Market*, v. II, pp. 246-50.

58. "Boerenlitanie, ofte Klachte der Kempensche Landlieden, over de ellendn van deze lankdurige Oorloge," in Meertens, *De Lof van den Boer*, p. 81.

59. Van der Wee, *Growth of the Antwerp Market*, p. 249.

60. Quoted in van der Wee, pp. 249-50.

61. A. Cosemans, "Uitzicht van Brabant," p. 305.

62. Ibid.

63. Blink, *Geschiedenis van de Boerenstand en den Landbouw in Nederland*, pp. 8-10.

64. Robert Fruin, *The Siege and Relief of Leyden* (The Hague: 1927), pp. 22, 86-87.

65. Bor, *Nederlantsche Oorlogen*, Bk. VIII, pp. 6-7; Hooft, *Nederlandsche Historien*, p. 860.

66. Blink (*Geschiedenis van de Boerenstand*, v. II, pp. 8-9) quotes this survey, but notes that after the conclusion of the Twelve Years Truce, Holland and Zeeland were the provinces whose agriculture recovered most rapidly.

67. Quoted in Slicher van Bath, *Een Samenleving onder Spanning*, pp. 430-34.

68. Bor, *Nederlantsche Oorlogen*, Bk. XX, p.9.

69. The historical Spiegels were enormously popular. One, the *Spiegel der Jeught*, was reprinted more than twenty times between 1610 and 1670 (see J. C. Breen, "Gereformeerde Populaire Historiographie in de 17de en 18de eeuw," *Tijdschrift voor Geschiedenis* 1922: Deel 37, pp. 259ff, for an account of the history and function of these tracts). The *Spiegel der Jeught*, written as a dialogue between father and son, attempts to make the atrocities committed by Spanish soldiers upon the countryfolk part of the ideology of the new generation:

(De Spaanse soldaten) met alle moetwille goede inwoonderen der platte Landen dreyghende/slaende/berooven/ plunderende/de Vrouwen/jonghe Dochters verkrachtende/ /ende andere vele derghelijcke stucken bedrijvende. . . . Sy hebben Vrouwen en Dochteren gheschent in tegenwoordigheyt dere Vaderen ende der Mannen/ja sy dwinghen de selfde dat aen te sien/ende als iemand was die haer teghenstant dede/so riepen sy Straks Spania, Spania ende richten eenen moort aen. Op sommige plaetsen hebben sy de bevruchte Vrouwen den buyck op ghesneden/ende vrucht haer lichaams vermoort. Sy hebben in sommige plaetsen de Mans levendigh het vel ofte huydt afgestroopt ende habben deselfde over hare Trommelen ghespannen. Andere hebben sy met kleyne ijzeren langsam ghebraeden/ende verbrant/eenighe met gloeyande tanghen doot ghenepen. (Amsterdam: 1614, unpaged)

Another example of the Spiegel genre, the *Warachtige Beschrijvinghe ende levendige Afbeeldinghe van de Barbaarsche Tirannye bedreven by de Spaenjaerden*, recounts the sufferings of the peasants of Holland during the siege of Alkmaar, claiming that the Spanish troops tortured and then executed some peasants by hanging.

Although it is quite possible that such atrocities sometimes did occur, the central authorities were definitely against them and it is unlikely that atrocities took place on a very large scale. However, the "Spaense Tirannye" became part of the folklore of the Netherlands, and in 1672 it was revived as the "Franse Tirannye"—an outpouring of Spiegel literature which attributed the same catalogue of atrocities (rape, torture, hanging) to the troops of Louis XIV (for example, A. de Wicquefort, *Advis Fidelle aux Véritables Hollandois, touchant ce qui s'est passé dans les villages de Bodegrave and Swammerdam, et les cruautés inouïes, que les Francois y ont exercés* [The Hague: 1673]).

70. Sabbe, *Brabant in 't Verweer*, p. 129.

71. J. W. W. Wijn, "Krijgsbedrijven onder Frederick Henry," in *Algemene Geschiedenis van Nederland*, v. IV (1953), pp. 261-87.

72. Sabbe, *Brabant in 't Verweer*, p. 222.

73. P. Geyl, *The Netherlands in the Seventeenth Century* (London: 1961), v. I, pp. 118-19.

74. Quoted in A. Cosemans, *De Bevolking van Brabant*, pp. 9-10.

75. The prosperity of the rural folk of Holland and Zeeland became a matter of some concern to city dwellers, some of whom felt that the peasants were getting uppity and attempting to live above their station. A pamphlet from the final years of the Twelve Years Truce, written in the form of a conversation between a merchant, a courtier and a Holland peasant, portrays the courtier claiming that any troubles the peasants may have are of their own making:

Dat veel huyslieden beroyt worden/dat en doet de crijgh alleene niet maer meest hen quaet regiment/als drincke/dobbele/malle coopmanschappen/om groote wynkoopen te vinden/ hen lieder groote kermissen/ openbaer bruyloften onderhouden/ Item het domineeren en braveren van henlieder kinderen/met goud/silver/ koorden/al veel boven haren staet. [W. P. C. Knuttel, *Catalogus van de pamfletten verzameling berustende in de Konincklijk Bibliotheek* (The Hague: 1889), #1450].

76. Geyl, *Netherlands in the Seventeenth Century*, v. I, pp. 118-19.

77. V. A. M. Beerman, *Stad en Meierij van 's-Hertogenbosch van 1629-1649* (Nijmegen: 1940) gives a good account of the disruption of the countryside of this border area in the later years of the Eighty Years War.

78. Quoted in J. J. Poelhekke, *'t Uytgaen van den Treves: Spanje en Nederlanden in 1621* (Gronin-gen: 1960), pp. 7-8.

79. For example, when the States of Groningen and Friesland rejected peace measures which would abandon the southern provinces to Spain, they invoked the remembrance that a good part of the subjected Netherlands had once been allies in the Union of Utrecht, and that the war was begun "to free all of the Netherlands from the yoke of Spain." (Geyl, *Netherlands in the Seventeenth Century,* v. I, p. 109).

80. S. de Beaumont, "Boerepraat," from *De Zeeusche Nachtegael ende Dezelfs dryderly gesang . . . door verscheyden treffelijcke Zeeusche Poeten by een gebracht* (Middelburgh: 1623).

81. *The Struggle for Stability in Early Modern Europe,* by Theodore Rabb (New York: 1975) focuses upon war as a crucial factor in the European crisis of the seventeenth century.

82. Sabbe (*Brabant in 't Verweer*) has collected some popular songs and leaflets which describe the reaction of the Spanish Netherlands to events in the Thirty Years War. The *Atlas von Stolk-katalogus van Historie, Spot-en Zinneprenten* contains several allegorical prints which relate to the Dutch response to war excesses in the German/Czech theaters of war—see especially #1732, "Verhael van den seer desolaten Staet, waer in zij Duitsland . . . zij bevonden heeft, gedurende den Oorlog, zoo door de Fransche, maer Insonderheijd door de keyserlijke Troepen . . ." which introduces a series of twelve plates portraying the horrors of the Thirty Years War.

Chapter 2

1. The picture (Vienna: Kunsthistorisches Museum) is signed but not dated. Since it is similar in composition to the *Numbering at Bethlehem,* signed and dated 1566, most Bruegel scholars agree that it was painted sometime during the 1560s. C. Tolnay believes the *Massacre of the Innocents* to have been painted as early as 1563-64 ("Pierre Bruegel l'ancien," *Jahrbuch der kunsthistori-schen Sammlungen des allerhochsten Kaiserhauses* 1934); others have argued for the work's in-volvement with the arrival of the Duke of Alva in the Netherlands in 1567 and have thus con-cluded that it could have been painted at any time between this year and Bruegel's death in 1569 (see below, note 12).

 The attribution of the version of the *Massacre of the Innocents* in Vienna to Bruegel has long been disputed. G. Jedlicka (*Pieter Bruegel* [Leipzig: 1947]) and F. Grossman (*Pieter Bruegel: The Paintings* [London: 1955]) believes the work to be a copy, possibly by Pieter Bruegel II; Grossman believes that the altered version at Hampton Court is the original. Gustav Gluck, however, maintains that the Vienna version is genuine, and that its defects were caused by res-toration in the seventeenth and eighteenth centuries (*Bruegels Gemälde* [Vienna: 1932]).

2. C. van Mander, *Het Schilder-Boeck* (Haarlem: 1604):

 > Voort een Kinder-doodinghe/daar veel wercklijcke dinghen zijn te sien/waer van ick elder hebbe verhaelt/ hoe dat daer een gantsch gheslacht soecken te verbidden een Boerigh kindt/ dat een der moordighe krighs-luyden ghevat heeft om te dooden/den rouwe en t'versterven der Moeders/en andere werckinghen wel naghenomen wesende.
 > [There is as well a Massacre of the Innocents, in which we find much to look at that is true to life, as I have said elsewhere: a whole family begging for the life of a peasant child which one of the murderous soldiers has seized in order to kill, the mothers fainting in their grief, and there are other scenes all rendered convincingly].[from the Bruegel biography, p. 234.]

 Van Mander also discusses the *Massacre of the Innocents* in his introductory poem, "Den Grondt der Edel Vrij Schilder-const"—see text, p. 58. The idea that Bruegel has simply rendered

observed reality in the *Massacre* persists in the modern literature as well; see for example G. Gluck, *Bruegel: Details from His Pictures* (London: 1936), p. 251.

3. In Giotto's *Massacre of the Innocents,* for example, Herod stands on a balcony to the left and high above the square where the action takes place. The theme is rather rare in Northern painting before Bruegel; however, it survives in a few prints and drawings. In a drawing by Dirk Vellert (dated 1523, Private Collection: London—D.I.A.L. #2359) Herod, identified by his regal sceptre, is visible in the background but is quite off-center and does not face the viewer as the black-clad leader does in Bruegel's picture. An etching by Ph. Galle after a *Massacre of Innocents* by Frans Floris (Hollstein, *Dutch and Flemish Engravings, Etchings and Woodcuts,* v. VII, #100) shows a similar compositional schema. Only a pen drawing (London: British Museum) by Jan Swart van Groningen (active to 1553 in Antwerp) allocates responsibility to Alva in a manner similar to Bruegel's: here, Herod is a small standing figure at the center of the composition who surveys the slaughter with an upraised baton while the soldiers turn to show him the dead bodies of his victims. The setting and costumes, however, are antique rather than sixteenth-century.

4. Does the female allegory, raised on a plinth and thus slightly separated from her environment, represent an ideal which the cruel punishments betray, or are they simply the practical demonstration of Justice? I. Zupnick, ("The Influence of Erasmus' *Enchiridion* on Bruegel's *Seven Virtues,*" in *De Gulden Passer* 1969, p. 23ff.) argues that Bruegel's prints represent the inverse of virtue; C. G. Stridbeck (*Breugelstudien* [Stockholm: 1956]) claims the Virtues illustrate the external Church as opposed to its internal spiritual aspect.

5. Franzepp Würtenburger (*Pieter Bruegel der Altere und die deutsche Kunst* [Wiesbaden: 1957]) provides an illuminating comparison of the way in which Bruegel and Cranach deal with contemporary history in their art. See especially Würtenburger's comparison of Cranach's *St. John Preaching* with Bruegel's version of the same theme, pp. 160-65.

6. Würtenburger (ibid.) discusses the relationship of Bruegel's art to German print traditions. While he does not explicitly suggest that a German Planetenkinder might be a source for the *Massacre of the Innocents,* Würtenburger has argued that Bruegel's other "peasant" subjects may have originated in the prints of the Kleinmeisters. For the origins and development of the Planetenkinder iconography, see A. Hauber (*Planetenkinder und Sternbilder* [Strassburg: 1916]) and F. Lippman (*The Seven Planets* [London: 1895]).

7. According to Gluck, the red uniforms correspond to the description in the contemporary chronicle of Marcus van Vaernewyck of the Walloon soldiers in the service of Spain (Gluck, *Bruegel: Details from his Pictures,* p. 20). Charles Terlinden ("P. Bruegel et l'histoire," *Revue Belge d'Archéologie et de l'Histoire de l'Art* 1942: pp. 229-57) argues that the black borders of the robes the soldiers wear conflict with Vaernewyck's report, but offers no convincing evidence to support his assertion that the red-garbed men are local gendarmes, sent to punish a village late in its tax payments.

8. Van Mander, *Het Schilder-Boeck.*

 Veel vreemde versieringhen van sinnekens sietmen van sijn drollen in Print: maer hadder noch seer veel net en suyver geteyckent met eenighe schriften by/selcke ten deele al te seer bijtigh oft schimpich wesende/hy in zijn doot-sieckte door sijn Juysvrouwe liet verbranden/ door leetwesen oft vreesende sy daer door in lijden quaen/oft te verantwoorden mocht hebben. [from the Bruegel biography, fol. 233]

9. Stridbeck, *Bruegelstudien.*

10. Würtenberger, *Bruegel der Altere.*

11. Stridbeck, *Bruegelstudien*, p. 245. The translation from the modern German version is mine.

12. Attempts to link certain Bruegel works concretely with the events of the early Netherlands' revolt have a long history. The older efforts are enumerated in available bibliographies; among the more recent are I. Zupnick ("Pieter Bruegel and the Revolt of the Netherlands," *Art Journal* 1964: v. 23, no. 4). which adds little of interest to earlier research; S. Ferber, "Pieter Bruegel and the Duke of Alva," *Renaissance News* 1966; v. 19, pp. 205-19, discussed above in the text; Hanna Deinhard's chapter on the *Massacre of the Innocents* in *Meaning and Expression: Toward a Sociology of Art* (Boston: 1920) which is inconclusive on the relation between Herod and Alva but makes some interesting observations on the form of the *Massacre of the Innocents*. D. Kunzle ("Pieter Bruegel's *Proverbs* and the World Upside Down," *Art Bulletin:* June 1977) argues that the *Proverbs* embodies an ideological view of the peasantry which Bruegel shared with the ruling class of his country; the relation of this work to other Bruegel pictures which appear to view the peasantry more sympathetically (for example, the *Massacre of the Innocents)* remains problematic.

13. See, for example, the satirical prints on Alva in F. Muller, *De Nederlandsche Geschiedenis in Platen* (Amsterdam: 1863-1882), nos. 520-521, 569, also the portrait of the Duke by Willem Key, dated 1568, in Madrid (Palacio de Liria).

14. For an account of sixteenth- and seventeenth-century historiographical practice in the Netherlands, see: Herman Kampinga, *De Opvattingen over onze Vaderlandsche Geschiedenis* (The Hague: 1917); for the general development of historical iconography in the art of the Netherlands, H. van de Waal, *Drie Eeuwen Vaderlandsche Geschied-Uitbeelding: Een Iconologische Studie* (The Hague: 1952).

15. On the satirical pamphlet literature and its use of Classical and Biblical models, see: J. C. Breen, "Gereformeerde Populaire Historiographie in de 17de en de 18de eeuw," *Tijdschrift voor Geschiedenis* 1922: dl. 37; and P. A. M. Geurts, *De Nederlandse Opstand in de Pamfletten* (Proefschrift Nijmegen: 1956), especially Ch. II, "Mythevorming, Personon en Gebeurtenissen." For the iconography of Alva, see J. Becker, "Hochmut kommt vor dem Fall. Zum Standbild Albas in der Zitadelle von Antwerpen 1571-74," *Simiolus* 1971: no. 1/2, pp. 75-115.

16. *Het Geuzenliedboek,* ed. by P. Leendertz (Zutphen: 1924), #65-1572 "Vornameste Feyten v/d Ducdalve"

> Pharoao is nu int leven
> Antiochus thoont zijn quaet:
> Herodes heeft nu ghegheven
> Sijn fel moordadich Zaet . . .

17. Geurts, *Nederlandse Opstand*, p. 280. Alva is compared to Herod in a pamphlet (Knuttel 213) entitled "Sendbrief. Informe van Supplicatie aen die Conincklicke Maiesteyt van Spagnien" 1573.

18. P. Bor, *Nederlantsche Oorlogen* (Leyden: 1621), Bk. I, pp. 467-68.

19. The relevance of the polemical literary tradition with regard to Bruegel's *Carrying of the Cross* was discussed in a paper delivered by Joseph Gregory at the annual meeting of the College Art Association, Washington, D.C. 1979 ("Contemporization as Polemical Device in Pieter Bruegel's *Procession to Calvary*," summary in *Abstracts of Papers Delivered in Art History Sessions: 67th Annual Meeting of the College Art Association of America,* Jan. 31-Feb. 3, 1979). Gregory argues that Bruegel contemporizes the Biblical theme in order to generate a comparison between the Spanish Inquisition in the Netherlands and the Synagogue which crucified Christ. The same analogy, Gregory shows, is to be found in the literature of the period; so far as I know,

he does not articulate the ways in which Bruegel's picture does not conform to the polemical model.

20. Pieter Geyl, *The Revolt of the Netherlands* (New York: 1958), pp. 99-110.

21. Tibor Wittman, *Les gueux dans les 'bonnes villes' de Flandre* (Budapest: 1969), p. 131.

22. See Elizabeth McGrath, "A Netherlandish History by Joachim Wtewael," *Journal of the Warburg and Courtauld Institutes* 1975: v. 38, pp. 182-217. McGrath claims that the series is an allegory of the Netherlands' suffering under Alva and redemption by William of Orange.

23. The play (*Moordadighe Werck en Manhatigetanden*) is summarized in E. Ellerbroek-Fortuin, *Amsterdamse Rederijkerspelen in de Zestiende Eeuw* (Groningen: 1937).

24 The print is one of a series of four, entitled "Zinneprenten op de Spaansche overheersing," F. Muller, *Nederlandsche Geschiedenis in Platen*, no. 521.

25. Van Mander, *Het Schilder-Boeck,* from the introductory poem "Den Grondt der Edel Vrij Schilder-const," p. 27.

26. Deinhard (see above, note 12) notes that only from the viewer's high vantage point can order and sense emerge from the picture.

27. E. H. Kossman and A. F. Mellink (Introduction to *Texts Concerning the Revolt of the Netherlands* [New York and London: 1974]) have recently pointed out that the motives for the revolt(s) were continually fluctuating—those of the 1560s were not those of the 1580s. The revolt was not only the conflict between the Netherlands and Spain, between local authority and Alva, but was a process of the gradual estrangement of Protestant and Catholic, rich and poor, northern and southern provinces.

28. The Hampton Court version was altered some time in the late sixteenth or early seventeenth century.

29. Saverij's soldiers wear long, slashed overcoats of a type not represented in any of the early seventeenth-century military handbooks I have seen, although one soldier is equipped with a musket, crutch and cartridge belt very similar to that shown in De Gheyn's *Exercise of Armes* (The Hague: 1607). The costumes are probably a mixture of fantasy and observation; certainly nothing identifies the troops as members of a particular war-party.

30. McGrath believes these prints to be the source of Wtewael's image of sorrowing Belgica flanked by a Boerenverdriet (see above, note 21).

31. See Ch. 1, pp. 12–14, which deals in detail with the abuses suffered by the rural population in these years.

32. The tree portrayed in these pictures is unmistakably a Maypole. The first of May was widely celebrated in the Netherlands as elsewhere in early modern Europe by cutting down a tree, lopping off its branches and decorating it with ribbons, paper hoops and garlands. The tree then became a focal point for village dances and festivities (E. O. James, *Seasonal Feasts and Festivals* [New York: 1961]).

33. See, for example, David Rijckaert's pendants, the *Kermis* and *Boerenverdriet* in Vienna (Figs. 26 and 27); also Ch. 4, note 32.

34. Since seventeenth-century troops did not wear uniforms, their allegiance was often proclaimed by the color of their cockades or sashes (G. Parker, *The Army of Flanders and the Spanish Road* [New York and London: 1975], pp. 164-65). In the paintings from the "Maypole" group which I have seen in the original or in color reproduction (for example, the version owned by a private

collector in Ghent, shown at the exhibition "Eenheid en Scheiding in de Nederlanden, 1555-1585," Ghent, 9 September-8 November 1976, cat. #404) the invaders wear either a single orange feather in their hats or a cockade of three plumes, white, blue and orange, displaying their loyalty to the Prince of Orange.

35. None of the paintings is dated; however, Vrancx was active until 1647, well after the events in question took place.

36. See Ch. 1, p. 15. Maurits Sabbe (*Brabant in 't Verweer* [Antwerp: 1933]) discusses the popular outcry against this action in pamphlets, remonstrances and broadsheets.

37. *Contribution* simply means the payment of an agreed sum to enemy troops by the peasantry in return for safety. Since it was an important source of income for the enemy, the authorities often tried to prevent it—just as Isabella did in this case. See Ch. 1, pp. 5–6.

38. Sabbe, *Brabant in 't Vermeer*, pp. 122-24.

39. Broadsheet text in F. Muller, *Nederlandsche Geschiedenis in Platen*, Deel I, no. 1457.

40. See above, notes 13 and 14.

41. Van de Waal, *Drie Eeuwen Vaderlandsche Geschied-Uitbeelding*, pp. 22 and 28.

42. Van Mander, in his chapter on landscape in "Den Grondt der edel vrij Schilder-const," shares the humanist view of landscape painting. He makes it clear that historical or mythological figures are indispensable for the good landscape. While van Mander to some extent practiced what he preached, his theory of landscape painting had little effect upon the consequent development of the genre in seventeenth-century Netherlandish painting (H. Miedema, ed., *Den Grondt der Edel Vrij Schilderconst* [Utrecht: 1973]).

43. See Ch. 1, pp. 9–10.

44. Christian Tumpel, "Beobachtungen zur Machtwache" in: *Neue Beitrage zur Rembrandtforschung*, ed. O. von Simson and J. Kelch (Berlin: 1974), has shown how Rembrandt incorporated actual military practice as portrayed in the handbooks of the period (which were used by the shooting companies) as well as emblem and ceremonial costume in his portrait of the militia company of Captain Banning Cocq.

45. For the view of contemporaries on the only major peasant revolt of the Eighty Years War, see Ch. 1, p. 11.

46. Ch. 1, pp. 11–12.

47. In a recent article by Sten Karling ("The Attack by P. Bruegel the Elder in the Collection of the Stockholm University," *Konsthistorisk Tidskrift* 1976, XLV, nos. 1-2, pp. 1-182), this picture has been attributed to Bruegel the Elder. The author argues that the date (1630) is a forgery and that the work's affinities with the *Massacre of the Innocents* support an attribution to the older Bruegel. But it is precisely because the picture quotes so directly from the *Massacre* (the pose of the central landsknecht in the *Attack* is the same as that of the soldier who breaks into a peasant house in the lower right foreground of the *Massacre*) that the attribution seems dubious. It would be anomalous for Bruegel the Elder to repeat a figure so exactly.

48. For example, P. de Jode's *Coler*, portrayed as a sixteenth-century mercenary.

Chapter 3

1. The Rijksmuseum paintings do not correspond precisely with any of the Bolswert prints. However, A. Czobor ("Zu Vinckboons Darstellungen von Soldatenleben," *Oud Holland* v. 78. 1962-

63) argues that Vinckboons did produce paintings with the exact composition of the print series. A painting attributed to Vinckboons, auctioned in 1934, is identical in composition to the second plate of the Bolswert series, and another work in the collection of P. Kadosa, Budapest, corresponds to plate three of the print series. Czobor believes that two existing drawings by Vinckboons (one in the Louvre; the other owned by P. Van Eeghen, Amsterdam) replicate the compositions of the two lost paintings, which would answer respectively to the first and final episodes of the print series.

2. In the armies of the sixteenth and seventeenth centuries, the troops were accompanied by vast numbers of camp-followers—the independent victualers known as sutlers, lackeys, prostitutes, sometimes the soldiers' legitimate wives and children (Geoffrey Parker, *The Army of Flanders and the Spanish Road* [New York and London: 1972] p. 176). Sutlers were often, although not always, women, and sometimes they would supplement their income by becoming prostitutes on the side. This was precisely the course taken by Grimmelshausen's indestructible heroine of the Thirty Years War, Courage, who, with the earnings she saved from sutlery, decked herself out in jewelry and fine clothes and turned, with equal financial success, to prostitution (H. J. C. von Grimmelshausen, *The Runagate Courage,* translated by Robert Hiller and J. C. Osborne [Lincoln, Nebraska: 1965] pp. 103-5). Because of their elaborate finery, as well as the epithets hurled by the peasants in the captions to Bolswert's prints, it seems likely that the soldiers' female companions in Vinckboons' Boerenverdriet are sutler/prostitutes rather than wives.

3. *Atlas von Stolk-Katalogus van Historie, Spot-en Zinneprenten*, ed. G. van Rijn (Amsterdam: 1902), item #1249.

4. J. de Coo, *De Boer in de Kunst* (Rotterdam: n.d.), Ch. III, passim.

5. J. Goossens, *David Vinckboons* (The Hague: 1954), pp. 84-89.

6. Parker, *Army of Flanders*, p. 164.

7. W. P. C. Knuttel, *Catalogus van de pamfletten-verzameling berustende in de Konincklijk Bibliotheek* (The Hague: 1889), #1616, ''Een nieuw liedeken gamaeckt van een Boer en een Soldaet.''
 Other pamphlets dealing in similar fashion with the relation of peasant and soldier are: Knuttel #1450, ''Schuytpretgens tusschen een Lantman, een Hovelinck, een Borger en een Schipper;'' Knuttel #3198, ''Een nieuwe Tydinghe van de Siecke Treves ende het krancke Bestand-1621;'' Knuttel #1396, ''Boerenlitanie;'' Knuttel #1617, ''Een nieu Liedeken ghemaect tusschen Bestant ende Oorlogh;'' Knuttel #1409, ''Het Testament vande Oorlogh-1607;'' Knuttel #1555, ''Een Lustighe t'samensprekinghe van vier Personagien-Meestendeel van Menschen, Tyt van Twist, Tyt van Pays, Onderwijs der Schriftuere.''

8. Knuttel, #1571, ''Claghte v/d Cloecken Soldaet/ ende vanden poltron: als ooch een Disput v/d Soldaet ende Boer.''

9. *Het Geuzenliedboek*, ed. P. Leendertz (Zutphen: 1924), v. I, #206, ''Een nieu liedeken vant beghin des Krijchs, 1621.'' The peasant/soldier theme is not new to the Geuzenliederen, however; similar themes of mercenary greed and peasant simplicity appear in late-medieval popular song. See, for example, F. van Duyse, *Het Oude Nederlandsche Lied* (The Hague: 1903), v. I, pp. 221-23.

10. Here I have only dealt directly with those plays which share the dialogue form and concerns of the Truce literature. There are other plays, however, in which the peasant/soldier theme is significant. In a *rederijker* play from the midsixteenth century entitled *Moordadig Werck en Manhatigetanden* (in: E. Ellerbroek-Fortuin, *Amsterdamse Rederijkerspelen in de Zestiende Eeuw* [Groningen: 1937]), a peasant family meets with the two characters who give the play its title and who are dressed, according to a surviving stage direction, as ''Spaensche soldaten.'' Moordadich

Werck and Manhatigetanden come directly from late-medieval *rederijker* figures known as *sinnekens,* players who always appear in pairs and who are responsible for most of the evil in the drama. In this play, they are intended to represent the ills of war, while the peasant family, who must wander begging since their home has been destroyed, represent the sufferings of the innocent (their names are D'onnosele, D'onbeschuldige, De beschaede). Peasant/soldier encounter also occurs in an early seventeenth-century play by Jacob Duym entitled *Een Nassausche Perseus* (in: K. Poll, *Over de toneelspelen van Jacob Duym* [Groningen: 1898]). Most of this play is in the allegorical mode, with the Prince of Orange in the role of Perseus setting out to rescue the Netherlands in the form of Andromeda. The second act, however, has more in common with the sixteenth-century *Moedwillig Bedriff* (discussed above, in the text, pp. 36–37). The scene opens with a peasant lamenting the behavior of the soldiers garrisoned on him. Every day he has to provide for fifteen of these rough guests as well as for their women companions, and far from being satisfied with his simple fare they must have veal, capons, wine and white bread. As his monologue ends, three of his guests appear and attack him, grabbing the wine flask he has brought and insisting that he go out again to purchase more. After the peasant leaves, the soldiers return to his house to molest his wife and daughter. Although the play continues, the peasant never gets revenge: that privilege is reserved for Perseus-Orange in the final scene when he rescues Andromeda-Nederland from her chains.

In *Een Boerdighe Cluchte van Kijck in de Krijgh,* written around 1600 (in: *Tijdschrift voor Nederlandse Taal en Letterkunde* 1930: v. 49) the peasant/soldier theme is important but is treated less directly. The main characters are: Kijck in de Krijg, a cowardly mercenary who would rather spend his time drinking and gambling than in combat; Werck Nooit, a vagabond the soldier meets on his way to an inn and Luije Waert, the innkeeper bent on using the vices of the other two for his own gain. The play centers around Kijck in de Krijg's cowardice. Werck Nooit sarcastically remarks that the only persons ever frightened by his bluster are the peasants; Luije Waert points out that while the soldiers have been hired to protect the land, instead they persecute it:

> In plaets dat hij 't volck en lant sou beschermen
> Soo federft hij 't dat den huisman moet swermen
> En doetse vressen met sijn sweren en vloecken.

The play ends, however, in a round of insults heaped on each character in turn, so that Kijck in de Krijg gets a chance to show Werck Nooit and Luije Waert that they are no better than he is. While the action is thus concluded in a favored comic fashion—a pox on all houses—nevertheless the peasant/soldier theme, in the words of Luije Waert, has a genuinely critical thrust, directed at the excesses committed by hired mercenaries in the last quarter of the sixteenth century.

11. "Moedwillig Bedrijf: een Tafelspel van Twee Personagien," in P. J. Meertens, *De Lof van den Boer* (Amsterdam: 1942), pp. 191-203.

12. Ibid., p. 195.

13. Ibid., p. 198.

14. Ibid., p. 200.

15. Ibid., p. 202.

16. G. H. van Brueghel, "Soldatengeweld," from: *Brueghels Boertige Cluchten* (Amsterdam: 1613).

17. D. Kunzle gives a social analysis of the World Upside Down tradition in "The World Turned Upside Down: Iconography of a European Broadsheet Type," from *The Reversible World: Symbolic Inversion in Art and Society,* ed. B. Babcock, (Ithaca, New York: 1978).

18. Sex-role inversion is the most frequent reversal in the World Upside Down tradition. Kunzle argues that male-female inversions were used to deflect attention from potentially more revolutionary ones, i.e., master-servant.

19. Jan de Wasscher was an offshoot of the World Upside Down broadsheet which was particular to Holland (see C. F. van Veen, *Dutch Catchpenny Prints* [The Hague: 1971], pp. 24-25). Jan is a meek house-husband whose wife gets him to do all the washing and baby-minding; in some cases she dominates him in other ways (see Kuzie, "World Upside Down," p. 7).

20. P. Grauls (*Volkstaal en Volksleven in het werk van P. Bruegel* [Antwerp and Amsterdam: 1957]) discusses the role of popular literary and visual traditions involving the bad wife or "Bose Griet" in the formation of Bruegel's *Dulle Griet*. See also Jeremy Bangs' note on a possible connection between the figure of *Dulle Griet* and a popular riot in the sixteenth century in: *Art Bulletin* December 1978.

21. Natalie Davis, "Women on Top," from *Society and Culture in Early Modern France* (Stanford, California: 1975); also in her (unpublished) lecture, "Men, Women and Violence: Some Reflections on Equality," Smith College, 1977.

22. F. de Witt Huberts, *Haarlems Heldenstrijd in beeld en woord 1572-73* (The Hague: 1943), pp. 52-53. Huberts quotes van Meteren's account of Kenau's actions:

> Kenau Simonsdr. Hasselaer was een cloecke vrouw . . . die dander vrouwen in allen noot aanvoerde en met eenighe andere veel manlyke daden boven vrouwen aert bedreef op ten vijant, met spiessen, bussen end sweert. [E. van Neteren, *Belgische ofte Nederlantsche Historie* Delft: 1599].

23. The role of women in popular rebellions and crowd actions in early Modern Europe is discussed by Davis in the articles cited in note 19; also to some extent by Christopher Hill, in "The Many-Headed Monster in Late Tudor and Early Stuart Political Thinking," (from: C. H. Carter, *From the Renaissance to the Counter-Reformation* [New York: 1965]) and E. P. Thompson, "The Moral Economy of the English Crowd in the Eighteenth Century," *Past and Present* 1971: v. 50.

24. Svetlana Alpers ("Bruegel's Festive Peasants," *Simiolus* 1972-73: v. 6, pp. 163-76) argues that certain kinds of excess—drunkenness, fighting, rough love-making—were tolerated and even expected during Kermis. Alpers has also pointed out (in: "Realism as a Comic Mode: Low Life Painting Seen through Bredero's Eyes," *Simiolus* 1975-76: v. 8, pp. 115-44) that Vinckboons' kermises in particular, in which middle-class people actively join in the festivities, display social approval of the activities depicted. The shared feasting which concludes Vinckboons' Boerenverdriet series is somewhat different. The soldiers do not represent a different class; moreover, in separate iconographic traditions soldierly feasting has negative connotations. In some of the graphic arts of Urs Graf, for example (see Ch. 4, "Rubens' *Carousing Landsknechts,*" fig. 23), it is clear that greed for wine and women leads the mercenary to wage war for booty. Such traditions, coupled with the scenes of explicit exploitation in Vinckboons' Boerenverdriet, suggest that if the final scene uses festivity to resolve conflict, the seeds of that conflict remain ingredients in the festive activity itself.

25. For example, a *rederijker* pamphlet drama from 1609 entitled *De Treves* (in: W. Hummelen, *Repertorium van het Rederijkersdrama* [Assen: 1968], cat. no. 1-OR-1), in which a peasant is not satisfied after the Truce is announced—"Boven een bestand is een vrede te verkiezen. Is het niet alleen maar een adem pauze?"

26. The culture in question is that of the Andaman Islanders; the example of their peace ceremony is discussed by Gregory Bateson, in "A Theory of Play and Fantasy," from *Steps to an Ecology of Mind* (New York: 1972).

27. A good general discussion of antique literary attitudes toward country life, including the notion of the peasant world as a refuge from war, is to be found in Raymond Williams' *The Country and the City* (London: 1973), especially Chs. 3 and 4.

28. P. J. J. van Thiel, "Marriage Symbolism in a Musical Party by J. M. Molenaer," *Simiolus* 1967-68: v. 2.

29. Cesare Ripa, *Iconologia* (Milan: 1602). Ripa says that *Ira* can be a man or a woman: youth, rather than sex, is the crucial factor. The drawn sword, however, is necessary to show that the personification of *Ira* is ready for revenge. For the personification of the Choleric temperament, Ripa specifically prescribes a young male figure with a raised sword.

30. See above, Ch. 2, p. 2.

31. A good overview of attitudes toward war in the sixteenth century is supplied by J. R. Hale, in "Sixteenth-century Explanations of War and Violence," *Past and Present* 1971: v. 51, pp. 3-26; for the seventeenth century, George Clark, *War and Society in the Seventeenth Century* (Cambridge, England: 1958), especially Chs. I and II.

Chapter 4

1. The precise date of the original painting and the preliminary drawing is unknown. H. G. Evers (*Rubens und sein Werk: Neue Forschungen* [Brussels: 1943]) dates the painting between 1632 and 1635. He argues that figures on the reverse side of the drawing are studies for *Landscape with a Rainbow* (Leningrad: Hermitage) executed around 1632. J. S. Held (*Rubens' Selected Drawings* [London: 1959]) believes that *Landsknechts* was painted in 1638. In that year, Rubens wrote to Antwerp for a painted panel which Held thinks is a preparatory sketch for the painting.

2. M. Rooses, *L'ouvre de P.O. Rubens* (Antwerp: 1890), v. IV, p. 81.

3. M. Haraszti-Takacs, *Rubens and his Age* (Budapest: 1972), text to Plate 6.

4. Evers, *Rubens und sein Werk*, p. 317.

5. Haraszti-Takacs, *Rubens and His Age*, text to Plate 6.

6. Evers, *Rubens und sein Werk*, p. 319.

7. Ibid.

8. Ibid., p. 318.

> Mit der andern Hand balanziert der Landsknecht ein gefülltes Glas. In der Zeichnung war es ein eiförmiges Gebilde. . . . Im Gemälde ist das van Bruch bedrohte, Glücksblinde dieses Glases verdeutlicht durch den nächtraglich eingefügten Bärtigen, der mit entzündeten Lidern über erblindeten Augen grinst, und mit der Hand in irgend einem Gefässe rührt.

9. The hurdy-gurdy, formerly a court instrument, was primarily associated with beggars and street musicians in the seventeenth century. See E. Winternitz, "Bagpipes and Hurdy-Gurdies in their Social Setting," *Metropolitan Museum Bulletin* Summer 1943, pp. 56-83.

10. Compare the costumes of Vrancx' and Snayers' troops with the dress of the musketeer in De Gheyn's *Exercise of Armes* (in the facsimile edition with an introduction by J. B. Kist, New York and London: 1971). Several of the Flemish landscapists' soldiers carry the gun, crutch and cartridge belt worn by De Gheyn's model. None of the equipment possessed by Rubens' central landsknecht is displayed or demonstrated in this 1607 military handbook.

11. E. Major and E. Gradmann, *Urs Graf* (London: 1947), p. 38.

12. The inscriptions to Callot's *Misères* are by Michel de Marolles, abbé de Villeloin, a poet and collector of prints. See D. Wolfthal, "Jacques Callot's *Misères de la Guerre*," *Art Bulletin* June 1977, pp. 222-23, for an evaluation of the inscriptions' significance.

13. K. Renger, *Lockere Gesellschaft* (Berlin: 1970), p. 46.

14. Ibid., p. 52.

15. Stuart Miller, *The Picaresque Novel* (Cleveland, Ohio: 1967) and Robert Alter, *Rogue's Progress: Studies in the Picaresque Novel* (Cambridge, Mass.: 1964) both supply good general definitions of the picaresque genre.

16. H. J. C. von Grimmelshausen, *The Adventures of a Simpleton* (translated by W. Wallich; New York: 1962).

17. *La vida y hechos de Estebanillo Gonzales* (Antwerp: 1646).

18. A brief bibliographical history of *Estebanillo* and a fairly detailed summary of the novel are to be found in: E. Gossart, *Les Espagnols en Flandre* (Brussels: 1914), pp. 243-97.

19. Gossart, p. 293.

20. R. Alter discusses the importance of the concept of Fortune in the picaresque genre (see *Rogue's Progress: Studies in the Picaresque Novel*, pp. 72 ff.), as does S. Miller in *The Picaresque Novel*, pp. 28-38.

21. From Mateo Aleman, *Guzman de Alfarache* (translated by James Fitzmaurice-Kelly, London: 1924), introduction to Book I.

22. See Ch. 1, pp. 7–9, for an account of attempts to regulate the "free-lance" style of mercenary warfare.

23. The Joyous Entry decorations simultaneously flatter the youthful Cardinal Infante Ferdinand with portrayals of his and other Hapsburg victories and display the misery inflicted upon Antwerp by the war. Here, martial assertiveness is portrayed positively, since its use in the Hapsburg cause is unquestionably just.

 For an interpretation of the martial image of St. George in Rubens' Antwerp *Madonna and Saints* and a brief account of other instances in which Rubens portrays physical aggressiveness positively, see C. Brusati, "The Antwerp Madonna and Saints: Meaning and Pictorial Mode in Rubens' Painted Epitaph" (unpublished master's thesis, University of California, Berkeley: 1976).

 Although both these works stem from the same years in which Rubens produced the *Carousing Landsknechts,* they derive from very different and far less ambivalent sources than those which inform the central image of Rubens' mercenary.

24. Ruth S. Magurn, *The Letters of Peter Paul Rubens* (Cambridge, Mass.: 1971), Letter 210 (November 23, 1629), p. 350.

25. Joachimi's report is quoted by H. G. Evers, *Rubens und sein Werk, Neue Forschungen*, pp. 291-92.

26. Magurn, Letter 218 (January 13, 1631), p. 371.

27. Ibid., Letter 237 (August 16, 1635), p. 400.

28. The history of this commission and its iconography are discussed in J. R. Martin, *The Decorations for the Pompa Introitus Ferdinandi*, Corpus Rubenianum Ludwig Burchard (New York and London: 1972).

29. Martin, Plates 82-87.

30. Magurn, Letter 242 (March 12, 1638).

31. Reinhold Baumstark, "Ikonographisches Studien zu Rubens Kriegs-und Friedensallegorien," *Aachener Kunstblatt* 1974: bd. 45; pp. 125-234.

32. Erasmus, *The Complaint of Peace*, ed. W. J. Hirten (New York: 1946).

33. S. Alpers, "Rubens' Kermess: A View of the State of Flanders and the State of Man," MS. 1975.

34. Vienna, Kunsthistorisches Museum, *Gemälde: Beschreibendes Verzeichnis* (Vienna: 1892), entries 1204 and 1205, pp. 416-417. Similarly in Constantijn Huygens' "Een Boer," from *Zedeprenten* (1623-1624) the joys of the peasant during peacetime are set off against his sufferings during war:

> Hij leeft gelijckmen leeft daer 't Leven leven is/Daer voor noch achterdenck, daer geen gebeef en is,/Tot dat de Trommel komt. . . ./ Kipt Trommel-tyden uyt: geen sijns gelijcke Koning. [from "Een Boer," in M.C.A. van Heijden, *Profijtelijk Vermaak: Moraliteit en Satire uit de 16de en 17de eeuw* (Utrecht: 1968), pp. 242-43.]

And in one of the many anonymous "Remonstrances" written on the occasion of Frederik Henry's 1622 invasion of Brabant, Kermis and Boerenverdriet are joined in a narrative, descriptive fashion which suggests that peasant festivities may sometimes have actually been interrupted by marauding troops:

> De Boeren waren meest gevlucht met haer paerden/ beesten/en ghereetste mobelen/die gebleven waren/ waren seer hardneckigh/ende mits de heylighe daghen en de Kermis haer noch in 't hooft lagh/meest droncken/ soo datter in de seventich soo dorpen/gehuchten/als Heere huysen afgebrand zijn/de Dorpen die contributie gaven wierden verschoomd. [Quoted in M. Sabbe, *Brabant in 't Verweer* (Antwerp: 1933) p. 121.]

35. In Rubens' *Kermes*, for example, there are no ambiguities of this sort—the model for the picture is clearly the low peasant frolic in the manner of Bruegel the Elder. Without the original painting by Rubens, however, it may be impossible to define the function of the woman in black in *Landsknechts*. Though it is clear that her role changes from preparatory drawing to finished work (see above, text pages 46–48), her pose and gesture are rendered slightly differently in the Wijingaert print and in both copies. In the Munich copy her posture is more upright and her expression less imploring, suggesting that she could be the mercenary's accomplice; in the Budapest version the reverse is true.

36. Baumstark, pp. 146-47.

37. Cesare Ripa, *Iconologia* (Milan: 1602).

Chapter 5

1. See, for example, the broadsheet listed in the *Atlas von Stolk* (#1732) "Verhael van den seer desolaten Staet, waer in zij Duitsland, en wel voornamentlijk Keur Paltz. zij bevonden heeft, gedurende den Oorlog, voornamentlijk A° 1632-1636, zoo door de Fransche, maer Insonderheijd door de keyserlijke Troepen onder den Oversten Gallas. . . ." Twelve plates of different sizes depict the atrocities committed by the troops. Romeyn de Hooghe's illustrations to *Keur-Stof Deses Tydts, Behelsende de voornaemste Geschliedenissen . . . Meest voorgevallen zedert het Jaer 1640* (Dordrecht: 1672) also include some incidents from the Thirty Years War.

2. De Hooghe's prints originally illustrated A. de Wicquefort's *Advis Fidelle aux Véritables Hollandois*, (The Hague: 1673).

3. See Knuttel, *Catalogus*, especially #s 5748 and 5749; also 5751-56. The same change is evident in an anthology of verse published to commemorate the Treaty of Munster, *De Olijfkrans der Vreede* (Amsterdam: 1649). Not a single entry employs peasant/ soldier dialogue; the peasant, when he appears, is not Dutch at all, but rather the pipe-playing shepherd of the high pastoral mode (see especially "De Vreede," by J. Vos, p. 171).

4. The historical context, literary sources and imagery of Vondel's *Leeuwendalers* are discussed in an introduction to an annotated edition of the play by A. van Duinkerken *(Vondels Leeuwendalers, Lantspel*, Utrecht and Brussels: 1948).

5. See, for example, Atlas van Stolk #s 1956 and 1958, "De vertooningen, gedaan binnen Amsterdam, op de Eeuwige Vrede en Vryheit" and "Zes vertooningen, die op den Schouburg vertoont zijn 23 juni 1648." The six scenes represented in the latter print are all in the high allegorical mode: De gekroonde Vrede, 't Ontwapenen van Mars, 't Verbont der Vorsten, 'd Ontloocken Aarde, Gewenste Vryheid, De Verplette Oorlog.

 In another historical print from the Atlas von Stolk (#1961-"Zalig aijn de voeten der geener die de vreede verkondigen"), the Treaty of Munster is celebrated by an allegorical print showing Ferdinand III, Louis XIV and Christina of Sweden joined by a cord and surrounded by nobles and clergy. In front of Ferdinand, allegorical figures of Justice, Peace and Love restrain Mars. On either side, three small plates represent the Disasters of War and the Blessings of Peace (one of the three Disasters prints is a small-figured scene of a peasant village under attack by soldiers). Atlas von Stolk #1964—"Der mars ist nun im Ars"—also has a central allegorical scene commemorating the Treaty, while a small scene above depicts peasants plowing as an emblem of Peace.

6. Peter Burke, in "Dutch Popular Culture in the Seventeenth Century: a Reconnaissance" (Centrum voor Maatschappijgeschiedenis, Universiteit Erasmus-Rotterdam, *Mededelingen* no. 3: 1978) discusses urbanization as a factor in the separation of elite from popular culture in seventeenth-century Holland. The effect of pastoral as an aristocratic mode adopted by the Regent class is discussed by A. Kettering, "The Batavian Arcadia" (unpublished doctoral dissertation, University of California, Berkeley: 1975) and by P. A. F. van Veen, *De Soetigheyt des Buitenlevens* (The Hague: 1960).

7. None of these artists (sometimes called the "guardroom painters" because of their concern with military recreations) has been discussed in a monograph. However, their works have been treated collectively by C. Playter, in "Willem Duyster and Pieter Codde: The 'Duystere Werelt' of Dutch Genre Painting" (unpublished doctoral dissertation, Harvard University: 1972). Playter is largely concerned with paintings involving soldiers and their entertainments and does not devote attention to scenes including both peasants and soldiers.

8. Compare the breast plates, cartridge belts, muskets and crutches used by the troops in De Gheyn's *Exercise of Armes* (The Hague: 1607).

9. For example, in Roemer Visscher's *Sinnepoppen* (Amsterdam: 1614) emblem LVII, p. 57. Here, arms and armor are displayed in still-life fashion, but each piece of equipment is slightly damaged, articulating the sense of the motto "Och oft soo altijdt mocht blyven." In van Velsen's picture, the gear is in excellent condition; the armor highly polished, the musket carefully replaced on its stand.

10. We do not know whether such plays as *Moedwillig Bedrijf* or G. H. Brueghel's *Soldatengeweld* (See Ch. 2, pp. 36–38) were performed after midcentury, though given the cultural changes described above, it seems unlikely that these dramatic pieces would have remained popular in the major urban centers.

Boerenverdriet did surface in pamphlet form, however, suggesting that this type of literature may have reached a different audience than that which attended the Amsterdam Schouwburgh. The example in question was written on the occasion of William II's attempted coup in Amsterdam in 1650, and describes in popular verse form the panic of the peasants in the surrounding countryside on the arrival of the Prince's troops. Unlike the Munster pamphlets of 1648, this poem ("Een samen-Gesangh, van verscheyden Personen, en 't Beklagh van de Boeren van Ouwer Kerck, Slooten, Diemen, Muyden en andere Plaetsen, over 't goed Tractement dat sy de Ruyters en Soldaten moesten doen," in W. Zuidema, "Soldaten leven en Schuttersmoed in 1650," *Amsterdams Jaarboekje:* 1897) revives the demotic style and dialogue form of the 1609 Truce literature.

11. Playter ("'The Duystere Werelt,'" p. 117) argues that the display of booty in such pictures may have a *Vanitas* connotation, but her argument does not seem convincing except in those instances where specifically vanitas objects, such as watches, appear.

12. F. Redlich, in *De Praeda Militari: Looting and Booty 1500-1815* (Wiesbaden: 1956) discusses the military regulation of looting. See also the military code of the United Provinces, the Artikelbrief of 1590 (Art. 63), regarding the required registration of captured booty.

13. Redlich, p. 20.

14. Burke, "Dutch Popular Culture in the Seventeenth Century," pp. 19-20.

15. E. J. Hobsbawm, in *Bandits* (London: 1969) defines some of the characteristics and social functions of heroic bandits; his examples, however, are mainly from the eighteenth and nineteenth centuries.

16. *Thysken vander Schilden* was first published in 1613, and again in 1615 and 1642. There is little literature on the play, perhaps because its attribution to Coster is dubious; it is discussed briefly in G. Kalff, *Geschiedenis der Nederlandse Letterkunde* (Groningen: 1906-12), Deel IV, p. 121.

17. See J. Vles, *Le roman picaresque hollandais des XVIIe et XVIIIe siècles et ses modèles* (The Hague: 1926).

18. The *grillen* and their relation to art have been discussed briefly by H. Miedema in *Proef* February and May 1974.

19. *De Gave van de Milde St. Martin,* by Kornelius Last (Amsterdam and Rotterdam: 1654-1657). The teasing introduction to this work, which chaffs the reader for his choice of this unworthy reading material, resembles the introductions to the picaresque novels *Guzman de Alfarache* (1604) and *La vida del Buscon* (1626):

> Aen den Leser:
> Ghy leser seght, waer toe dees grillen?
> Schrijft yet, dat waerdigh zu gepresen,
> Maer Vriendt, wilt hier uw hooft van stillen
> Dat prijstmen, maer dit wort gelesen.
> De beste Boeken blijven leggen
> Nu overkost, soo is 't gestelt,
> De Druckers winnen, soo zy zeggen,
> Aen Uylespiegels 't meeste gelt.

20. *De Gave van de Milde St. Martin,* Part II, p. 182.

21. Ibid., Part II, p. 32.

22. S. Slive ("Notes on the Relation of Protestantism to 17th Century Dutch Painting," *Art Quarterly* v. 19: 1956, pp. 315 ff) suggests that it is likely that Wouwermans was Catholic; J. C. Droochsloot certainly was (see Thieme-Becker, *Kunstler-Lexicon, v. IX*).

23. Callot's *Siege of Breda* was commissioned by the Infanta Isabella, certainly for commemorative and very likely for instructive purposes. The prints are accompanied by detailed tables coded by letter to the pictures. The tables describe each area of operations in four different languages, just as some military handbooks do for the benefit of armies of mixed nationality. (For the conditions of the commission of the *Siege of Breda* see: J. Lieure, *Jacques Callot* [Paris: 1927], v. V, cat. #593).
 J. W. Wijn (*Krijgswezen in het Tijd van Prins Maurits* [Utrecht: 1934]) discusses the use of siege pictures in military education (see esp. Ch. VII, "Vestingbouw en belegerings oorlog").

24. An interesting play on winning in gambling and in war is developed in a siege print mentioned by F. Muller (#1655) and the Atlas von Stolk (#1707). The print, entitled "Die waecht Die Wint," shows two soldiers gambling before a sutler's tent, while in the background Hertogenbosch is besieged. It would be interesting to explore the connection, if any, between such prints and and the guardroom scenes of Amsterdam and Utrecht (C. Playter, in the dissertation cited above, has not investigated this question).

25. For example, in his paintings in the Pinakothek, Munich (#432); in the collection of D. L. Hase, Almelo; and in Mannheim, Städtisches Reiss Museum (H. de G. #499).

26. L. G. Rogier (*Geschiedenis van het Katholicisme in Noord-Nederland in de 16e en de 17e Eeuw* [Amsterdam: 1945]) describes the resistance (which varied from province to province) of the peasantry to Protestantization.

27. Rogier, *Algemene Geschiedenis van Nederland* (Utrecht: 1952), v. V, Ch. XI, "Protestantiseering van Noord-Nederland," p. 356.

28. Wolfgang Stechow, in "Jan Steen's Marriage at Cana" (*Nederlands Kunsthistorisch Jaarboek* 1972: 23) argues that one of Steen's versions of this subject contains disguised Eucharistic symbolism. The most recent study of Steen's religious and historical pictures (Baruch Kirschenbaum, *The Religious and Historical Paintings of Jan Steen* [New York: 1977]) makes few specifically iconographical connections between the painter's confession and work, but suggests that the overall vision of his religious works may have been affected by his Catholicism.

29. Steen painted the Boerenverdriet theme at least twice. The picture to be discussed here, known as the *Sauvegarde van den Duyvel,* was formerly in the collection of the Rijksmuseum, Amsterdam (#2249 in the 1905 Catalog; Hofstede de Groot #785). The painting was auctioned by F. Muller (Amsterdam) in 1912, and again by Mak van Waay (Amsterdam) in 1976; its most recent owner was the Prestige Art Gallery (J. Knoop) also of Amsterdam.
 The second picture, Hofstede de Groot #786, was formerly in the collection of John Crichton-Stuart, Marquess of Bute; its present location is unknown. My best efforts have failed to produce an acceptable photograph of it; the only reproduction I have seen is that in the Rijksbureau voor Kunsthistorisch Documentatie at The Hague.

30. The older catalogue entries (Hofstede de Groot #785, Rijksmuseum Catalog: 1905, #2249; F. Muller auction catalog, 5/14/1912, #174) all agree that the two figures in the center foreground of the picture are a monk and a Protestant dominee.

31. W. Martin, *Jan Steen* (Amsterdam: 1954), p. 154.

32. Rogier's claims about the extent to which the Northern Netherlands were forcibly Protestantized have been criticized in an article by Enno van Gelder ("Nederland Geprotestantiseerd?" in *Tijdschrift voor Geschiedenis* 1968: 81, pp. 445-64).

33. S. J. Gudlaugsson, *The Comedians in the Work of Jan Steen and his Contemporaries* (Soest: 1975), pp. 31-34.

34. The monk's habit generally resembles the cowl, tow-belt and sandals worn by Franciscans as they are portrayed in the northern print tradition (see, for example, the costumes worn by the friars in Tobias Stimmer's *Friars Minor with the Dead Body of St. Francis,* reproduced in M. Geisberg, *The German Single Leaf Woodcut 1550-1600,* revised edition [New York: 1974]).

35. See note 29.

36. For example, Leonhard Beck's *Monk and Maiden* (dated 1523; reproduced in M. Geisberg, *The German Single-Leaf Woodcut 1500-1550,* #140) in which a monk, seated at a table with a wine tankard, attempts to buy the favors of a young girl; also Matthias Gerung's *The Gaming Table of Blasphemers* (Geisberg, p. 270) which portrays among others a monk and a nun who drink together, a child (theirs?) hidden beneath the bench they sit on; finally, the tipsy monks in Pieter Flotner's satirical *Procession of the Clergy* (dated 1535; Geisberg, #s 825-26).

37. Erasmus, *The Praise of Folly* (translated by B. Radice, Harmondsworth: 1971), p. 167.

38. See Mikhail Bakhtin, *Rabelais and his World* (Cambridge, Mass.: 1968) for an interpretation of Rabelais's Friar John as an expression of "Carnivalized" Catholicism (pp. 86 ff.).

39. Steen often portrayed himself as a participant in peasant and *rederijker* festivities. He is clearly recognizable in the *Sauvegarde van den Duyvel;* compare the grill-wielding figure with the *Self-portrait playing the Lute,* c. 1661-3, Coll. Thyssen-Bornemisza: Lugano.

40. C. W. de Groot, *Jan Steen: Beeld en Woord* (Utrecht and Nijmegen: 1952), section on Volks-sleven in Steen, pp. 74-86.

41. In Steen's version of Driekoningenavond in Kassel; also in the versions mentioned by Hofstede de Groot, #s 491, 494, 507, 508.

42. The social function and history of the sixteenth-century French *charivari* have recently been examined by N. Z. Davis, in "The Reasons of Misrule," from *Society and Culture in Early Modern France* (Stanford, California: 1975). The practice certainly existed in the sixteenth-and seventeenth-century Netherlands, but to my knowledge it has been examined only from the ethnographical point of view (see: A. van Gennep, *Le Folklore de la Flandre* [Paris: 1935], v. I, Ch. IV, "Le Mariage," pp. 94-99; and Jos. Schrijnen, *Nederlandsche Volkskunde* [Zutphen: 1930], v. I, Ch. IV, pp. 281-83.)

43. Davis, "Reasons of Misrule," p. 106.

44. The overage suitor was a theme which Steen depicted in other instances; for example, *De oude vrijer* in the collection of Lord Swaithling, London. Here, an old man with a flute protruding from his pocket courts a young girl in a kitchen, while her mother and a laughing Jan Steen look on. The old man's inappropriate lust is satirized with specifically sexual imagery: the flute (which had long had erotic connotations—see A. Kettering, "Rembrandt's *Flute Player,*" in *Simiolus* 1977: v. 9, no. 1) and the birdcage (see E. de Jongh, "Erotica in vogelperspectief," *Simiolus* 1968-69: v. 3).

45. This has been discussed by Rogier, *Geschiedenis van het Katholicisme* v. II, pp. 782-85; and more recently, in the article by Peter Burke cited above, note 6.

46. According to Rogier, v. II, p. 789.

47. The 1654 Synod of Leeuwarden specifically forbade wedding farces or *bruydespelen (Acta der Synoden van Zuid-Holland* [Den Haag: 1916], v. 8: 1646-1656, p. 417) but it is difficult to tell

from the wording of the act whether the practice prohibited was in fact *ketelmuzik (charivari)* or the more formal skits performed by *rederijkers* at private weddings.

In France, the Calvinists were definitely hostile to the *charivari* (See Davis, "Reasons of Misrule," p. 210).

48. See, for example, Yves-Marie Berce, *Fête et Révolte: des mentalités populaires du XVI au XVIII siècles* (Paris: 1976):

> Le rétablissement des fêtes et des processions dans toute leur pompe accoutumée sitôt après le reflux du parti protestant prenait dans chaque province figure de manifeste. Des affluences populaires prenaient une revanche des fêtes interrompues, des réjouissances empêchées par les malheurs de la guerre ou par les armes du parti protestant. (p. 70).

49. The self-portrait with Saskia in Dresden, identified as a version of the Prodigal Son in the Tavern by I. Bergstrom, *Nederlands Kunsthistorisch Jaarboek* 1966: 17, pp. 143-69.

50. Kirschenbaum, *Paintings of Jan Steen*, p. 59.

51. De Groot (*Jan Steen*) identifies the holidays and folk customs in a number of Steen's genre paintings and acknowledges their Catholic origin, but does not address the question of how such works might be related to the struggle between the Calvinist church and popular literature described above.

Conclusion

1. Hollstein, IX, nos. 90-96 (incomplete). Ten full page etchings (c. 19.5 x 30 cm) signed by De Hooghe. They were used as illustrations to polemics on the war with France such as A. de Wicquefort's *Advis Fidelle aux Veritables Hollandois* (The Hague: 1673), *De Fransche Tyrannie* (Amsterdam: 1674), and others. For complete bibliographical information on these prints see J. Landwehr, *Romeyn de Hooghe as Book Illustrator* (Amsterdam: 1970).

2. Theodore Rabb, *The Struggle for Stability in Early Modern Europe* (New York: 1975), p. 121.

3. Ibid., p. 139.

4. Ibid., p. 131.

5. Ch. 1, p. 10. See also the Artikelbrief of 1590, in J. W. W. Wijn, *Krijswezen in den Tijd van Prins Maurits,* items 3, 4, 5, 7, 14 for sanctions against harassment of civilians. D. Wolfthal ["Jacques Callot's Misères de la Guerre," *Art Bulletin:* June 1977] links Callot's print series specifically with the French military handbooks of Fourquevaux *(Les Instructions sur la faict de Guerre)* and G. Joly *(Traite de la justice militaire).*

6. The development of secular "just war" theory has been recently discussed by James T. Johnson, *Ideology, Reason and the Limitation of War* (Princeton: 1975).

7. Rabb, *Struggle for Stability*, p. 124.

8. The Resolutions of the States General of Utrecht for 1672 recount how the countryside of that province had suffered from troops hired in its defense:

> Want yder weet wel dat het platteland soo veel gheleden heeft, eerst door de deurtocht der Spaensche krijghsbenden, die tot bystant der Ver. Nederlanden quamen, en by gevolgh door de legeringhen der andere krijgslieden, dat het gantschelijck daer door verdorven is.

9. Both Clark (*War and Society in the Seventeenth Century* [Cambridge: 1958]) and Michael Roberts (''The Military Revolution 1560-1660'' in *Essays in Swedish History* [London: 1967]) maintain that the severity of warfare may have been reduced (but in some aspects worsened) by the rationalization process itself. Clark in particular is sceptical about the extent to which improvement actually did occur; unlike Rabb, he pushes any amelioration in practice well into the eighteenth century (*War and Society,* pp. 81-82).

10. According to Johnson (see above, note 6) Grotius' *De Jure Belli ac Pacis* exemplifies the transitional status of just war theory in the seventeenth century. Although the *jus in bello* (which was concerned with noncombatant immunity and weapons restrictions) had become as important in theoretical writing as the *jus ad bellum* (concerned with the right to make war), the former was not yet sufficiently developed to adequately prescribe limitations on war. While Grotius urged moral restraints, and implied that there were certain limits on war which could not be transgressed if the war were to remain just, he also maintained that in a legitimate cause ''Whatsoever is necessary to the End . . . that we are understood to have a power unto.'' (Johnson, p. 222). Thus Grotius admitted that it was lawful to kill prisoners of war, that devastation of enemy lands and cities was permissible even after surrender, that women and children could be slaughtered in order to terrorize an enemy as recommended in Psalm 137, ''Blessed shall he be that taketh thy children and dasheth them against the stones.'' Roberts, even more strongly than Johnson, believes that Grotius gives the state *carte blanche* with regard to treatment of enemy civilians (''Military Revolution,'' pp.216-17).

Bibliography

Alpers, S. "Bruegel's Festive Peasants," *Simiolus*, v. 6: 1972-73 (pp. 163-76).

_____."Realism as a Comic Mode: Lowlife Painting seen through Bredero's Eyes," *Simiolus*, v. 8: 1975-76 (pp. 115-44).

Alter, R. *Rogue's Progress: Studies in the Picaresque Novel* (Cambridge, Mass.: 1964).

Atlas von Stolk: Katalogus van Historie, Spot-en Zinneprenten, ed. G. van Rijn (Amsterdam: 1902).

Ballis, W. *The Legal Position of War* (The Hague: 1937).

Bateson, G. "A Theory of Play and Fantasy," in *Steps to an Ecology of Mind* (New York: 1972).

Baumstark, R. "Ikonographische Studien zu Rubens Kriegs- und Friedensallegorien," *Aachener Kunstblatt*, Bd. 45: 1974 (pp. 125-234).

Beller, E. A. *Propaganda in Germany during the Thirty Years War* (Princeton: 1940).

Berce, Y.-M. *Fête et Révolte: des mentalités populaires du XVI au XVIII siècles* (Paris: 1976).

Blink, H. *Geschiedenis van den Boerenstand en den Landbouw in Nederland* (Groningen: 1902-1904).

Blok, P. J. "De Nederlandsche Vlugschriften over de Vredeshandelingen te Munster 1643-48," *Verslagen en Mededelingen der Konincklijke Akademie van Wetenschappen: Afdeling Letterkunde*, Series 4, v. 1: 1897 (pp. 292-336).

Bor, P. *Nederlantsche Oorlogen* (Leiden: 1621).

Brants, V. *Histoire des classes rurales aux Pays-Bas jusqu'à la fin du XVIIIe siècle* (Brussels: 1881).

Bredius, A. "Pieter Jansz. Quast," *Oud Holland*, v. 20: 1902.

Bredius, A. and Bode, W. von. "Der amsterdammer Genremaler Simon Kick," *Jahrbuch der preussischen Kunstsammlungen*, v. 10: 1889.

Breen, J. C. "Gereformeerde populaire historiographie in de 17de en 18de eeuw," *Tijdschrift voor Geschiedenis*, v. 37: 1922.

Brueghel, G. H. "Soldatengeweld," from *Brueghels Boertige Kluchten* (Amsterdam: 1613).

Buitendijk, W. J. C. *Nederlandse Strijdzangen uit de 16e en eerste Helft der 17e Eeuw* (Zwolle: 1954).

Burke, P. "Dutch Popular Culture in the Seventeenth Century," *Centrum voor Maatschappijgeschiedenis: Mededelingen-Universiteit Erasmus-Rotterdam*, No. 3: 1978.

Clark, G. *The Seventeenth Century* (Oxford: 1947).

_____.*War and Society in the Seventeenth Century* (Cambridge, England: 1958).

Cockle, M. *A Bibliography of Military Handbooks to 1642* (London: 1902).

Coo, J. *De Boer in de Kunst* (Rotterdam: n.d.).

Cosemans, A. *De Bevolking van Brabant in de XVIIde en XVIIIde eeuw* (Brussels: 1939).

_____."Het uitzicht van Brabant op het einde der 16e eeuw," *Bijdragen tot Geschiedenis*, v. 27: 1936-37 (pp. 285-351).

Coupe, W. A. "Political and religious cartoons of the Thirty Years War," *Journal of the Warburg and Courtauld Institutes*, v. 25: 1962 (pp. 65-86).

Czobor, A. "Zu Vinckboons Darstellungen von Soldatenleben," *Oud Holland*, v. 78: 1962-63.

Davis, N. Z. "The Reasons of Misrule," in *Society and Culture in Early Modern France* (Stanford, California: 1975).

———."Women on Top," in *Society and Culture in Early Modern France* (Stanford, California: 1975).

Decimal Index to the Art of the Lowlands (The Hague: 1959-).

Deinhard, H. "The Massacre of the Innocents," in *Meaning and Expression: Toward a Sociology of Art* (Boston: 1970).

De Vries, J. *The Dutch Rural Economy in the Golden Age* (New Haven: 1974).

Dohmann, A. "Les Evénements contemporains dans la peinture hollandaise du XVIIe siècle," *Revue d'Histoire Moderne et Contemporaine*, v. V: 1958.

Drop, W., Gestel, F. C. van, and Steenbeck, J. W. *Voer voor polemologen: Oorlog en vrede in de Nederlandse literatuur* (Groningen: 1970).

Duyse, F. van. *Het oude Nederlandsche Lied: Wereldlijke en geestlijke Liederen uit vroegeren tijd* (Antwerp and the Hague: 1903-08).

Eenheid en Scheiding in de Nederlanden 1555-1585, Catalog of an exhibition commemorating the Pacification of Ghent (Ghent: 9 September-8 November 1976).

Ellerbroek-Fortuin, E. *Amsterdamse Rederijkerspelen in de Zestiende Eeuw* (Groningen: 1937).

Evers, H. G. *Rubens und sein Werk: Neue Forschungen* (Brussels: 1943).

Ferber, S. "Peter Bruegel and the Duke of Alva," *Renaissance News*, v. 19: 1966 (pp. 205-19).

Franz, G. "Von Ursprung und Brauchtum der Landsknechte," *Mitteilungen des Instituts fur Oestereichische Geschichtsforschung*, v. 61: 1953.

Franz, H. G. *Niederlandische Landschaftsmalerei* (Kassel: 1969).

Fredericq, P. *Het Nederlandsch Proza in de Zestiendeeuwsch pamfletten* (Brussels: 1907).

Fromentin, E. *The Old Masters of Belgium and Holland* (1882; rpt. New York: 1963).

Geisberg, M. *The German Single-Leaf Woodcut 1500-1550* (rev. ed., New York: 1974).

Gennep, A. van. *Le Folklore de Flandre* (Paris: 1935).

Gerson, H. *Art and Architecture in Belgium 1600-1800* (Baltimore: 1960).

Geurts, P. A. M. *De Nederlandse Opstand in de Pamfletten 1566-1584* (Nijmegen: 1956).

Geyl, P. *The Netherlands in the Seventeenth Century* (New York: 1966-68).

———.*The Revolt of the Netherlands* (New York: 1958).

Het Geuzenliedboek, ed. P. Leendertz (Zutphen: 1924).

Gheyn, J. de. *The Exercise of Armes* (The Hague: 1607; facsimile edition with an introduction by J. B. Kist, New York: 1971).

Goossens, J. *David Vinckboons* (Antwerp and The Hague: 1954).

Gossart, E. *Les espagnols en Flandre* (Brussels: 1914).

Grauls, P. *Volkstaal en Volksleven in het werk van P. Bruegel* (Antwerp and Amsterdam: 1957).

Grimmelshausen, H. J. C. von. *The Adventures of a Simpleton* (Translated by W. Wallich, New York: 1962).

———.*The Runagate Courage* (Translated by Robert Hiller and J. C. Osborne, Lincoln, Nebraska: 1965).

Groot, C. W. de. *Jan Steen: Beeld en Woord* (Utrecht and Nijmegen: 1952).

Grote Placaetboek: Inhoudenden: De Placaten ende ordonnantien van de Hogh-Mogende Heeren Staten Generael der Vereenighde Nederlanden ende van de Edel Groot Mogende Heeren Staten van Hollandt ende West-Vrieslandt (The Hague: 1664).

Gudlaugsson, S. J. *The Comedians in the Work of Jan Steen and his Contemporaries* (Soest: 1975).

Hahlweg, W. "Aspekte und Probleme der Reform des niederlandische Kriegswesens unter Prinz Moritz van Orangien," *Bijdragen en Mededelingen betreffende de Geschiedenis der Nederlanden*. v. 86: 1971.

Hale, J. R. "Sixteenth-century Explanations of War and Violence," *Past and Present*, v. 51: 1971 (pp. 3-26).

Haraszti-Takacs, M. *Rubens and His Age* (Budapest: 1972).

Harrebomee, P. J. *Spreekwordenboek der Nederlandsche Taal* (Utrecht: 1858).

Hauber, A. *Planetenkinder und Sternbilder* (Strassburg: 1916).

Heidenreich, H. *Pikarische Welt* (Darmstadt: 1969).

Heijden, M. C. A. van. *Profijtekijk Vermaak: Moraliteit en Satire uit de 16e en 17e Eeuw* (Utrecht and Antwerp: 1968).

Held, J. S. "Notes on David Vinckboons," *Oud Holland*, v. 66: 1951.

————.*Rubens' Selected Drawings* (London: 1959).

Heppner, A. "The Popular Theater of the Rederijkers in the Work of Jan Steen and His Contemporaries," *Journal of the Warburg and Courtauld Institutes*, v. 3: 1939-40.

Hermesdorf, B. H. D. *De herberg in de Nederlanden. Een blik de beschavingsgeschiedenis* (Assen: 1957).

Heurck, E. H. van. *L'imagerie populaire des Pays-Bas* (Paris: 1930).

Hobsbawm, E. J. *Bandits* (Harmondsworth: 1972).

Hollstein, F. W. H. *Dutch and Flemish Engravings, Etchings and Woodcuts 1450-1700* (Amsterdam: 1949).

————.*German Engravings, Etchings and Woodcuts 1400-1700* (Amsterdam: 1954 . . .).

Hooft, P. C. *Nederlandsche Historien 1555-1587* (Amsterdam: 1642).

Hummelen, W. *Repertorium van het rederijkersdrama* (Assen: 1968).

Huygens, C. *Zedeprenten* (1623-24; edited and annotated by H. J. Eijmael, Groningen: 1891).

————.*Zes Zedeprenten* (edited and with notes and introduction by members of the Institut de Vooys, Universiteit van Utrecht: 1976).

Jacques Callot und Sein Kreis; Werke aus dem Besitz der Albertina und Leihgaben aus den Uffizien, Exhibition Catalog (Vienna, Albertina: 1969).

Johnson, J. T. *Ideology, Reason and the Limitation of War* (Princeton: 1975).

Kalff, G. *Geschiedenis der Nederlandse Letterkunde* (Groningen: 1906-1912).

————.*Literatuur en toneel te Amsterdam in de 17e eeuw* (second edition, Haarlem: 1915).

Karling, S. "The Attack by P. Bruegel the Elder," *Konsthistorisk Tidskrift*, v. 45: 1976 (pp. 1-18).

Kettering, A. M. "The Batavian Arcadia: Pastoral themes in seventeenth-century Dutch Art" (doctoral dissertation, University of California, Berkeley: 1974).

Kirschenbaum, B. *The Religious and Historical Paintings of Jan Steen* (New York: 1977).

Klingender, F. "Les misères et les malheurs de la guerre," *Burlington Magazine*, v. 81: 1942 (pp. 205-06).

Knuttel, W. P. C. *Catalogus van de pamfletten-verzameling berustende in de Konincklijk Bibliotheek* (The Hague: 1889).

Knuvelder, G. P. M. *Handboek tot de geschiedenis der Nederlandse Letterkunde* (Den Bosch: 1970).

Koenen, H. J. *De Nederlandsche boerenstand, historisch beschreven* (Haarlem: 1858).

Kossman, E. H., and Mellinck, A. F., eds. *Texts Concerning the Revolt of the Netherlands* (New York and London: 1954).

Kossman, E. H. *De Nederlandsche Straatzanger en zijn liederen in vroeger tijden* (Amsterdam: 1941).

Kunzle, D. *The Early Comic Strip: narrative strips and picture stories in the European broadsheet c. 1450-1825* (Berkeley and Los Angeles: 1973).

————."Pieter Bruegel's *Proverbs* and the World Upside Down" *Art Bulletin*, v. 59: June 1977.

————."The World Turned Upside Down: Iconography of a European Broadsheet Type," in *The Reversible World: Symbolic Inversion in Art and Society*, ed. B. Babcock (Ithaca, New York: 1978).

Landwehr, J. *Romeyn de Hooghe as book illustrator* (Amsterdam: 1970).

————.*Romeyn de Hooghe the etcher: contemporary portrayal of Europe 1662-1707* (Leiden: 1973).

Last, K. *De Gave van de Milde St. Martin* (Amsterdam and Rotterdam: 1654).

Laube, A., Steinmetz, M., and Vogler, G. *Illustrierte Geschichte der deutschen fruhburgerlichen Revolution* (Berlin: 1974).

Lieure, J. *Jacques Callot* (Paris: 1927).

McGrath, E. "A Netherlandish History by Joachim Wtewael," *Journal of the Warburg and Courtauld Institutes*, v. 38: 1975 (pp. 182-217).

Magurn, R. *The Letters of Peter Paul Rubens* (Cambridge, Mass.: 1971).

Major, E., and Gradmann, E. *Urs Graf* (London: 1947).

Mander, C. van. "Boereklacht," from *Den Nederduytsche Helikon* (Haarlem: 1610).

_____.*Den Grondt der Edel Vrij Schilderconst* (Haarlem: 1604; edited and translated into modern Dutch by H. Miedema, Utrecht: 1973).

_____.*Het Schilder-boeck* (Haarlem: 1604; photofacsimile, Utrecht: 1969).

Manesson-Mallet, A. de. *Den Arbeid van Mars* (Amsterdam: 1672).

Martin, J. R. "The Decorations for the Pompa Introitus Ferdinandi," *Corpus Rubenianum Ludwig Burchard* (New York and London: 1972).

Martin, W. *Jan Steen* (Amsterdam: 1954).

Meertens, P. J. *De Lof van den Boer* (Amsterdam: 1942).

Meteren, E. van. *Belgische ofte Nederlantsche Historie/ van onsen tyden* (Delft: 1599).

Meyer, M. de. *Volks-en Kinderprent in Nederland* (Antwerp and Amsterdam: 1952).

Miller, S. *The Picaresque Novel* (Cleveland, Ohio: 1967).

Moerkerken, P. H. van. *Het Nederlandsch Kluchtspel in de 17e Eeuw* (Utrecht: n.d.).

Muller, F. *De Nederlandsche Geschiedenis in Platen* (Amsterdam: 1863-1882).

Muls, J. *De Boer in de Kunst* (Leuven: 1946).

_____."Vondel en de vrede," *Liber Amicorum van B. H. Mollenboer* (Amsterdam: 1938).

Nef, J. U. *War and Human Progress* (Cambridge, Mass.: 1950).

Oman, C. *History of the Art of War in the Sixteenth Century* (New York: 1937).

Parker, A. A. *Literature and the Delinquent: The Picaresque Novel in Spain and Europe* (Edinburgh: 1967).

Parker, G. *The Army of Flanders and the Spanish Road* (Cambridge, England: 1972).

Pianzola, M. *Peintres et Vilains* (Paris: 1962).

Pigler, A. *Barockthemen. Eine Auswahl von Verzeichnissen zur Ikonographie des 17. und 18. Jahrhunderts* (Budapest: 1956).

Playter, C. "Willem Duyster and Pieter Codde: The "Duystere Werelt" of Dutch Genre Painting 1625-1635" (doctoral dissertation, Harvard University: 1972).

Pleij, H. "De sociale funktie van humor en trivialiteit op het rederijkers toneel," *Spektator: tijdschrift voor neerlandistiek*, v. 5: 1975 (pp. 108-27).

Poelhekke, J. J. *'t Uytgaen van den Treves: Spanje en de Nederlanden in 1621* (Groningen: 1960).

Politieke Balladen, Refereinen, Liederen en Spotgedichten der XVI eeuw (Maatschappij der Vlaemsche Bilbliophilen, Ghent: 1847).

Poll, K. *Over de toneelspelen van Jacob Duym* (Groningen: 1898).

Presser, J., Romein, W. J., and Vrankryker, C. J. de. *De Tachtigjarige Oorlog* (Amsterdam: 1948).

Raa, F. J. G. ten, and Bas, F. de. *Het Staatsche Leger* (Breda, Konincklijke Militaire Akademie: 1919).

Rabb, T. *The Struggle for Stability in Early Modern Europe* (New York: 1975).

Redlich, F. "The German Military Enterpriser and his Workforce" *Vierteljahrschrift für Sozial- und Wirtschaftsgeschichte. Beiheft*, v. 47-48: 1964-65.

_____."Der Marketender," *Vierteljahrschrift für Sozial- ünd Wirtschaftsgeschichte*, v. 41: 1954.

_____.*De Praeda Militari: Looting and Booty 1500-1815* (Wiesbaden: 1956).

Reinsberg-Duringsfeld, baron de. *Traditions et Légendes de la Belgique* (Brussels: 1870).

Renger, K. *Lockere Gesellschaft* (Berlin: 1970).

Reyd, E. van. *Historie der Nederlandscher Oorlogen . . . tot 1601* (Second edition, Amsterdam: 1644).

Roberts, M. "The Military Revolution," in *Essays in Swedish History* (London: 1967).

Rogier, L. G. *Geschiedenis van het Katholicisme in Noord-Nederland in de 16e en de 17e Eeuw* (Amsterdam: 1945).

Rollin-Conquerque, L. M. "Oude strafwetgeving voor ons krijgsvolk te lande 1572-1705," *Militaire-rechtelijk Tijdschrift*, 1942-43 (pp. 91-182, 375-80).

Rooses, M. *L'oeuvre de P. P. Rubens* (Antwerp: 1890).

Rosenberg, A. *Hans Sebald und Barthel Beham* (Leipzig: 1875).
Rosenberg, J., Slive, S., and ter Kuile, E. H. *Dutch Art and Architecture 1600-1800* (revised edition, Baltimore: 1972).
Sabbe, M. *Brabant in 't Verweer* (Antwerp: 1933).
Scheidig, W. *Die Holzschnitte des Petrarca-Meisters* (Berlin: 1955).
Schotel, G. D. J. *Het Maatschappelijk leven onzer vaderen in de 17de eeuw* (Rotterdam: 1869).
Schrijnen, J. *Nederlandsche Volkskunde* (Zutphen: 1930).
Schulten, J. W. M. *Het Leger in de 17e Eeuw* (Bussum: 1969).
Scribner, R. W. "Images of the Peasant 1514-1525," *Journal of Peasant Studies*, v. 3: 1975-76 (pp. 29-48).
Slicher van Bath, B. H. *Een Samenleving onder Spanning: Geschiedenis van het Platteland in Overijssel* (Assen: 1957).
Slive, S. "Notes on the Relation of Protestantism to 17th Century Dutch Painting," *Art Quarterly*, v. 19: 1956 (pp. 315-17).
Stechow, W. *Dutch Landscape Painting of the Seventeenth Century* (London: 1966).
Stoett, F. A. *Nederlandse Spreekworden en Gezegden* (Zutphen: 1974).
Stridbeck, C. G. *Bruegelstudien* (Stockholm: 1956).
Swillens, P. T. A. "Roomsch-Katholieke Kunstenaars in de 17e eeuw," *Katholieke Cultureele Tijdschrift*, v. 1: 1945.
Terlinden, C. "P. Bruegel et l'histoire," *Revue Belge d'Archéologie et de l'Histoire de l'Art*, v. 3: 1942 (pp. 229-57).
Veen, C. F. van. *Dutch Catchpenny Prints* (The Hague: 1971).
Vermaseren, B. *De Katholieke Nederlandsche Geschied-schrijving in de XVIe en XVIIe eeuw over den Opstand* (Maastricht: 1941).
Veth, C. *De politieke prent in Nederland* (Leiden: 1920).
La vida y hechos de Estebanillo Gonzales, hombre de buen amor, compuesto por el mismo . . . (Antwerp: 1646).
Vles, J. *Le roman picaresque hollandais des XVIIe et XVIIIe siècles et ses modèles* (The Hague: 1926).
Vloten, J. van. *Nederlandse Geschiedzangen, naar tijdsorde gerangschikt en toegelicht* (Amsterdam: 1864).
———.*Het Nederlandse Kluchtspel van de 15e tot de 18e Eeuw* (Haarlem: 1878-81).
Vollenhoven, C. van. "The Framework of Grotius' De Iure Belli Ac Pacis 1625," *Verhandelingen der Koninicklijke Akademie van Wetenschappen te Amsterdam: Afdeling Letterkunde*, v. 30: 1932.
Vondel, J. van den. *Werken* (Amsterdam: 1942).
Vos, A. de. "Strijd tegen vrijbuiters 1584-1609," *Handelingen der Maatschappij voor Geschiedenis en Oudheidkunde te Gent*, New Series v. 11: 1957 (pp. 134-64).
Waal, H. van de. *Drie Eeuwen Vaderlandsche Geschied-Uitbeelding: Een Iconologische Studie* (The Hague: 1952).
Wee, H. van der. *The Growth of the Antwerp Market and the European Economy* (The Hague: 1963).
Wijn, J. W. W. "Krijgsbedrijven onder Frederick Henry," in *Algemene Geschiedenis der Nederlanden*, v. 4 (Utrecht: 1953).
———.*Het Krijgswezen in den Tijd van Prins Maurits* (Utrecht: 1934).
Williams, R. *The Country and the City* (London: 1973).
Wittman, T. *Les gueux dans les "bonnes villes" de Flandre* Budapest: 1969).
Wolfthal, D. "Jacques Callot's Misères de la Guerre," *Art Bulletin*, June 1977 (pp. 222-33).
Wright, J. W. "Sieges and Customs of War at the Opening of the 18th Century," *American Historical Review*, v. 39: 1934.
Würtenburger, F. *Pieter Bruegel der Altere und die deutsche Kunst* (Wiesbaden: 1957).
Zoet, J. (and others). *De Olijfkrans der Vreede* (Amsterdam: 1609).

Index